ART-EXPO 88

The international review of the major exhibitions and events of the past year

ART-EXPO 88

The international review of the major exhibitions and events of the past year

Phaidon

Phaidon Press Limited, Littlegate House, St. Ebbe's Street, Oxford, OX1 ISQ

First published in England 1988

Originally published in German as ART-EXPO 1987

© 1987 by Jeunesse Verlagsanstalt, Vaduz

British Library Cataloguing in Publication Data

Billeter Erika
Art expo '88
1. Art-Exhibitions
I. Title – II. Art-expo '87. English
708 N 4395

ISBN 0-7148-2529-8

Edited by Dr. Erika Billeter, Lausanne
Designed by Andreas Christen and Patricia Schmid, Baar
Reproductions made by Cliché + Litho AG, Zurich
Typeset by Offset + Buchdruck AG, Zurich
Printed by Druckerei Winterthur AG, Winterthur
Bound by Eibert AG, Eschenbach SG

Printed in Switzerland

Introduction

Each new edition of Art-Expo poses again the question of which exhibitions should be included. It goes without saying that it is impossible to offer anything approaching a complete picture of the many exhibitions held in the course of the year, but is hoped that the Exhibition Guide at the end of the book will go some way towards filling any gaps.

This volume is the second in the English Art-Expo series. If each volume is seen as a link in a chain, the task of selection becomes somewhat easier. Our aim is to build up, over the years, as wide a spectrum of art as possible, with the articles coming together to form a whole, like tiles in a mosaic, thus giving the reader a picture of history—a form of history in which past and present are interwoven.

I have tried to include every major exhibition, including those that were shown at one venue only rather than enjoying a tour of several cities or countries. Examples include: "Van Gogh in Arles" in New York; "The Magic of Medusa" in Vienna; "Ecce Arcimboldo" in Venice. I could not, of course, leave out the big event of the year, the Documenta in Kassel. But the reader will notice that I have also included a number of one-man shows by contemporary artists. This is an excellent way, I believe, of gradually building up a picture of contemporary art and its foremost exponents. A new feature of this volume is an article on the very latest artistic trends.

It was under the title "Dark horses" that over 20 years ago the magazine "DU" presented young talents who were embarking on their careers and who had yet to be influenced by the media, the art market and the eccentricities of the art scene. I have chosen this same title for a series which starts in this volume. "Dark horses" will be a regular feature of future Art-Expos. Each year an art critic will be asked to write on his own country. We begin with Germany. Dr Mathias Bleyl of Bonn University presents four young artists from Cologne.

My sincere thanks go to the auction houses Christie's and Sotheby's for their contributions and also to my colleagues at Weltrundschau for their tireless efforts in co-ordinating the production of this book.

Erika Billeter

Contents

Yoshihara Jirō

Joan Miró

Francesco Clemente

Le Corbusier

International Exhibitions

Eugène Delacroix

Art-Special

Martial Raysse

Eero Jänefelt

Homage to Beuys

Munich

The organizer of the exhibition "Homage to Beuys", which included objects, sculptures and drawings grouped around the centrepiece of the show, the environment "Show your wounds", was *Armin Zweite,* Director of the Städtische Galerie in Lenbachhaus and a leading expert on the work and ideas of *Joseph Beuys* who died last year. "Show your wounds" caused a great outcry when purchased by the Munich museum. It was works such as this by *Beuys* that set the standard for the 70 other artists who accepted the Lenbachhaus's invitation to contribute to the exhibition. All were paying tribute to *Beuys* through their own work just as, several centuries earlier, according to *Vasari,* Florentine artists honoured *Michelangelo* through an exhibition of their works.

The exhibition was originally planned to mark the artist's 65th birthday. *Beuys* himself had supported and encouraged the project. It was his personal wish to include in the exhibition not just students, friends or artists similar to himself, but also artists working in entirely different directions. Their differences were to illustrate what *Beuys* understood by the universal appeal of art, while at the same time emphasizing *Beuys'* own consistent outlook. *Joseph Beuys* died on 23 January 1986 and the exhibition became a posthumous homage to the artist who had done so much to change the course of post-war art, and who had hoped that his ideas would form a new basis of expression for the art of the future. Few artists, if any, took up his concept of art, but many looked up to him as a great magician and innovator, the real revolutionary of the avant-garde.

The names of the artists included in this "Homage to Beuys" form the élite of international contemporary art today. Scarcely any major artist is missing. The Austrian artist, *Günter Brus,* paraphrased *Beuys'* leitmotifs in his drawings; *Andy Warhol* projected a photo of the artist onto a background resembling camouflage material; *Klaus Rinke* constructed a tombstone, a door to eternity, which he called "Joseph Beuys—Present!". *Beuys'* concept that all material things are imbued with the spiritual was taken up here by *Klaus Rinke* and transposed into his own work of art.

It was an ovation from 70 artists to a man who rejected the artistic trends of our time and wished to replace them with, in the words of *Armin Zweite,* "the original, metaphysical appeal of creativity within the actual reality of life". "Every man is an artist", this was the slogan with which *Beuys* hoped to change art, but which was so tragically misunderstood. His hope was to change the quality of life on earth through an anthropological concept of art, and he believed in the power of art to bring about this change. But even during his lifetime, and increasingly since his death, we have learned that such a hope is not so much an ideal as a fiction. Reality still lies in the art that binds us all together. This is exemplified in this wide-ranging exhibition. Of the 70 artists represented here, 40 of whom created new works especially for this exhibition, all belong to what *Beuys* would term the mainstream of art. Certain works may find their inspiration in *Beuys,* taking up his themes or motifs, yet even so, none could be described as belonging to "an extended concept of art". Thus the artists exhibited alongside *Beuys* serve to highlight his individual approach. This dualistic exhibition, conceived both by *Armin Zweite* and the artists involved as a kind of posthumous thankyou, brings to mind the words of *Beuys* himself: "The work of art is the greatest riddle, but man is the solution."

*Visitors to the
private view*

*Joseph Beuys
Horns
1961
145×80×30 cm
Private collection*

*Evolutionary threshold
1985
8 pieces of felt
Private collection*

*Stag
1959
Aluminium (cast, 1984)
46×175×105 cm
Bernd Klüser Gallery, Munich*

*Jason II
1962
Zinc bath
Bernd Klüser Gallery, Munich*

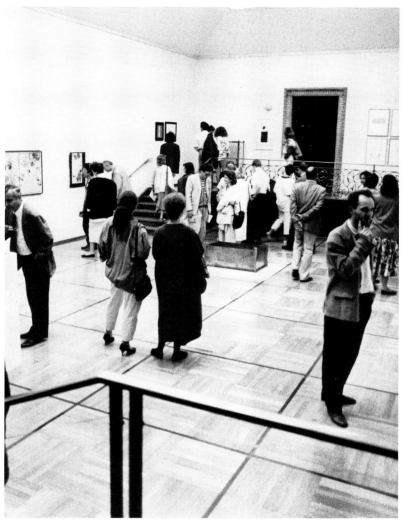

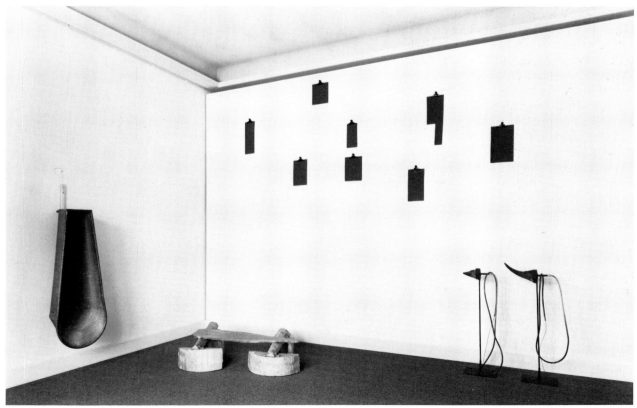

Richard Long, Magpie Long, 1985, black and white flint, 1130×152 cm, Konrad Fischer Gallery, Düsseldorf
Donald Judd, 85–25, 1985, lacquered aluminium, 30×360×30 cm, Grässlin-Ehrhardt Gallery, Frankfurt

Gotthard Graubner, Zodiacal light (Erdlicht), 1980–81, foam cushion covered with canvas, two parts, each 133×133 cm, property of the artist

Nam June Paik
65
1986
Video installation

Volker Tannert
Untitled
1986
Oil and object on canvas
180×360×16 cm
Property of the artist

Mimmo Paladino
Il pane della storia
1986
Iron and bronze
120×240×100 cm
Bernd Klüser Gallery, Munich

Mimmo Paladino
Al termine della notte
1986
Mixed media
150×600×30 cm
Bernd Klüser Gallery, Munich

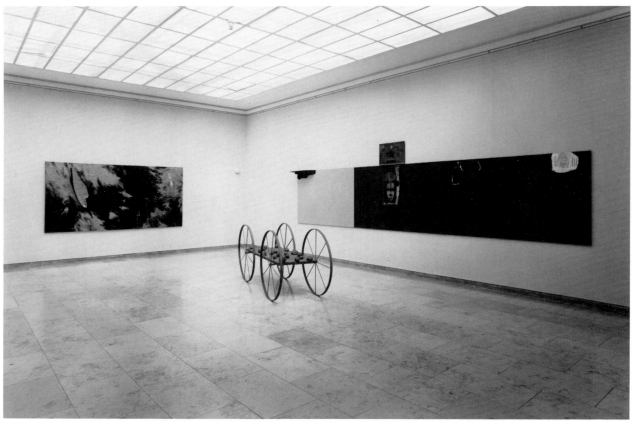

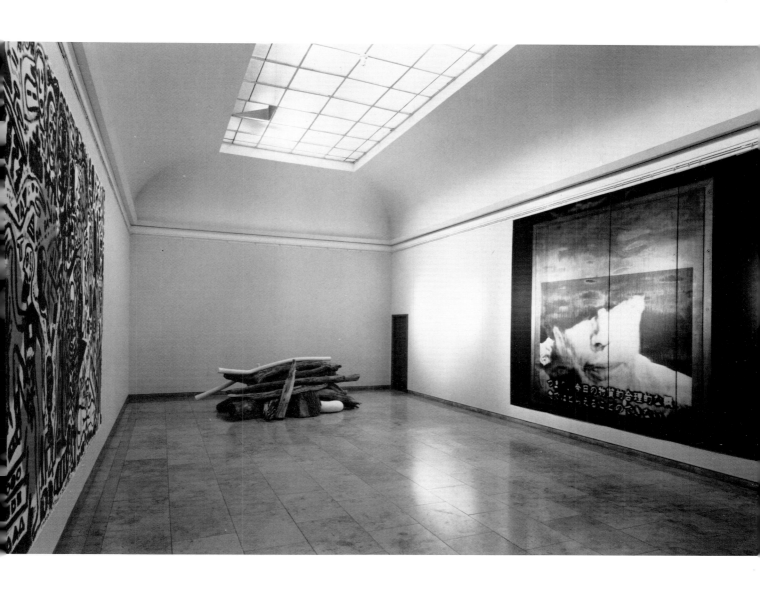

A.R. Penck
Documenta documents,
Civilization at the crossroads,
white eagle meets black eagle
1982
Acrylic/canvas
290×500 cm
Michael Werner Gallery, Cologne

Tony Cragg
Sculpture
1986
Property of the artist

Katharina Sieverding
Continental core V
1986
Photography
Property of the artist

Enzo Cucchi
Untitled, 1986
Encaustic and fresco in cement
280×422 cm
Bernd Klüser Gallery, Munich

Richard Serra
Two Plate Prop, 1969
Antimony-lead, two plates
each 122×122×2.5 cm
Gallery for Film, Photo,
New Concrete Art and Video, Bochum

Enzo Cucchi
Rue Rimbaud, 1985
Oil on canvas and painted
sheet iron
280×350 cm
Bernd Klüser Gallery, Munich

Ulrich Rückriem
Untitled, 1986
Slate, three parts
each 150×150×17 cm
Property of the artist

Andy Warhol
Portrait of Joseph Beuys
1986
Silkscreen on canvas
243×205 cm
Bernd Klüser Gallery, Munich

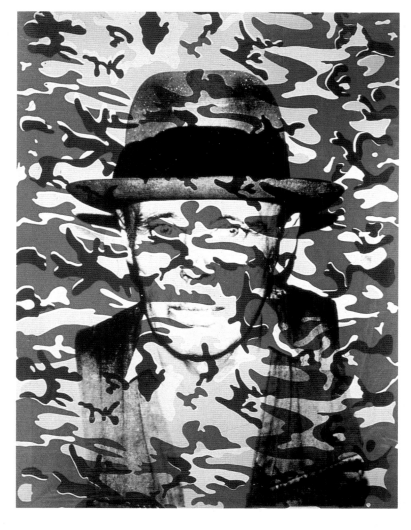

Joseph Beuys
Untitled
1969–85
Plate glass window with several objects
Private collection, Munich

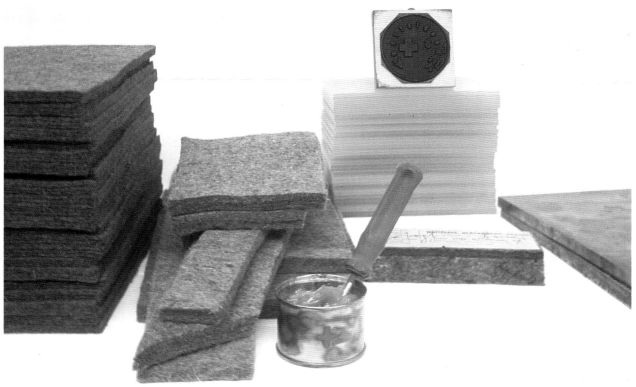

The Sketchbooks of Pablo Picasso

New York – London

It was something of a sensation when the Pace Gallery showed the sketchbooks of *Picasso* in 1986, an exhibition which later moved to London. A sensation in so far as the emphasis was not on the genius of *Picasso,* but on the quantity of work which formed a foundation for this genius. 175 sketchbooks have survived, produced between 1894 and 1967. "Je suis le cahier" (I am the notebook), wrote *Picasso* on one of the sketchbooks. This title, evidently a spontaneous inscription, says much about his method of work. Sketches and drawings were of fundamental importance for *Picasso's* work. His paintings are based on thousands of sketches, not direct studies, but jottings of ideas, shapes, stylistic experiments. There are eight sketchbooks alone for "Les Demoiselles d'Avignon", *Picasso's* masterpiece which heralded the arrival of cubism, and four for "Le Déjeuner sur l'Herbe, après Manet".

The sketchbooks corroborate what the major works suggest—unceasing work, the reworking of a theme over months or even years. *Arnold Glimcher* has brought out an outstanding work on the sketchbooks which serves as a catalogue to the exhibition and provides a comprehensive insight into the sketchbooks. It is the tireless seeker, the artist endlessly correcting himself, that we meet in the sketchbooks. Nothing is left to chance in a Picasso painting. Despite the apparent spontaneity, each work is the result of a lengthy thought-process and formal study. Some pages resemble finished drawings, complete works of art, but most are stages leading towards a work, and it is this that constitutes the excitement of the sketchbooks. They reveal the changes in thought and concept which help to determine the final form of a Picasso picture. There are fascinating sketches which combine realistic sketches with cubist transcriptions and which allow us to accompany *Picasso* along the long road from the real object to its unfamiliar artistic representation.

Sam Hunter writes, in his commentary on the sketches, that they reveal to what extent for *Picasso* human life is only one of several forms of existence. Metamorphoses from one form to another are a constant possibility. Thus a chair, a dress, a figure, a hat or a plant can become part of a formal, figurative dialogue in which every object becomes important as a living element. Even banal objects become imbued with magical powers. In the light of this irresistible urge to draw, it is worth remembering the words of *Picasso's* mother as recalled by *Roland Penrose:* "His mother liked to describe how his first words were 'piz, piz', which in Castelan was a categorical demand for a pencil." Right up to the end of his life this urge never left him. This was the way in which he gave expression to his love of experimenting. Sketching was his way of discovering and developing new ideas. Spontaneity and speed characterize the thousands of pages of sketches but as well as the rapid fixing of an idea, there is also the patient probing of a particular problem of form and the slow circling round a prescribed aim.

With the staging of this exhibition and the publication of the accompanying book, the sketchbooks have become an indispensable guide to the work of *Picasso.* They are evidence of his creative vitality and his unceasing efforts to interpret the world around him. *Picasso* never let anyone see his sketchbooks, even his closest friends were hardly aware of their existence. Now they are universally accessible as a continual reminder of the respect we owe to the act of creation, for it is this, in the truest sense of the word, that the sketchbooks indicate.

From sketchbook no. 110, 1940
Seated female nude
Ink drawing (in connection
with the painting
"Woman combing her hair", 1940)

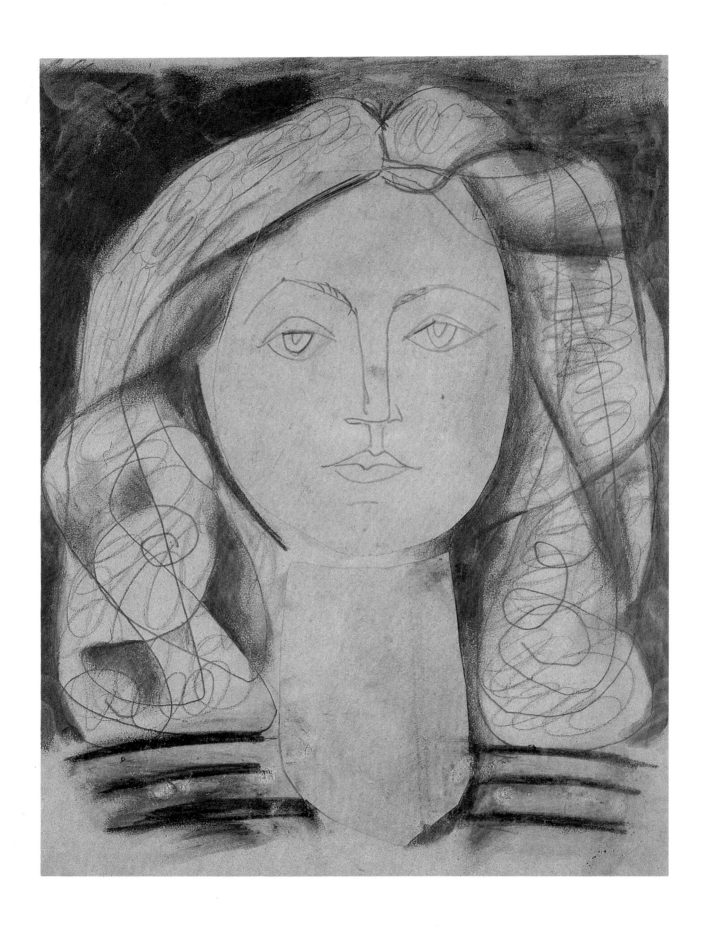

From sketchbook no. 115, 1946
Portrait of Françoise Gilot
Collage and chalk

From sketchbook no. 115, 1946
Portrait of Françoise Gilot
Collage and chalk

From sketchbook no. 35, 1905
Drawing of a male figure
in ink and watercolour (Sketch for
the painting "The Juggler", 1905)

From sketchbook no. 35, 1905
Ink drawing of seated male
figure (Sketch for the
painting "The Juggler", 1905

From sketchbook no. 92, 1926
Collage with leaf

From sketchbook no. 59, 1916
Pencil drawing of a
harlequin and a man reading
with cylinder

From sketchbook no. 110, 1940
Ink drawing of a female
figure, coloured with red and
blue chalk

From sketchbook no. 92, 1926
Drawing in blue pencil
of an abstract guitar

From sketchbook no. 77, around 1922
Pencil drawing of a woman
and child

*From sketchbook no. 35, 1905
Ink drawing with pink
watercolour of a seated
harlequin (in connection with
the drypoint etching "Juggler
resting", 1905)*

From sketchbook no. 20, around 1900
Chalk drawing of a female
head (in connection with the
painting "French Cancan", 1901)

From sketchbook no. 38, 1906–07
Ink drawing of a female
head (in connection with the painting
"Les Demoiselles d'Avignon"
1907)

Der Blaue Reiter

Berne

This outstanding exhibition took place at the Kunstmuseum in Berne. It had originally been intended that the exhibition would tour Europe, but because touring exhibitions tend to be frought with problems, the wealth of pictures included in the "Blaue Reiter" exhibition were, in the end, shown only in Berne. Nevertheless, over 100,000 visitors saw the exhibition, which was one of the highlights of the European art scene. The exhibition marked the 75th anniversary of the "Blaue Reiter" association, a community of artists founded by *Wassily Kandinsky* and *Franz Marc,* which included *Kandinsky's* companion of the time, *Gabriele Münter.* "Association" is not really the right word to use here. "Der Blaue Reiter" was a kind of utopian dream, made real by *Kandinsky* and *Marc* by means of an almanac which was regarded as the "New Testament of art". In it artists of similar outlook were represented. Only one edition of the almanac was ever published, in May 1912, after scarcely a year in preparation, and two exhibitions were organized in parallel with the publication. The intention was to publish the almanac annually and to restrict it to reproductions and articles by artists alone.

"In the book the entire year must be reflected, while links with the past and a beam of light into the future must give this mirror its full vitality", wrote *Kandinsky* to *Marc.* The watchword of the "Blaue Reiter" was "freedom of artistic expression" in accordance with "inner impulses" within the two extremes of "great abstraction" and "great realism" *(Kandinsky).*

The aim of the current exhibition was to present to the public an intellectual circle of artists while at the same time portraying their artistic roots. The importance of these roots to modern art was repeatedly emphasized by *Kandinsky.* Thus, the exhibition included examples of medieval and even classical art, non-European art and in particular Russian folk art whose influence on *Kandinsky,* was paramount. The most fascinating aspect of this exhibition, however, was not the theoretical foundation of the movement, but the pictorial material that *Christoph von Tavel* was able to bring together. There were room upon room of masterpieces produced in the brief period 1911–12, a concentration of artistic motivation, the like of which had never been seen before.

The early works and first abstract paintings of *Kandinsky* were a highlight that one could never forget. Many of the pictures on loan for the exhibition were from two major sources, the Lenbachhaus in Munich with its Gabriele Münter Bequest, and the Musée National d'Art Moderne in Paris, one of the centres for *Kandinsky's* work in Europe, thanks to the gift of *Nina Kandinsky.* The *Franz Marc* room, containing major works by this artist who was killed at Verdun in 1916, made manifest his concept of "objective colours" and brought together many of his most important animal paintings—expressions of "the absorption of the animal kingdom within the absolute laws and rhythms of nature and the cosmos". *August Macke, Gabriele Münter* and also *Arnold Schönberg,* with whom *Kandinsky* had a lively correspondence, complete the picture of a generation of artists for whom *Kandinsky's* criterion of "inner impulses" had become a credo. As the almanac came to the end of its brief life, the artists themselves were disappointed at the outcome of all their efforts. *Kandinsky* lamented the narrow outlook of the intellectual world and *Marc* the lack of understanding of the artistic world and artists in general. The main aim of the "Blaue Reiter", "namely to show by example, by practical demonstrations, by theoretical arguments, that the question of form in art is secondary and that art is chiefly a question of content" had proved unattainable, wrote *Kandinsky.*

Ernst Ludwig Kirchner
Three Bathers in
the Moritzburg Lakes
1909
Dry-point etching
39.4×42.4 cm
E.W. Kornfeld Collection, Berne

Ernst Ludwig Kirchner
Dancer with
Lifted Skirt
1909
Woodcut
41.6×55.1 cm
E.W. Kornfeld Collection, Berne

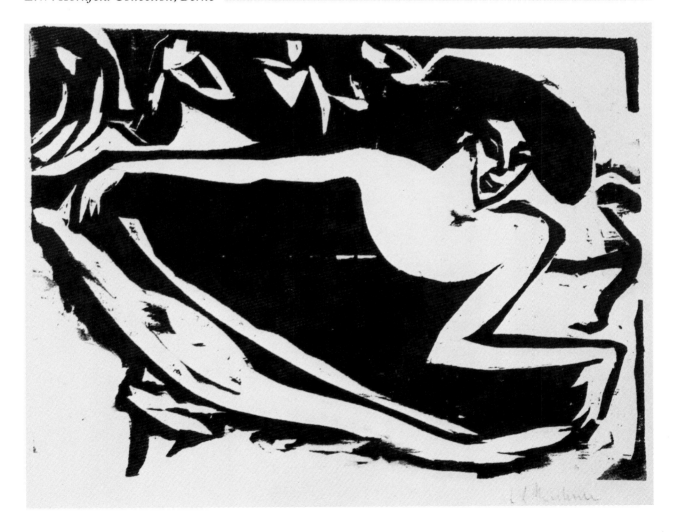

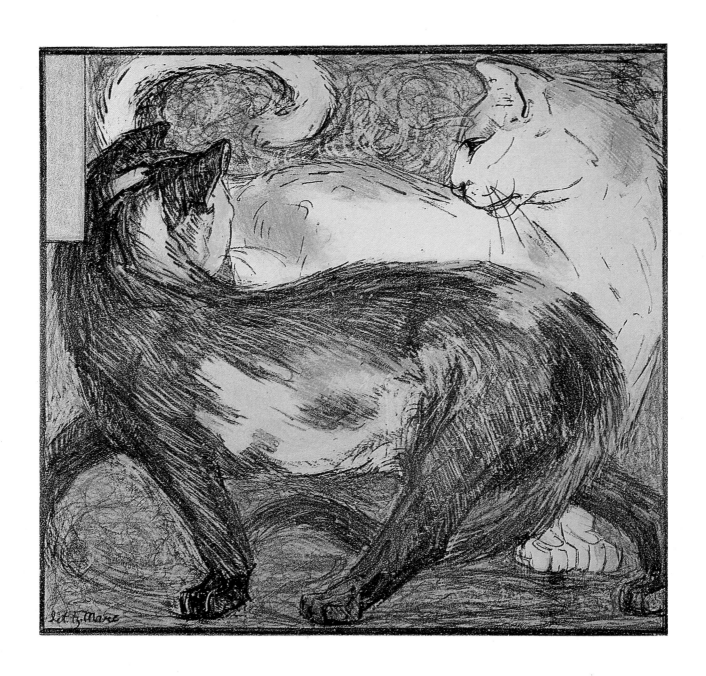

Franz Marc
Two Cats
1909
Lithograph
40.5×42 cm
E.W. Kornfeld Collection, Berne

Wassily Kandinsky
Interior (with two women)
1910?
Oil on board
50.5×65 cm
Paul Klee Estate Collection, Berne

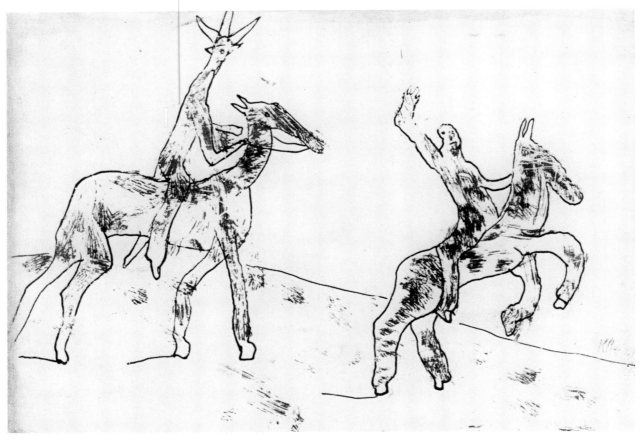

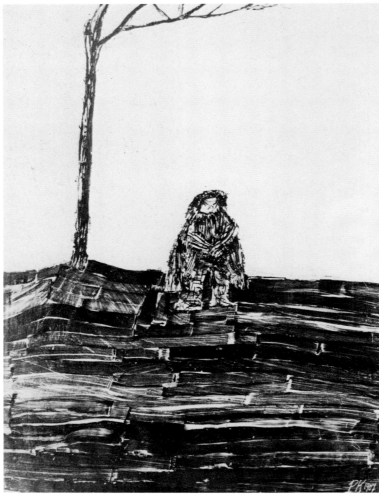

Paul Klee
Rider and Outrider
1911
Ink and caput mortuum behind glass
13×18 cm
Paul Klee Estate Collection, Berne

Paul Klee
Dwarf under a Tree
1907
Ink behind glass
32×23 cm
Paul Klee Estate Collection, Berne

Robert Delaunay
Eiffel Tower with Trees
1909
Oil on canvas
124×91 cm
Solomon R. Guggenheim
Museum, New York

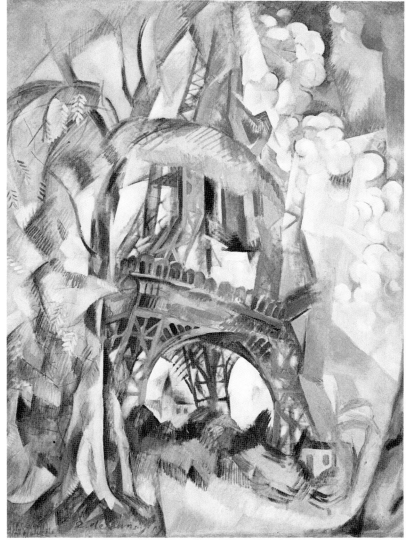

Franz Marc
Dog Lying in the Snow
1911
Oil on canvas
62.5×105 cm
Städelsches Kunstinstitut,
Frankfurt
Property of the Städelsches
Museum Association

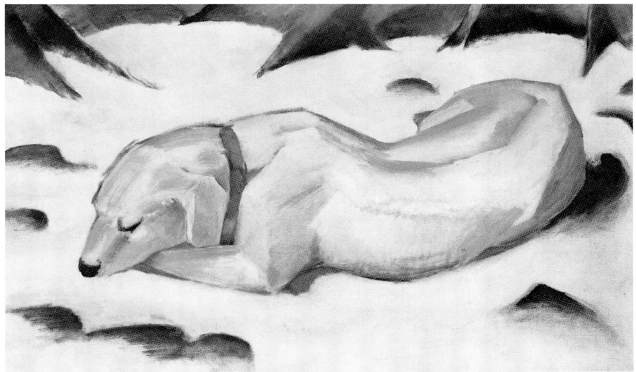

Franz Marc
Deer in Wood I
1911
Oil on canvas
129.5×100.5 cm
Private collection

Franz Marc
Blue Horse II
1911
Oil on canvas
112×86 cm
Othmar Huber Bequest

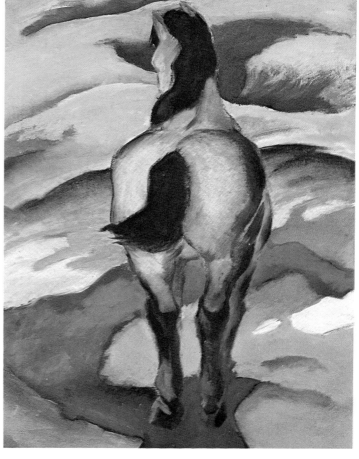

Wassily Kandinsky
Lyric
1911
Oil on canvas
94×130 cm
Boymans van Beuningen
Museum, Rotterdam

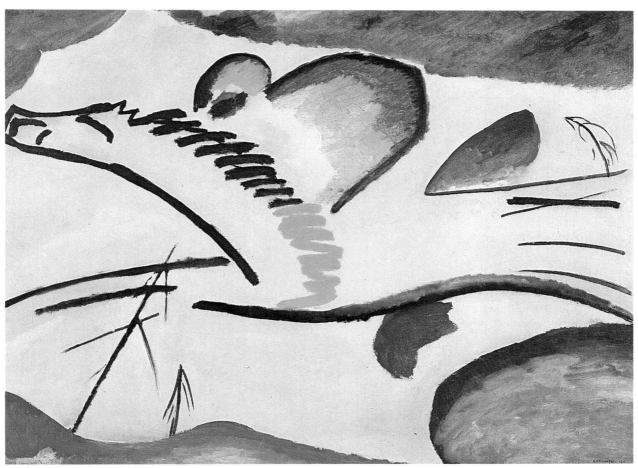

Europe/America
A history of artistic fascination since 1940

Cologne

The opening of the Ludwig Museum in Cologne was accompanied by an exhibition befitting the monumental new building. It was an ambitious project aimed at exploring the relationship between European and American art, a truly gigantic and extremely interesting theme and one which was well worth exploring! The famous Armory Show of 1913 put everything in motion. This marked the beginning of an intense interchange between American artists and the European Moderns. It was the start of an American avant-garde, deeply influenced by Europe and following the trends of the European avant-garde. The emigration of European artists during the Thirties and Forties gave European art a firm footing in the United States. The emigration of *Arshile Gorky* had laid the foundations as early as 1920 and following him *Marcel Duchamp, Max Ernst, Hans Hofmann* and *Josef Albers* completely altered the climate. It was this generation of artists that gave the impulse to what we now understand by modern American art. They had a direct influence on the generation of painters who established the first truly American school of painting, abstract expressionism. These painters were the first to translate the European concept of art into their own style, creating a new situation in the history of European art. American art became a factor to be reckoned with. Europe no longer reigned supreme in the area of pictorial art, but now had to recognize American art as its equal. For a time, from the early Fifties until the Seventies, it was American art that led the world with Europe trailing in its wake. In the Eighties the wheel of history seemed to turn once more, with European artists at least the equal of the Americans. New York is still admittedly the centre of modern art, but European artists are exhibited increasingly in its galleries and museums.

The *Joseph Beuys* retrospective at the Guggenheim Museum in New York in 1979 was indicative of the mutual understanding between European and American artists. Today they share the same trends, the same concepts. The same leitmotifs are found in both American and European art. It is still possible to pick out national characteristics, like those that distinguish German art from Italian and which separate both from the Americans. Because the personality of the individual artist is still paramount the course of both American and European art is still determined by a few leading individuals.

It was understandable that the Ludwig Museum should choose a theme of this kind for its opening exhibition, for its own collection was able to provide the starting point for the project. The Ludwig Collection was one of the first museum collections to recognize the value of American Pop-art from the outset, and its present collection of American contemporary art is impressive. The exhibition is spiritually linked to the museum's own collection. In this exhibition 25 years of European and American art are shown together rather than face to face. It is a dialogue not a confrontation. With the advantage of hindsight, one can recognize the contemporaneity of events in the Old and New Worlds which eventually became the basis of western art as a shared form of expression. There is no lack of big names in this exhibition and the numerous articles in the catalogue provide a variety of answers to the Euro-American problem.

Claes Oldenburg
Street Chick, 1960
Casein on cardboard-covered
wood
88.9×26 cm
Ludwig Collection, Ludwig Museum, Cologne

Franz Kline
Yellow Square, 1952
Oil on canvas
164.5×200 cm
Courtesy Marisa Del Re Gallery, New York

Jean Dubuffet
L'amphigourique, 1954
Stone- and iron-chippings
H 41 cm
Donald Morris Gallery,
Birmingham (USA)

Jean Dubuffet
De chaumage au Brabant
1943
Oil on canvas
92×73 cm
The Waddington Galleries,
London

Jasper Johns
Passage, 1962
Encaustic, length of ruler,
metal chain, fork, paper and
collage on canvas (3 parts)
178×102 cm
Ludwig Museum, Cologne

Fernando Botero

Munich – Bremen – Frankfurt – Madrid – Tokyo

There are few contemporary South American artists who can claim to have conquered Europe, but the Colombian painter and sculptor *Fernando Botero* is one. It is difficult to explain why he should have found recognition earlier than *Wilfredo Lam* or *Matta,* the painter who had direct contact with Europe through the Surrealist movement. One factor that has contributed to his popularity is doubtless his style which is easily recognizable and which has remained unchanged throughout his life; who is not familiar with those fat, chubby-faced people who fill his canvases?

Fernando Botero is today in his mid-fifties and properly belongs to the generation of American Pop-art. Yet, when one looks at his work, he seems completely out of tune with his times, his style contrasting forcibly with that of his contemporaries. "I am the most Colombian of Colombian painters", he said once in an interview. Thus he himself sees his work in the context of his homeland, far from the influence of European or American artistic trends. He has said: "The background of an artist who grew up in Europe or the United States is totally different from the experiences of a Latin American artist. In Colombia there were no museums. All there was to see was the Colonial Baroque in the churches. There was no *Goya,* no *Velázquez* or *Titian* and certainly no *Picasso.* I saw my first picture when I arrived in Barcelona from Colombia by ship at the age of 19. I headed straight for the town museum."

Such an unusual cultural background inevitably leads an artist to an unusual form of personal expression in his artistic visions. The limited colonial-style art of his homeland made a marked impression on *Botero.* It forms the basis of his paintings which know no comparison in either Europe or the United States. Although *Botero* has not lived in his homeland for many years now, he has never turned his back on this artistic legacy. Quite the reverse in fact, for in his brushes with foreign cultures it has guided him towards his own style.

He has never been a trendsetter. He has never been a member of the avant-garde. He paints for his homeland even though his pictures are sought after from Tokyo to New York; one does not have to come from Colombia to understand his art. Just as Latin American literature is read by people who have never set foot on that continent, so have the Colombian elements in *Botero's* pictures become common property. It is a vision of Colombia that they evoke rather than its reality. "One Hundred Years of Solitude" is surely the most Colombian novel ever written, and *Gabriel García Márquez* is read all over the world.

In *Botero's* work everything is fat—people, animals, still-lifes. This is the artist interfering with nature. It is an aesthetic decision, as *Werner Spiess* has called it. It is, for him, both a subjective interpreting of reality and simultaneously a questioning of the ideal of beauty passed down to us from the Renaissance. Sometimes the pictures strike one as caricatures, but this is to do *Botero* an injustice. The alteration and alienation of form is one of the canons of *Botero's* personal style. That which strikes one as satire is meant as a declaration of love. A declaration of love addressed to painting which for *Botero* is the only consideration. "From a certain point the picture becomes a still-life to me. To me every picture is a still-life." By this *Botero* is saying that he sees himself as a painter who has no metaphysical message to communicate. *Cezanne* once said to his wife when she was modelling for him: "Sit as if you were an apple". All that *Botero* asks is for his pictures to be seen as paintings. Not only is this show a delight— it is also a lesson in how to look at paintings.

Alof de Vignancourt "After Caravaggio"
1974
Oil on canvas
100×75 cm
Mr and Mrs Carlos Haime Collection

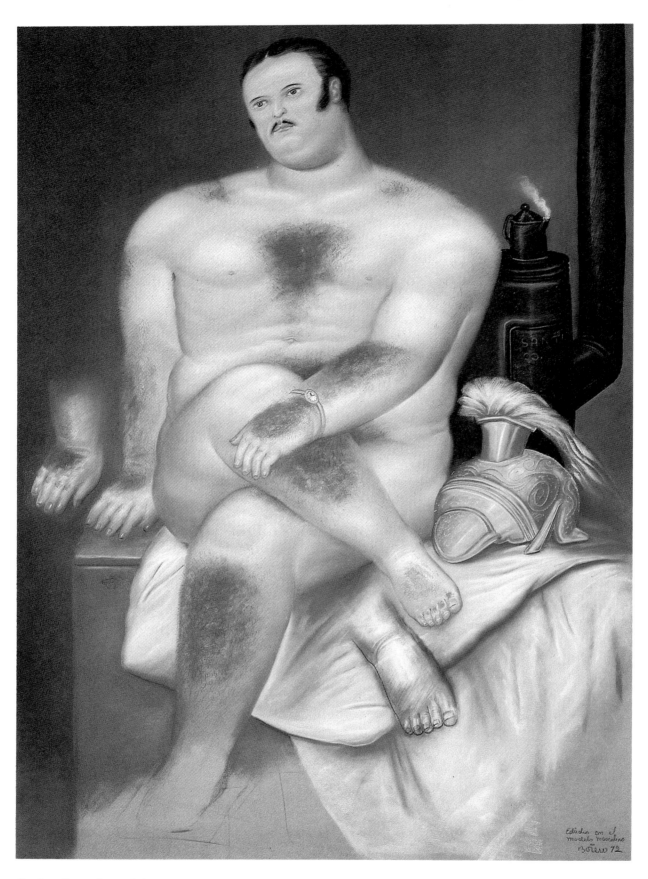

Study of a male model
1972
Pastel on canvas
170.2×123.2 cm
Mr and Mrs E.A. Bergman, Chicago

Still-life with woman dressing
1984
Oil on canvas
191×127 cm
Private collection

Colombiana
1986
Oil on canvas
144×199 cm
Beyeler Gallery, Basle

Dürer Self-portrait
1968
Charcoal on canvas
194×167 cm
Kunsthalle Nuremberg

Still-life with watermelons
1974
Oil on canvas
166×186 cm
Mrs Susan Lloyd Collection

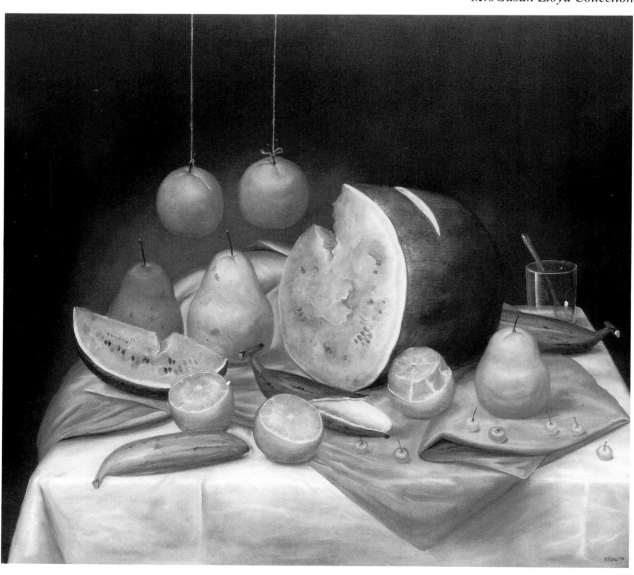

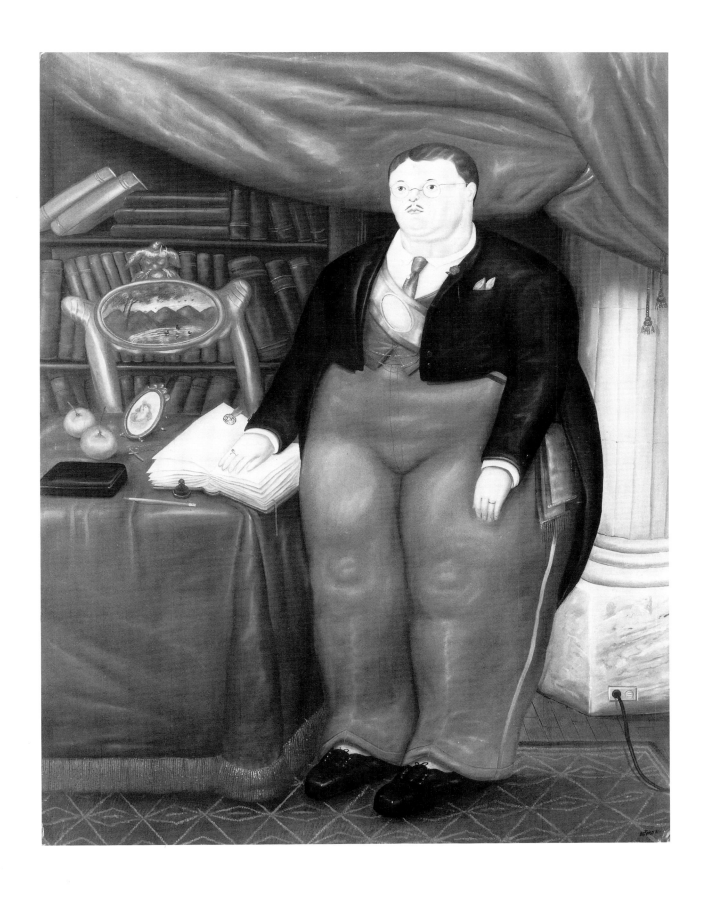

El Señor Presidente
1971
Oil on canvas
210.8 × 162.6 cm
Private collection, New York

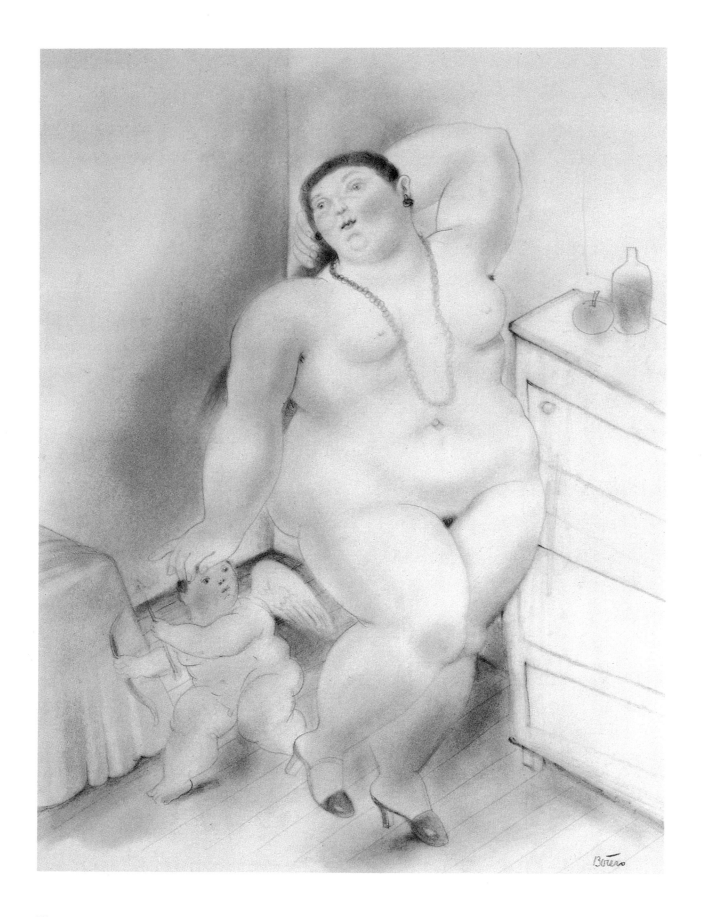

Venus
1984
Pastel and pencil
51×36 cm

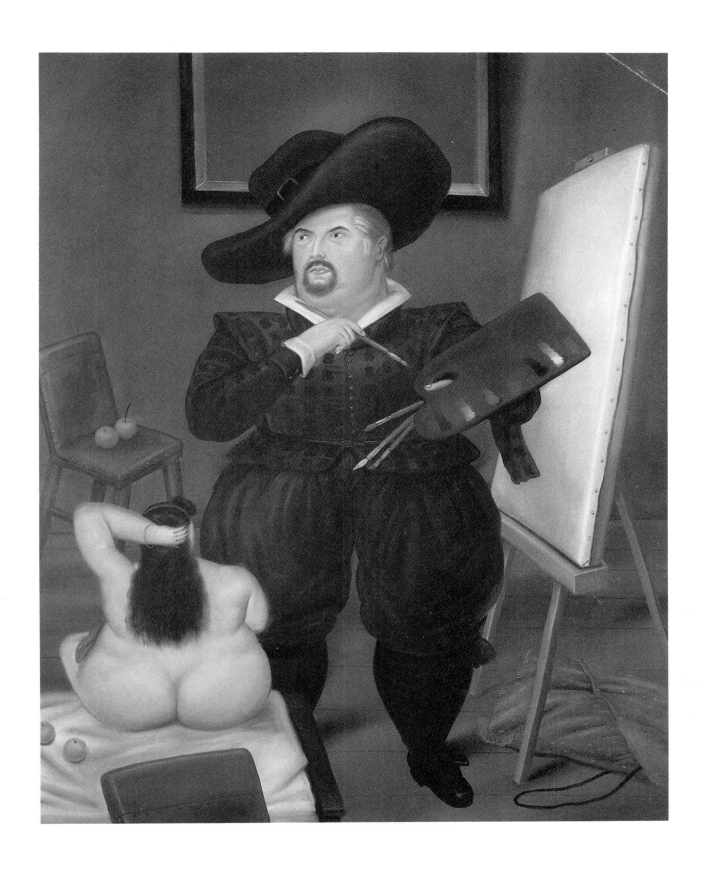

Self-portrait in costume of Velázquez
1986
Oil on canvas
218×175 cm
Beyeler Gallery, Basle

Joan Miró

Zurich – Düsseldorf

People came in their thousands to Zurich and Düsseldorf to see the life's work of this Spanish painter who died in 1983. They were met by a comprehensive selection of 176 works, mostly loaned by American museums and private collectors, and mostly outside the works most familiar in Europe. This was a public that loved *Miró* and was familiar with his work. For, like *Chagall* and *Picasso, Joan Miró* is one of those classic modern artists who achieve public acclaim during their lifetime and enjoy unusual popularity. In the foreword to the catalogue, the exhibition organizers suggest that *Miró's* popularity was because of his most recent work and that his fame arose chiefly from his large graphic productions. An enormous number of coloured graphics have made their way worldwide into drawing-rooms, offices, hospitals and have helped to spread the image of a cheerful, happy and witty artist.

But was *Miró* really like this? The exhibition has tried to clarify *Miró's* position in 20th-century art and in particular to make the early works from the Twenties and Thirties its point of interest. The works were consciously chosen in an attempt to show, in the words of *Felix Baumann*, the underlying formality and the development of content in this apparently spontaneous creativity. An outstanding series of works provides over 20 illustrations of artistic self-recognition from 1915 to 1924. The first pictures date from 1915 and reveal a figurative style, they are Cubist in inspiration and immediately striking for their intensity of colour. Even at this early date the quality that marks *Miró's* life's work was evident; a free, exhilarating use of colour. These early works are followed by a period of detailed, slightly stylized realism. The paintings have something of the look of medieval tapestries about them. *Miró* wanted to see and feel all objects, and all living things, in detail, before he made his daring leap into sign language! This was in 1923–4 and forms another highlight of the exhibition. The pictures produced at this time are "dream images" which brought *Miró* close to the Surrealists. Any illusion of perspective is now abandoned in favour of surface areas, with space developing out of the painting itself. Here *Miró* was establishing the basis for his later work. At the same time he was beginning to translate concrete quotations into symbols and metaphors and was developing his vocabulary of form with which he was to work. He wrote at the time to his friend *Rafols*: "I have succeeded in escaping from nature into the absolute, my landscapes have nothing at all to do with external reality. And yet they are actually 'more montroigic' than if they were painted from nature... Monstrous animals and angelic animals. A tree with ears and eyes and a peasant with a catalan cap, holding a hunting gun and smoking a pipe. All problems of imagery solved. All the golden sparks of our souls precisely expressed."

Admittedly there was still one crisis to be overcome, one which proved to have a creative effect upon the artist. Around 1930 *Miró* began to have doubts about painting. He decided "to kill off his painting" and began to make "constructions". He busied himself with collages and assemblages, creating objects out of the simplest materials, packing cases, nails, old junk. But not long after he was once more seized with the desire to paint, and he painted with a vehemence that never again left him. Later he became interested in sculpture and ceramics. While it was only paintings that were shown in Zurich and Düsseldorf, Madrid and Cologne were collaborating in a retrospective of sculpture so that this year Europe was presenting a fully comprehensive view of the work of *Joan Miró*.

Gouache drawing, 1934
Gouache
107.3×71.1 cm
Perls Gallery, New York

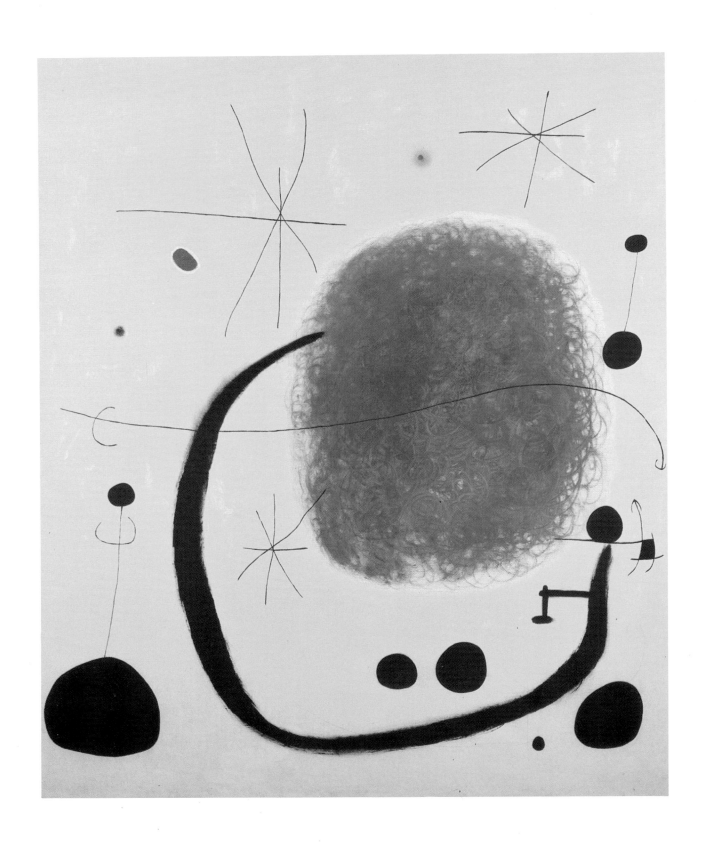

The gold of the azure
1967
Oil on canvas
205×175 cm
Fundació Joan Miró, Barcelona

Painting
1933
Oil on canvas
130×162 cm
Fundació Joan Miró, Barcelona

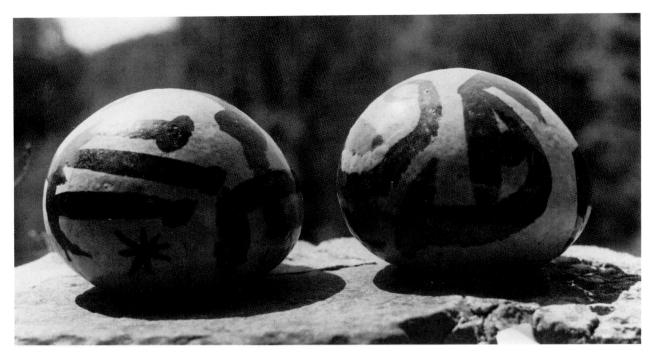

Boulder (Caillou), 1977
Ceramic
17×24×22 cm
Museu de Ceràmica, Ajuntament de Barcelona

Plaque-mask, 1977
Ceramic
49×51×4 cm
Museu de Ceràmica, Ajuntament de Barcelona

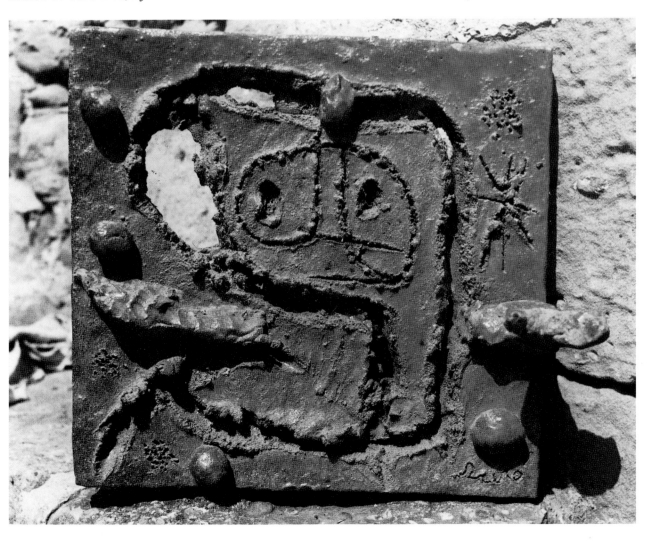

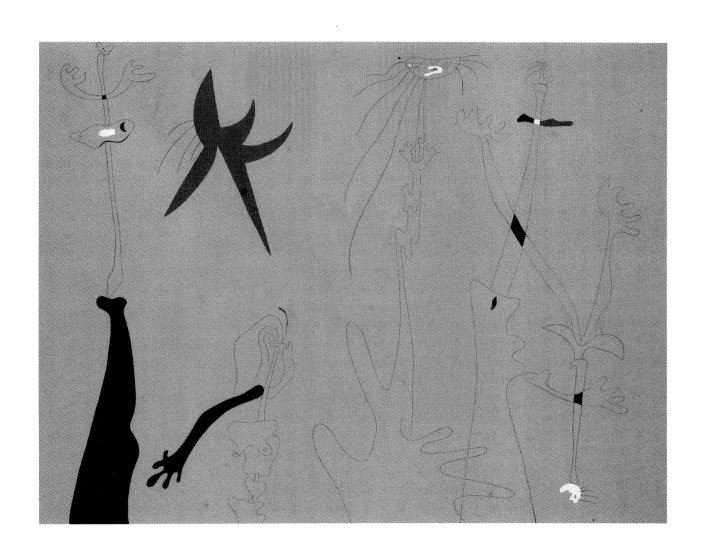

The smile of the star to the
twin tree of the plain
1968
Oil on canvas
174×217 cm
Susy and Daniel Lelong Collection, Paris

Painting
1933
Oil on canvas
130×162 cm
National Gallery, Prague

Painting (Mediterranean landscape)
1930
Oil on canvas
235×155 cm
Richard L. Feigen & Co., New York

Gilbert and George

Bordeaux – Basle – Brussels – Madrid – Munich – London

A truly European tour was organized for the first large-scale retrospective of the work of *Gilbert and George,* two artists who are joined like Siamese twins. They have worked together since 1967, the year in which they independently entered St. Martin's School of Art in London, where they met and decided to pursue a joint artistic career. From that point on they have shared a joint biography and joint output until they are practically one and the same person, as far as their work is concerned at least. Since it is impossible to say who does what in any one work, it is impossible to think of *Gilbert* without *George* and vice versa.

In line with this, their exhibition is described as a "one-man show". The two became famous in the early Seventies with their Happenings in which they appeared as Living Sculpture. "Our life is just one big sculpture" was the statement that said it all. Their first appearance in 1969 was decisive, affecting the whole of their following career. They posed for the public as bronze sculptures, with bronzed hands and faces, and dressed in the off-the-peg suits and ties which have become so familiar over the past twenty years. By standing motionless, sometimes for hours on end, they completely changed the meaning of sculpture. Then they turned to photographs, of themselves, naturally. From Living Sculptures to Photo-sculptures they showed themselves in the most varied situations, made them into stories, juggled with details of their bodies and, with their use of photography, made a significant contribution to the history of modern photography.

However, above all, their work constituted and still constitutes a change in the meaning of art. Their monumental photo-pieces have themselves brought about considerable change. From the beginning, their exhibitions formed an integral whole, and this explains perhaps why they have never been keen to take part in group exhibitions. Their exhibitions have always been a total work of art made up of photo-series on one particular theme. The first photo-series were in black and white, then red was added as a contrast. For the past few years they have worked in colour. Their world, which was originally confined to *Gilbert and George,* has now developed into an immense cosmos. *Gilbert and George* confront the world and the vision of this world. They have developed techniques that make their photos look like glass windows. With the extension of their palette they have invented a new type of picture, the pictogram, made up of photos, drawings and cut-out paper. At the same time they have added to the uniqueness of their work. *Gilbert and George* make few prints of their works. They are one-offs, intended to spread the message of the two artists: "We have discovered our own visual language and we are constantly trying to extend it. We are after a form that is as modern as possible so that through its visual images we can make the most modern statements possible... We create images in order to change people and not to congratulate them on being what they are." But their aim is not merely to change the world, but to improve it—an idealistic aim and one shared by so many artists throughout the course of history. The titles of many of their works are imbued with optimism— "Life", "Hope". As if anxious to exonerate themselves from the charge of an over-utopian outlook, some of their photo-pieces speak of death and anxiety. "Lost and tormented" was the title chosen for one of their earlier photo series. In either case the aim was the same—to change people through confrontation with their art. In this they see the only possibility of human progress.

Bad thoughts No. 9, 1975
Photography
122×102 cm

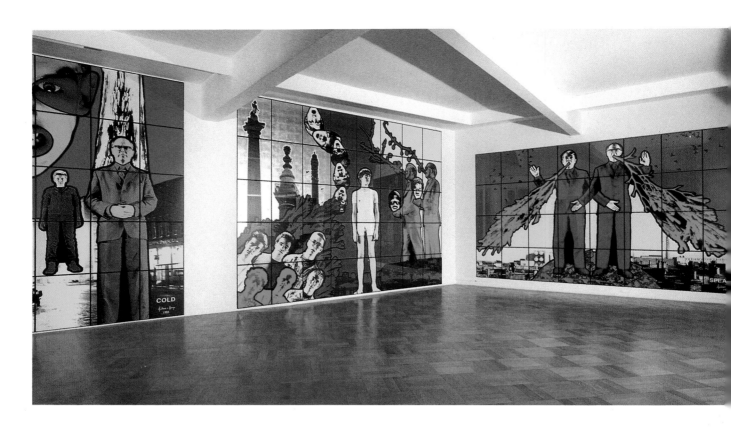

The believing world exhibition
Installation in the
Anthony d'Offay Gallery, London, 1984

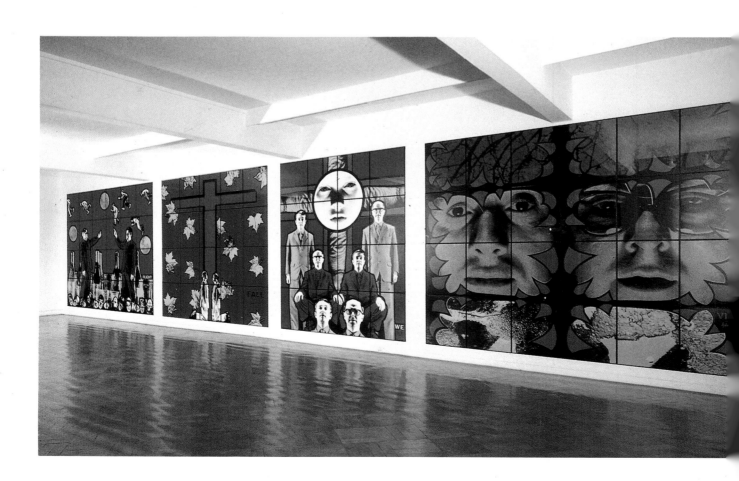

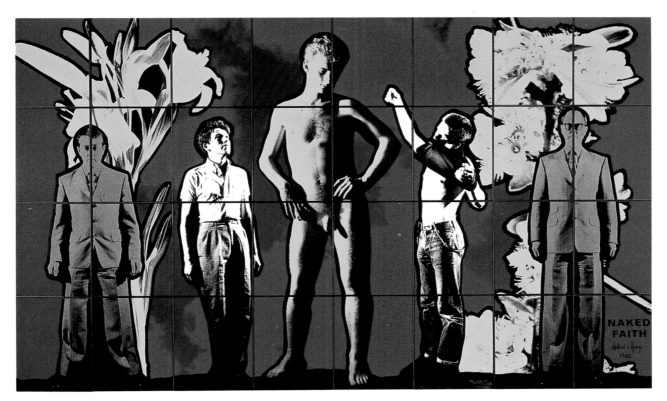

Naked faith, 1982
Photography
241×401 cm

Yellow crusade, 1982
Photography
302×451 cm

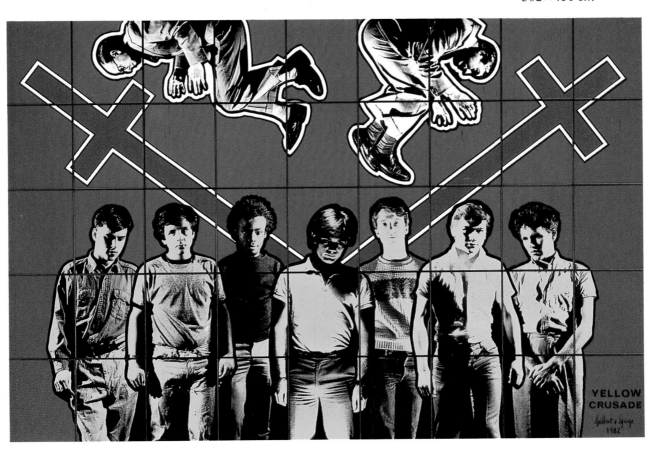

Julian Schnabel

London – Paris – Düsseldorf

He is one of the highest-paid young artists of our time. His name has long ceased to be a secret shared by the afficionados of art; it is a name that means money. The American painter, *Julian Schnabel,* rules the art market from New York to Paris and has recently been shown for the first time in the art museums of London and Paris and at the Kunsthalle in Düsseldorf. It was now the turn of these cities to show 40 of the artist's huge paintings and to follow in the footsteps of the Stedeljikmuseum in Amsterdam which staged a one-man show in 1982.

Schnabel is not an easy painter. *Stuart Morgan,* writing in the London catalogue, describes him as a cultural guzzler, making everything his own that takes his fancy. From American post-war art to the classic Moderns, he has no inhibitions about casting his eye from time to time towards *Paul Cézanne* and *Edouard Manet.* All his sources are reworked with great intelligence and with an outstanding talent for decorative effect. His identity mark, the broken pottery that he sticks onto his paintings, was established early in his career. This mannerism has not left him, but he has experimented with so many other possibilities of style that it is difficult to talk about a *Julian Schnabel* "style". He can be better defined as a virtuoso of stylelessness, a characteristic he shares with *Gerhard Richter* or *Siegmar Polke.* Nevertheless, he is superior to the view so many critics have of him, which is that *Schnabel* is nothing more than a product promoted by the art market and who is no longer able to live up to his early celebrity.

Schnabel sees himself in the context of his contemporaries. For him *Anselm Kiefer, Francesco Clemente* and *Siegmar Polke* share the same criteria when deciding what constitutes a good picture. Most important of all is the poetical transformation of what is seen. That is to say, a view of objects transformed through their own inherent poetry. When one looks at his pictures they contain a multitude of recognizable, highly familiar things. But, as with the Surrealists, they are all independent of one another, existing for themselves alone. It is only in the imagination of the artist that they come together to form a whole and that their content is communicated.

It can provide an entertaining game for the spectator, to try to decode the content or the theme of a picture. "The Geography Lesson", for example, contains a stag, a Corinthian pillar, figures of woman and children scarcely distinguishable against the dark background, a leafless tree, a green globe of the world. The stag in the centre is fiery red and bleeding. The artist did not intend us to try to unravel these different motifs and to try to work out a story from them. He uses each object, rather, to call up associations. It is these associations which determine the content of the picture so that everyone can interpret it in his own individual way.

There have been attempts to bring *Julian Schnabel* down to the level of a Salon painter. The ever increasing demand for his pictures and the ensuring rise in prices—a phenomenon which is by no means limited to *Schnabel*—have tended to encourage this view. Nevertheless it is amazing that an artist who is still in his thirties should enjoy fame of this kind. As an artist who can look back over a fifteen-year career he is not exactly the newcomer to painting who has been popularized by the art market alone. Bad artists tend not to become millionaires. And so one can say with all confidence that *Julian Schnabel's* success is well-earned.

There are painters whose one-man shows become boring since there is too little variety of style. When one has seen one picture, one has seen them all! *Julian Schnabel* is the complete opposite—he changes with every picture.

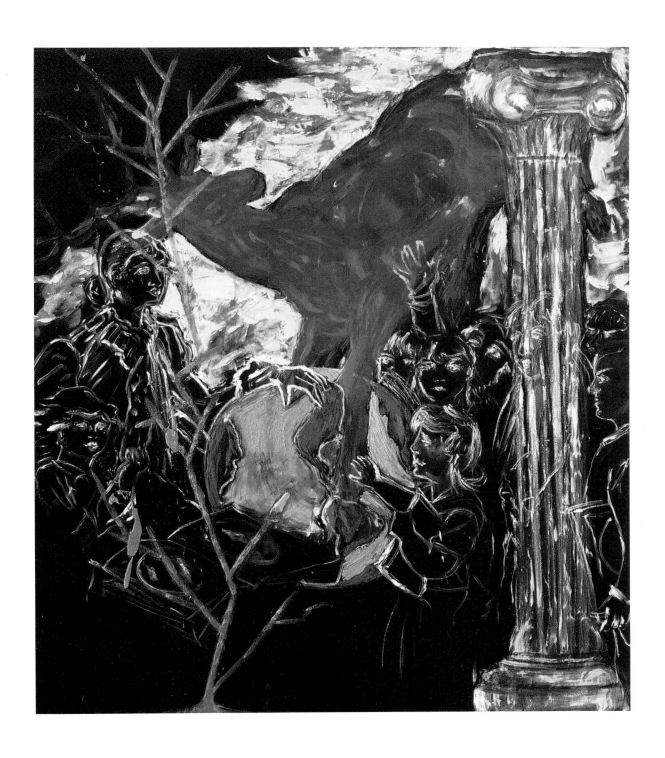

The Geography Lesson, 1980
Oil on velvet
244×213 cm
Bruno Bischofberger Gallery, Zurich

Griddle, 1983
Oil and fibre-glass
335×244 cm
Janet Green Collection, London

St Patrick, 1983
Oil and fibre-glass
290×396 cm
Private collection

The Sea, 1981
Oil, plates, fragments
of pottery and plaster
of Paris on wood
scorched wood
274×396 cm
Saatchi Collection, London

Ethnic Types 15 and 72
1984
Oil, animal fur,
costume jewellery on velvet
274×305 cm
Private collection

Van Gogh in Saint-Rémy and Auvers

New York

The highlight of the New York winter season was without doubt the *van Gogh* exhibition at the Metropolitan Museum. After the 1984 exhibition, at the same museum, which spotlighted the 15 months that *van Gogh* spent in Arles, this exhibition portraying the last 15 months of his life was almost inevitable. The limited number of works from this period restricted the size of the exhibition from the outset. It was an intimate, moving glimpse of the works that the artist painted during the final months of his life when, in 1890, deeply depressed, he shot himself. Like *Raphael, Caravaggio, Watteau* and *Toulouse-Lautrec* he was only 37 years old when he died. He lived in a private asylum in Saint-Rémy before moving to Auvers, where he painted for over two months before deciding to take his own life. *Van Gogh* had a history of mental disturbance. The distressing incident in which he cut off part of his ear took place earlier, in Arles.

The 89 drawings and paintings of these final months were produced between May 1889 and June 1890 and certainly do not indicate mental illness. Rather, they give the impression of boundless energy while many have a wonderful sense of harmony with nature. Nature is the main theme of this period. Cypresses, olive trees, fields, houses in surrounding villages, these are the objects on which he concentrates. A few portraits are amongst them, including three of his best self-portraits. Even the famous painting of his "Bedroom" was produced in Saint-Rémy. In Auvers, where *van Gogh* spent the last months of his life, his attitude towards painting and the world around him altered dramatically. He suddenly began to paint very large canvases of double his usual size. One of the paintings of the Auvers period is the portrait of *Dr Gachet, Vincent van Gogh's* doctor and one of the few men to admire his work during his lifetime.

Even though in the Auvers works his brushwork has become more intensive and individual, the paintings still give no indication of the dramatic end which awaited *van Gogh*. Once more we are struck by his deep understanding of nature, his love of nature which comes across in paintings like "Daubigny's Garden". It was here that he painted his famous "Crows over a Cornfield" interpreted by art critics as showing *van Gogh's* awareness of his approaching death. The original certainly does not give the impression that *van Gogh* was plagued with forebodings of death. The power of the colours and *van Gogh's* great simplicity of composition are overwhelming. The visitor to the exhibition is left with the feeling that *van Gogh* "almost died smiling", as *Delacroix* said. His attitude to both life and death was one of resignation, which was reflected in an inexplicable cheerfulness which in some mysterious manner imbues the late work of *van Gogh*.

Letters written during these final months are optimistic in outlook, showing that *van Gogh* has become resigned to illness and can even be grateful for the occasional abatement of his illness. In February he wrote from Auvers to his friend *Ginoux* and his wife in Arles: "Over and again I have told myself that it would be better if there were nothing more to come, if it were all over. But we are not the masters of our existence, and we have to learn to want to go on living, even when we are suffering... Illness has done *me* good—I would be ungrateful if I did not admit that it has made me calmer, not at all what I expected, and this year has been better than I had dared to hope... Illnesses are there to remind us that we are not made of wood and this strikes me as the good side of all this. Then one can go about one's daily work restocked with cheerful resignation and with less fear of disaster." It is this very resignation which gives *van Gogh's* late work its greatness and beauty.

Self-portrait
Oil on canvas
57×43.5 cm
Mrs John Hay Whitney
Collection

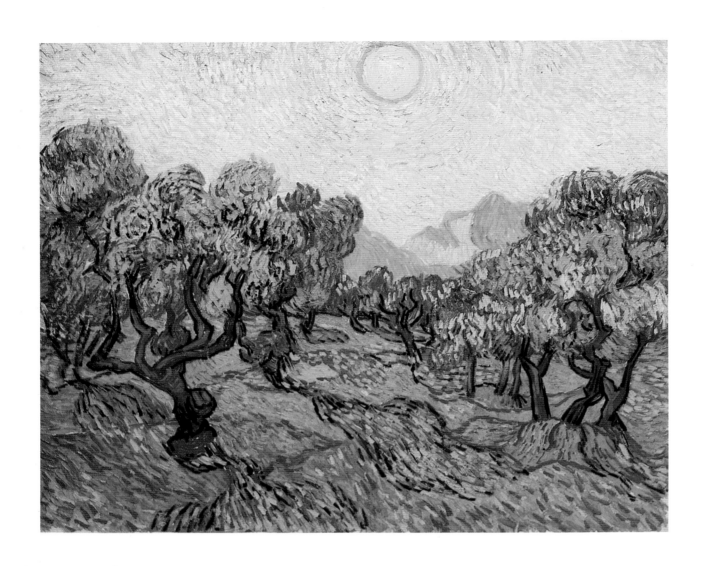

Olive trees with yellow sky and sun
Oil on canvas
73.7×92.7 cm
The Minneapolis Institute of Arts
The William Hood Dunwoody Fund

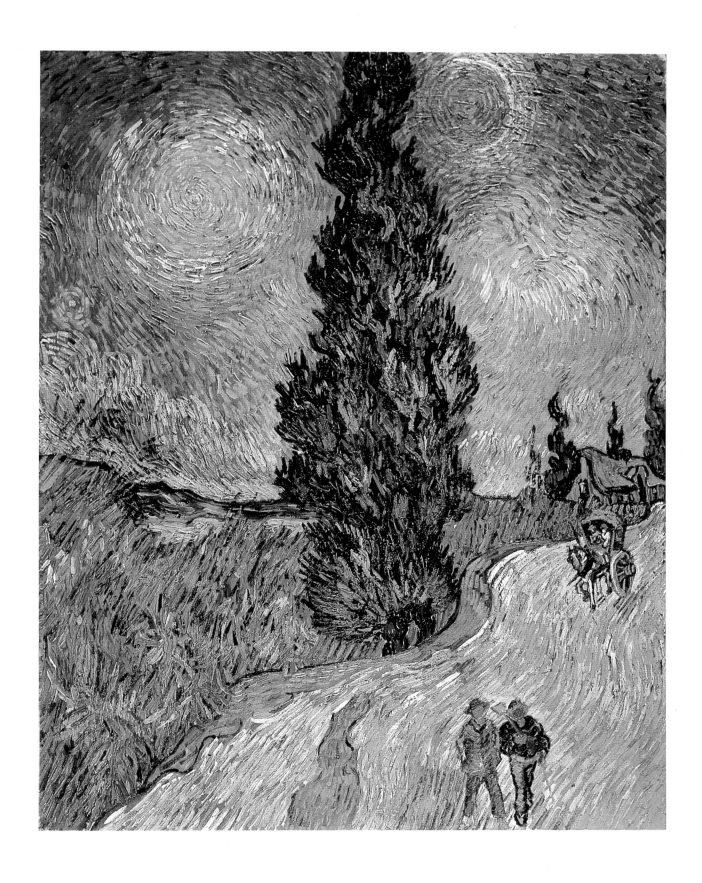

Road with cypresses and stars
Oil on canvas
92×73 cm
Kröller-Müller Rijksmuseum, Otterlo

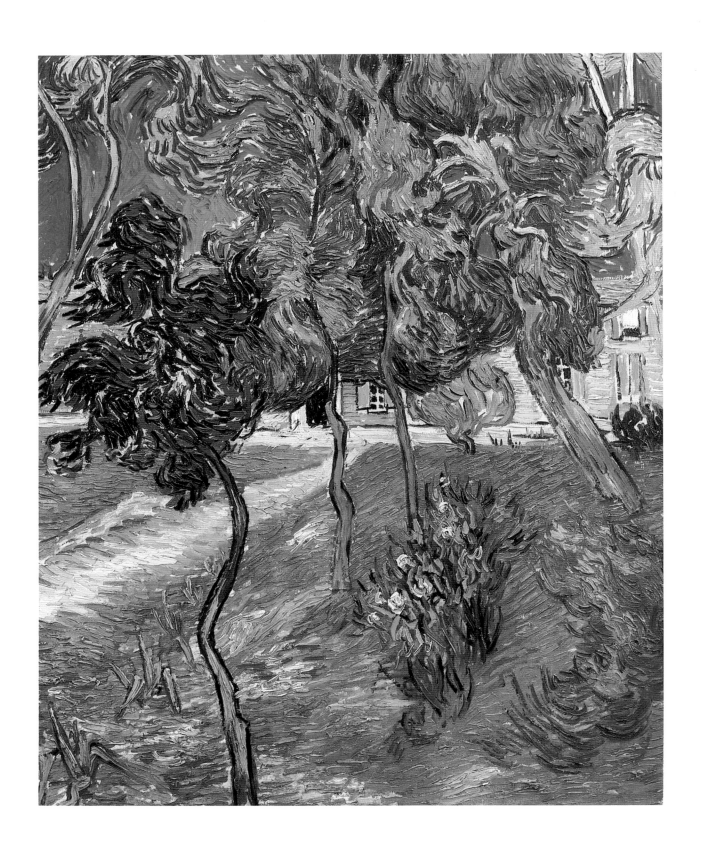

Trees in the garden of the asylum
at Saint-Rémy
Oil on canvas
73×60 cm
Private collection, USA

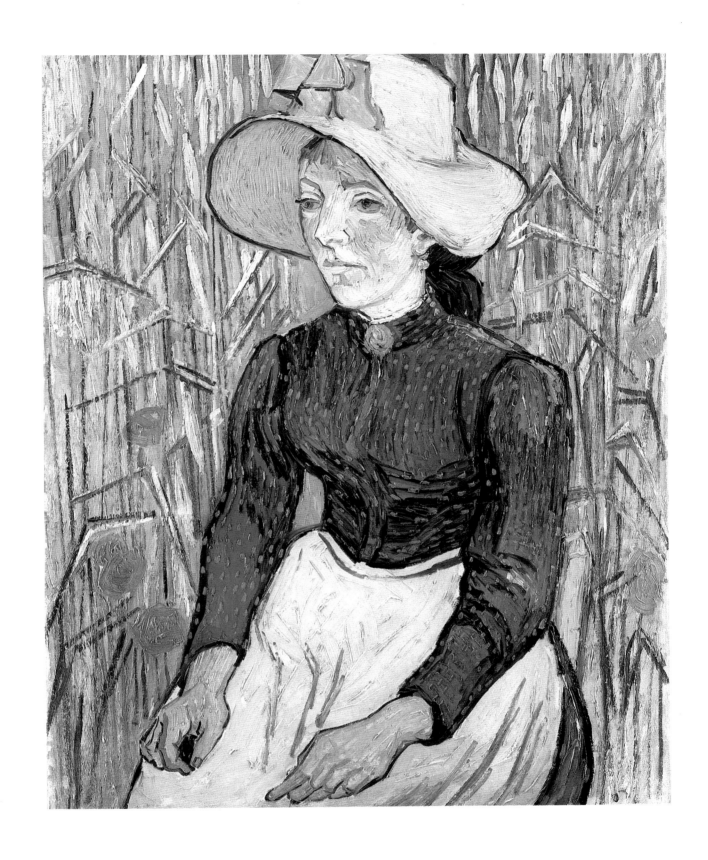

Peasant woman with straw hat in the corn
Oil on canvas
92×73 cm
Private collection

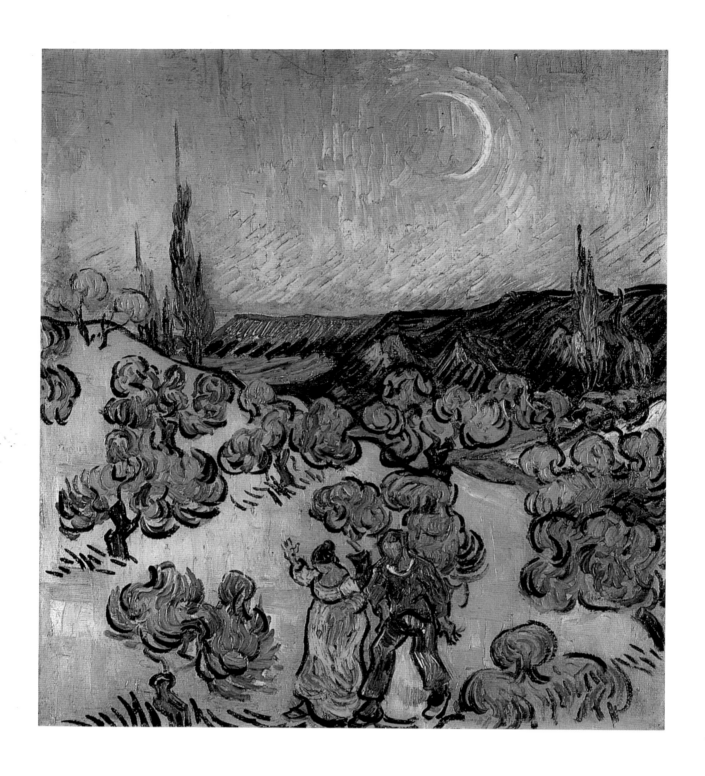

Landscape with couple and crescent moon
Oil on canvas
49.5×45.5 cm
Museu de Arte de São Paulo

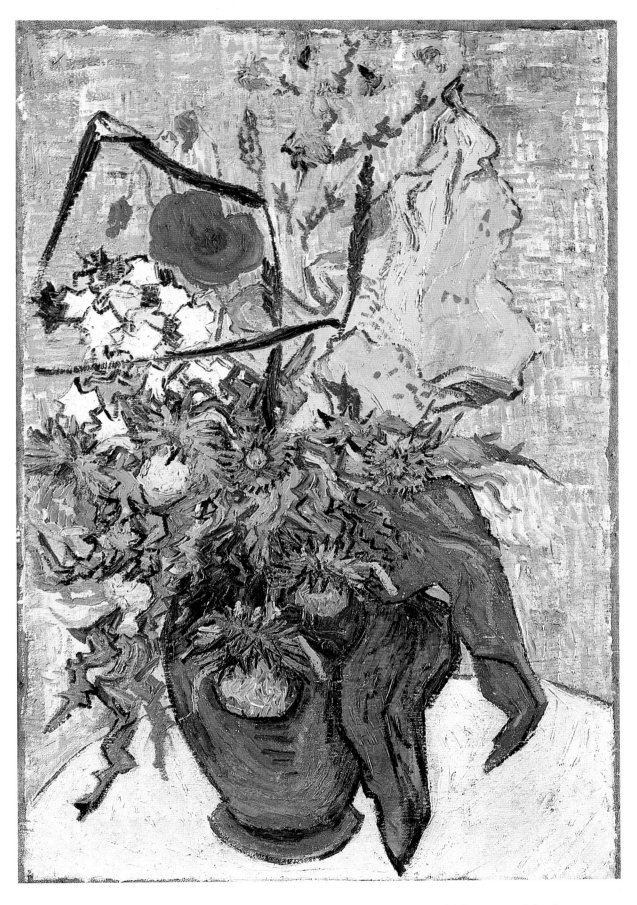

Wild flowers and thistles in a vase
Oil on canvas, 67×47 cm
Private collection

In the light of the North Scandinavian Painting at the Turn of the Century

London – Düsseldorf – Paris

Amongst the large-scale exhibitions of European painting to tour extensively in Europe and America last year, one region of our continent was neglected—Scandinavia. One has the lasting impression that the North has produced only one genius in the figure of *Edvard Munch*. The fact that, alongside this outstanding Norwegian painter, who still remains the greatest master of them all, there were other painters and artistic movements was brought home to an astonished public by an exhibition which this year toured London, Düsseldorf and Paris. Most of the pictures and artists represented were new to us, despite the fact that the period portrayed, the painting of the turn of the century, has been familiar for at least twenty years. The inclusion of *Akseli Gallen-Kallela, Carl Larsson* and *Anders Zorn* was only to be expected, not to mention *Ernst Josephson* and *August Strindberg* who was not only a dramatist and poet, but also left behind a considerable artistic œuvre.

But *Richard Bergh, Anna Ancher, Juho Rissanen* and *Ejnar Nielsen* are all artists well worth discovering. All were painting far from the international art centres of Europe. If they wanted to find out what was happening in the world, they had to go to Munich, Paris or Berlin. Most returned to Scandinavia after their trips abroad—just as *Munch* did after a visit to Berlin where he spent some time, observing in 1894: "It will be a long time before Berlin is an artistic centre." All those who left Scandinavia in order to learn to paint learned the tricks of their trade and were inspired by the current trends of their contemporaries in the southern half of Europe. On their return all were able to integrate this with the reality of their origins.

This produced a great era in the history of art, an era of realism and symbolism in which one thing in particular played a decisive part. Light—it gave the exhibition its title. Northern light is entirely different, completely unique. It has an intensity, clarity and transparency all its own. Since it is so short-lived and leaves the long shadows of the unending months of darkness, during its brief life-span it seems something almost supernatural. Artists have captured this light with its extraordinary intensity and its dark, disturbing shadows. It is the key to everything; life and death, the blossoming and fading of nature.

The paintings include a striking number of self-portraits, for the loneliness of life in the North naturally leads to psychological introspection, and strangely sorrowful landscapes. Even when dancing the peasants do not laugh. They seem, rather, to move in accordance with some archaic rule, as in *Anders Zorn's* famous painting "Midsummer-night's dance". "Only in the people of the North can one find a genuine feeling for art in its freshest form", he wrote. *Carl Larsson* is the only one to appear more cheerful, the artist whose "House in the Sun" has long been one of the most popular works in Swedish art. A strange melancholy and silence lay over the exhibition. In many paintings the figures appeared frozen and it is obviously no coincidence that the theme of death forms a leitmotif running through the exhibition. Elsewhere artists repeatedly take their themes from legends and poetry. Paradise lost, man's sinfulness and guilt, his corruption and loss of direction are themes with which we have become familiar through Symbolist poetry—but here in Scandinavian art they seem to have become a reality. Death becomes more substantial and the unreal real. In the light of the North things take on an unambiguous form.

Carl Larsson, Sweden
2 Watercolours for "The House in the Sun"
1894–1899, 32×43 cm
Nationalmuseum Stockholm

Eero Järnefelt, Finland
Seashore with Ship, 1905
Oil on canvas
94.5×75 cm
Ateneumin taidemuseo, Helsinki
Antell Collection

Eero Järnefelt, Finland
Summer night, 1886
Oil on canvas
100.5×135.5 cm
Nasjonalgalleriet, Oslo

Eugène Jansson, Sweden
Riddarfjärden in Stockholm
Oil on canvas
115×135 cm
Nationalmuseum Stockholm

Exhibition 75

Helene Schjerfbeck, Finland
The Schoolgirl II, 1908
Oil on canvas, 70.5×40.5 cm
Ateneumin taidemuseo, Helsinki

Helene Schjerfbeck, Finland
The Seamstress
1903–05
Oil on canvas
95.5×84.5 cm
Ateneumin taidemuseo, Helsinki

Anders Zorn, Sweden
Midsummer-night's dance, 1897
Oil on canvas, 140×98 cm
Nationalmuseum Stockholm

Halfdan Egedius, Norway
The Dreamer
1895
Oil on canvas
100×81.5 cm
Nasjonalgalleriet Oslo

Sol Lewitt
Prints 1970–1986

London

Amongst the leading artists setting the trend in Conceptual or Minimal art in the Seventies, the American *Sol Lewitt* was one of the first to practise the new art form in its most ascetic and simplest forms. It is all too easy to forget that he came up with his first structure as early as 1962 at the very time that the generation of Pop artists began to conquer the art world. Throughout the entire decade of the Sixties, Minimal artists like *Donald Judd, Robert Morris, Dan Flavin* and *Larry Bell* were producing their work without attracting the attention of art dealers or the public. Their hour was not to come until the Seventies, once the credo of the Pop generation "Art is life — life is art" had begun to lose its impact.

Sol Lewitt, whose prints this year formed the subject of an exhibition at the Tate Gallery, was publishing statements on his Conceptual art as early as 1967 and 1968 in which he explained the basis of his art. He was not to deviate from this basis in either the "Wall drawings" which made him famous, nor in his graphic work. In the restraint of his works, in the neutral, strict mathematical order of his images, there is a kind of timelessness. Since all emotion is lacking in his work, his art is reduced to a kind of sign language based always on the same vocabulary (an essential element of which is the series, the ever repeated form) but which also expresses his artistic mission. *Sol Lewitt,* like his contemporaries in the United States and Europe, *Robert Ryman,* for example, or *Brice Marden, Blinky Palermo, Robert Mangold* or the French artist *Daniel Buren,* is seeking through his work a form of expression unconnected with symbolism, with narrative and above all with realism. Despite Pop Art and Nouveau Réalisme, this trend has been with us since the Sixties and is still with us even though figurative art has recently recaptured the international art scene. There is a visible return by certain artists to the abstract-concrete concepts which, since the days of Malevitch, have imbued twentieth-century art. It is no coincidence that the concrete painters of Zurich are at the forefront of art today. So this exhibition

by one of the chief representatives of Minimal art today is something of a corroboratory exhibition, neither disturbing nor irritating. The Tate Gallery has long been interested in the work of *Sol Lewitt.* As early as 1971 it purchased two important editions of prints. The artist produced a number of Wall drawings specifically for this exhibition at the Tate Gallery. Since prints are central to the artist's work, the exhibition represents a fascinating insight into the work of *Sol Lewitt.*

His painting, prints and sculpture are notable for a system of order which *Sol Lewitt* sees as the guiding principle of his work. The extreme systematizing of the minimal basic elements with which he works has brought him close to Conceptual art, on which he has himself expressed his views. Yet he is not a genuine Conceptual artist like the members of the Art-Language school, for whom the "object" with which art manifests itself is eliminated. From an artist who seems to work on pure logic and whose vocabulary of forms seems to be based on pure reason, the following words come as something of a surprise: "Conceptual artists are more mystical than rational. They reach solutions which logic could not reach." In one of the 35 theses which *Sol Lewitt* put forward on Conceptual art, he said: "These propositions comment on art, but they do not constitute art."

Forms derived from the cube
(24 parts in all), 1982
Engraving with aquatint
53.3×53.3 cm
Edition of 25

Scribble in four directions
printed in four colours
(15 pieces in all), 1971
Engraving
38×38 cm
Edition of 8

Combinations
of 4 colours
1985
Screen print
97.8×91.4 cm
Edition of 35

The Japanese Avant-garde 1910–1970

Paris

At every turn one had the impression that one was coming across old friends, and yet these were works unknown to the European public. The occasion was an important exhibition of 20th-century Japanese art at the Georges Pompidou Centre. The exhibition was conceived as one of a series of large general exhibitions which has spanned the ten years that the Beaubourg Centre has been open. After New York, Moscow and Berlin, it was now the turn of Japan. But it was not the traditional image of Japan, the land of ancient Eastern culture, that was on show. In this exhibition the various artistic movements of the 20th century, and the spirit of European art from Cubism through to contemporary trends were acknowledged as an important part of Japanese art. We are already familiar with contemporary art from Japan. The work of the artist *On Kawara* or the action paintings of *Gutai* are well known in Europe and are seen as part of a modern trend. But we have been unaware of the direct influence of the Russian avant-garde, of Berlin Dadaism or European Surrealism on Japanese art.

A total break with tradition and with the respected ceremonial of the past took place in Japanese intellectual circles shortly after the middle of the 19th century. It was this initial breakthrough that eventually made it possible for artists to follow the European avant-garde of our century, but it also altered for the worst the position of the artist in society. The concept of the artist as an outsider, of the "artiste maudit", unknown in Japan up to this point, suddenly became part of a new vocabulary. The West has profited from the Far East for centuries and at the turn of the century it still provided a source of inspiration for European art. For European art to influence Japan was something new.

In this respect the exhibition at the Georges Pompidou Centre was one of the few exhibitions today that are able to surprise us. Space does not permit us to quote the names of artists, artistic centres or movements. It is enough to note the fascinating facts that in 1920 Russian Constructivism gained a firm foothold in Japan through the Russian artist *David Burlyuk*, a friend of *Kandinsky;* that *Mondrian* and the *De Stijl* movement were known there; that Art deco exerted an unmistakable influence on the applied arts. Even architecture made inroads into the religiously guarded traditions of Japanese house building. Not to mention realism which, after the Second World War, completely changed Japanese pictorial reality.

The exhibition was a striking illustration of the extent to which individual cultures have been swallowed by an all-embracing international style. The world is contracting. The national cultures which have evolved over thousands of years are beginning to disintegrate. Since the beginning of the industrial age Japan has been undergoing a permanent cultural revolution and art has provided a finely calibrated guage of this process.

The interaction between Japan and Europe has differed in our century from that of earlier epochs. The influence of Japan on Impressionism and Art Nouveau did not give rise to a tradition of Japanese art in Europe, but an art inspired by Japanese models. In the "Japanes Avant-garde" exhibition one cannot help wondering what Japanese content there is in many of the works. They are all to similar to Russian Constructivism, Cubism or the politically orientated Realism of the postwar years. What we are seeing here is the opening of the way for a universal art style from which all national characteristics have been banished.

Kudo Tetsumi
Chain reaction proliferating
in an elementary X-shaped body, 1960

Shinohara Ushio
Scarface, 1964

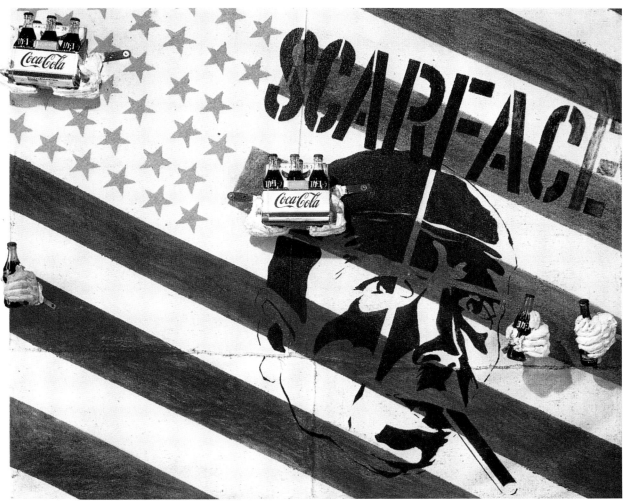

Kanbara Tai
On Scriabin's "Poem
of Ecstasy", 1925

Yoshihara Jiró
Mast, 1931

Murayama Tomoyoshi
Construction, 1925

Kusama Yayoi
Chair, 1965

Shiraga Kazuo
Sanbaso ultramodern, 1957
Reconstruction 1985–6

Fujita Tsuguharu
Victory of life
over death, 1930

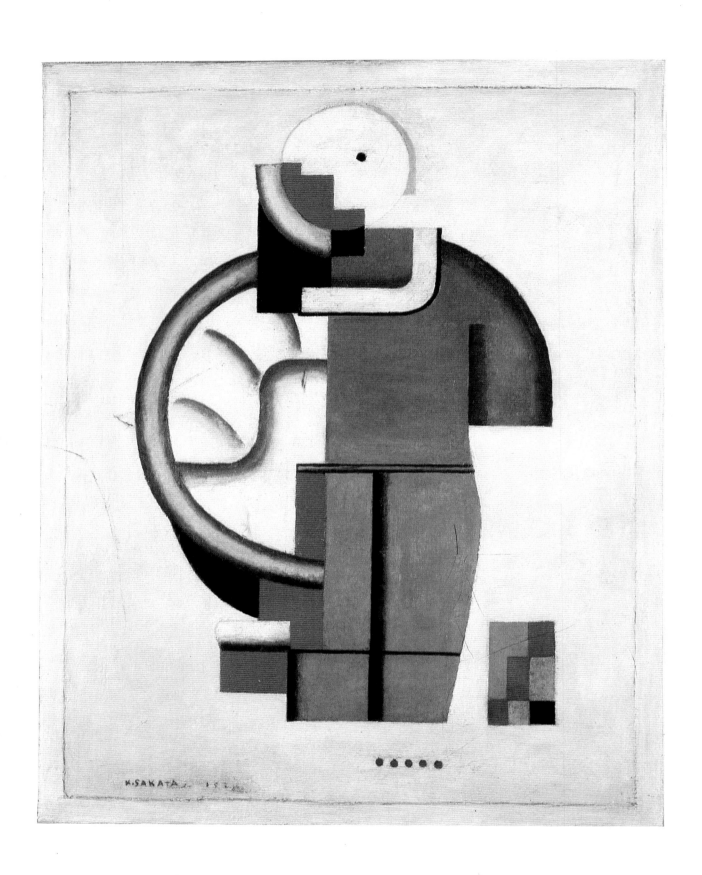

Sakata Kazuo
Woman and pot of flowers, 1926

Sugai Kumi
Red and Black, 1964

Koga Harue
The Sea, 1929

1960 – The New Realists

Paris – Mannheim – Winterthur

25 years on, three museums staged a tribute to "Nouveau Réalisme", or "New Realism", which was launched in Paris in 1960 and which has come to be seen as the European equivalent of Pop Art. 1960 was also the year of the movement's manifesto, published in Milan by *Pierre Restany* on 16 April. Now one of France's leading art critics, *Restany* was the leader of a group of artists which included such figures as *Arman, Yves Klein, Jean Tinguely, Daniel Spoerri, Niki de Saint-Phalle* and *Christo*, all of whom contributed to an art form embodying the avant-garde of their time. Their credo was: An object is what it is, representation and represented form one single unity. So *Yves Klein* rolled naked women over a blue painted canvas—or alternatively, naked girls were covered in blue paint and dragged across a white canvas; *Raymond Hains* stuck torn posters on to canvas; *Arman* shut objects up in perspex boxes; *César* compressed cars; *Niki de Saint-Phalle* fired guns at painted canvases; *Daniel Spoerri*, in his "Table-aux-Pièges" hung tables covered with the remains of a meal on the wall.

Everyone remembers the Actions, Demonstrations, Happenings staged by the Nouveau Réalisme artists, with *Tinguely's* "Homage to New York" of 1960 as the high-point when, in the garden of the Museum of Modern Art his machine-sculpture self-destructed. It was a period of intense activity. Art was going through a fundamental change and this was brought home to the public in a series of turbulent artistic events. Art was life, and life was calling out for change. The movement lasted for only three years and then the artists went their separate ways. Yet they achieved much in that time, helping to cast doubt on traditional views of and about art.

What have they left behind today? An art that was alive but is now aged. Has it aged badly? Some of the artists who were then acclaimed as the new avant-garde, such as *Jean Tinguely* and *Christo*, have gone on to create important and original work. Some, like the "Affichistes" *Mimmo Rotella* or *Raymond Hains*, have moved into a

peaceful old age. In others the creative process seems to have worn itself out, producing nothing worthy of note in the following years. The exhibits had already become history. It is with some nostalgia that we look back on the time when these works were created. They bear witness to a time of fundamental change and of hope, hope that art could be renewed, made to live, to be celebrated as a purely aesthetic event. For the most part it has not been able to establish itself as a classic. *Restany*, writing at the time in his manifesto, "Forty Degrees above Dada", said: "The New Realists regard the world as a picture, as the greatest fundamental masterpiece, from which they can take fragments of universal importance." Instead of presenting an image of reality and instead of discovering it in paint, they tried to present reality itself as a work of art. This "fundamentalism of the Realists" as *Werner Hofmann* described their approach to reality, was never pushed to its limits by the European Nouveaux Réalistes, as American artists attempted to do during the Sixties. Reality still had artistic value. Or, to put it another way, "Art was art with the characteristics of reality". Banality still had a tendency towards the mythical and never escaped a certain aestheticisation. Even *Daniel Spoerri's* tables with their eaten meals never deny that they had changed reality into art.

César (César Baldaccini)
The thumb
Bronze
1964–6
185×103×76 cm
Fonds National d'Art
Contemporain, Paris

Daniel Spoerri
Kichka's breakfast I, 1960
Objects mounted on block of wood
Chair
36.5×69.5×64.5 cm
The Museum of Modern Art, New York
Philip Johnson Fund, 1961

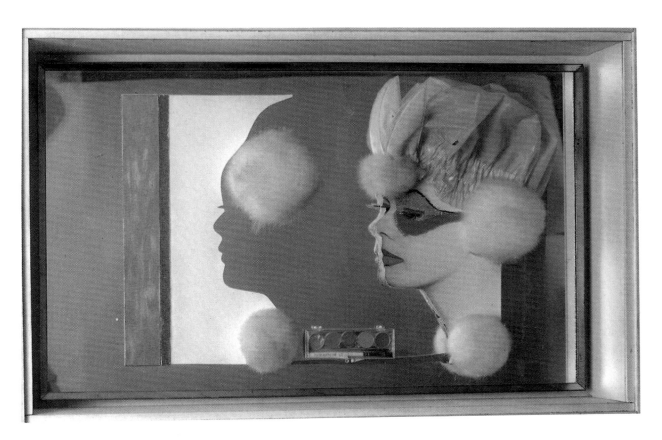

Martial Raysse
Miroir aux houppettes, 1962
Make-up, mirror, photographs,
plastic, paper
40×60 cm
Robert Calle Collection, Paris

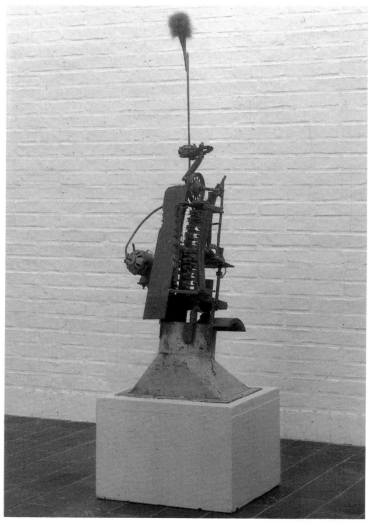

Jean Tinguely
How green was my valley, 1960
Iron, motor, feather
135×52×42 cm
Louisiana Museum, Humlebaek

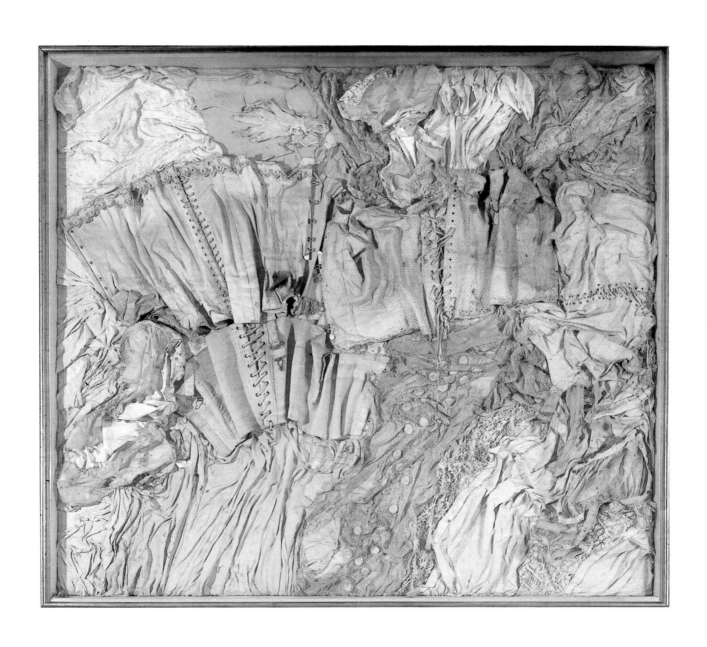

Gérard Deschamps
Pink corsets, 1962
Ladies' underwear
130×145×10 cm
Private collection, Paris

Exhibition 95

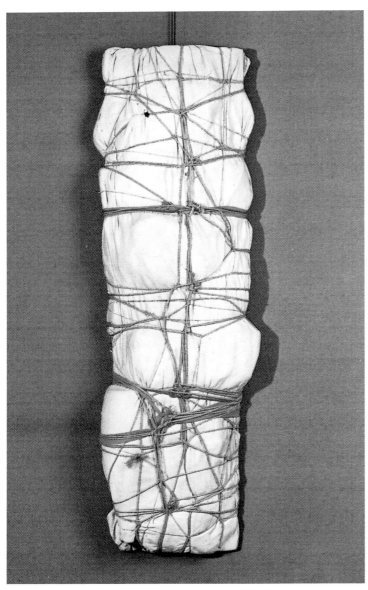

Christo
Package, 1962
Fabric, string, rubber
100×30 cm
Henri Rustin Collection, Paris

Christo
Wrapped dressmaker's dummy
on a roof-rack, 1962
Metal, polythene, fabric, wood,
string, elastic bands
47×150×99 cm
Boymans van Beuningen
Museum, Rotterdam

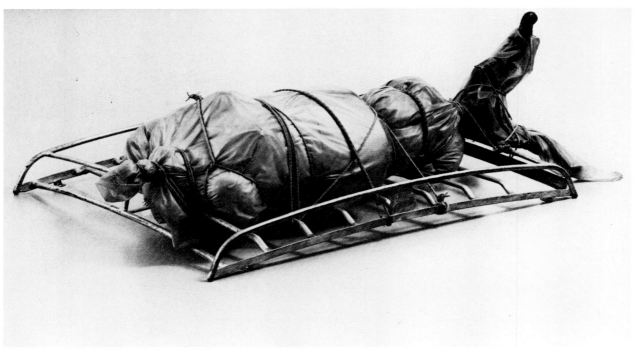

César (César Baldaccini)
Car compression, 1960
Compressed sheet metal
157×82×64 cm
Sonia Zannettacci Gallery, Geneva

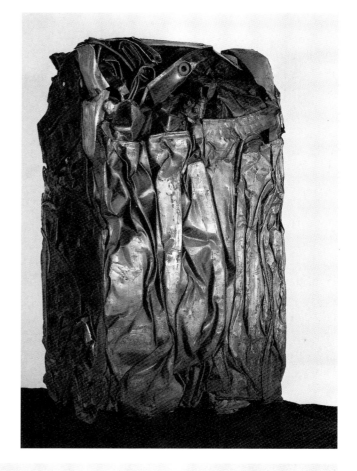

Niki de Saint-Phalle
Heart mirror, 1963
Assemblage of objects, painted
and mounted on wood
70×100 cm
Samy Kinge Gallery, Paris

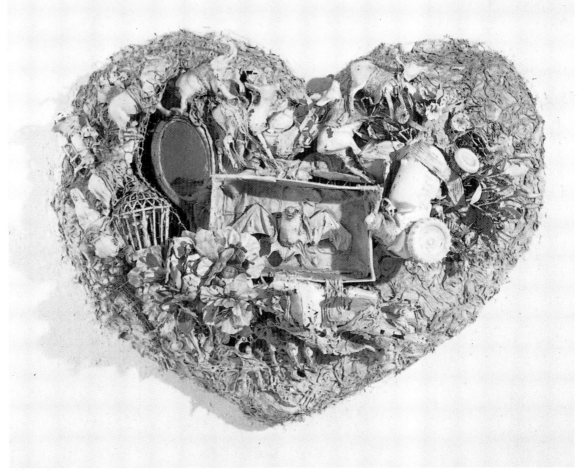

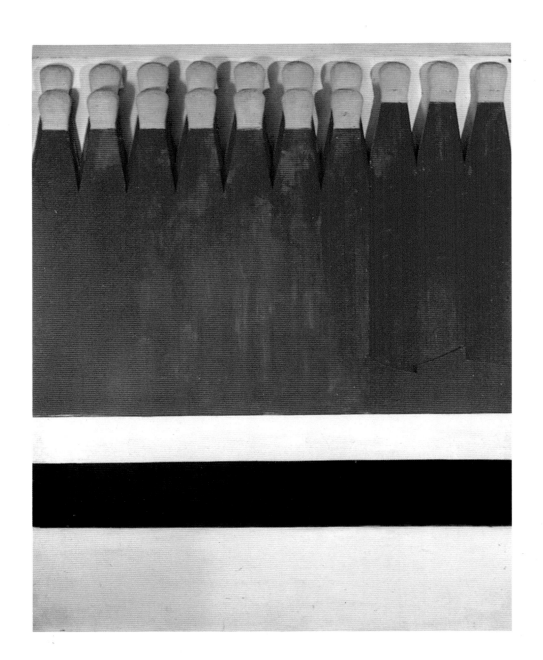

Raymond Hains
Book of matches, 1964
Painted wood
175×140 cm
Private collection, Paris

César (César Baldaccini)
Relief in sheet-metal, 1961
Assemblage of parts of car's bodywork
100×100×25 cm
Beaubourg Gallery, Marianne and
Pierre Nahon, Paris

Exhibition 99

Paul Klee

New York – Cleveland – Berne

The Museum of Modern Art in New York staged *Paul Klee's* first large-scale retrospective to be held in the United States, in order "to clarify *Klee's* place in modern art". This artist, who taught at the Bauhaus and who moved to his mother's home-town of Berne once Hitler came to power, although recognized as a man of great genius, is often seen at the same time as a loner, an outsider. In his highly inventive world of images, and the freedom with which he switched between abstract and figurative compositions, lies the key to various developments in modern art. Without him twentieth-century art would be robbed of one of its greatest treasures, one of the best of all the artist-poets.

If this exhibition was a revelation, it was for the sole reason that it presented a selection of his immense output with pictures of the very highest quality. There have been numerous *Klee* exhibitions in Europe. The co-operation between the Museum of Modern Art and the Klee Bequest in Berne, which supplied most of the exhibits, made this exhibition an outstanding event of the year. A catalogue accompanied the exhibition and many of its articles threw light on aspects of *Klee's* work which had scarcely been touched on previously, like the article by *Jürgen Glaessemer* which portrayed *Klee* as the heir of German Romanticism.

But no amount of interpretations and new scholarly discoveries and analyses, can ever reveal all the secrets of this artist who seeks in his work a unity between world and ego—an essentially Romantic idea. What developed from this was a new world in which people, animals and plants lived as symbols. For him the world of objects was "not the only possibility, there are a multiplicity of other hidden truths". He concerned himself with totality, paying no heed to such terms as "abstract" and "representational" in his pursuit of a new pictorial universe. This universe had to be created anew and he had to work with original, newly invented concepts. Through his powerful imagination he created a new stock of forms totally unconnected with traditional artistic images.

"Just as a child imitates us in play, we play at imitating the forces which invented and created the world."

None of *Klee's* best-known works, of which three hundred were brought together in this exhibition fails to show some aspect of his universe. By concentrating on only the best of the oils, watercolours and drawings, the New York exhibition, which was later seen in Cleveland and Berne, was one of the best to date. It took the visitor from one masterpiece to another, impressing upon him the irresistible magic which is a unique feature of *Klee's* work. What *Klee* was striving for was art in the absolute, but in doing so he made the greatest possible demands both upon himself and upon anyone who seeks to penetrate his cloak of secrecy. In his diary we read where, for him, "secrecy begins and where intellect painfully expires". In his own words: "There is nothing of the Faust about me. I take on the role of a remote original creator inventing formulae for man, animal, plant, stone and earth, fire, water, air and all the forces in the world. A thousand questions are stilled as if they have been solved. There is no lesson to be learned. The possibilities are too endless, only the belief in them lives in my creativity."

With his sign language *Klee* has not only opened up his own world, but also the hidden secrets of creation and the universe. His art is a kind of picture-writing which reduces objects to symbols. They will remain forever secret and the riddle unsolved.

They are Biting
1920
Watercolour and oil
on paper
31.1×23.5 cm
The Trustees of the
Tate Gallery, London

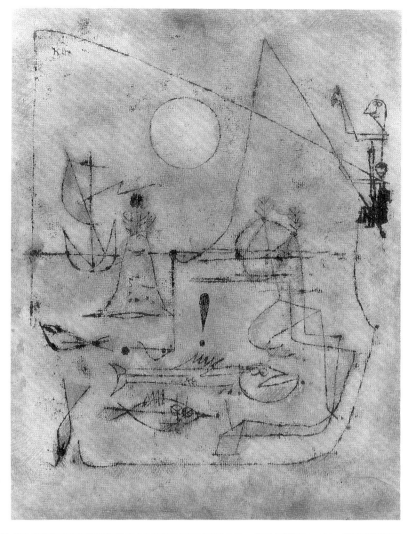

Metaphysical Transplantation
1920
Watercolour over oil sketch
on paper
27.3×43.8 cm
Helen Keeler Burke
Collection, Illinois

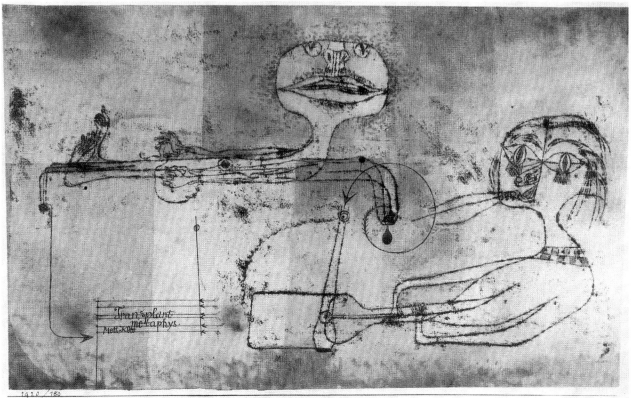

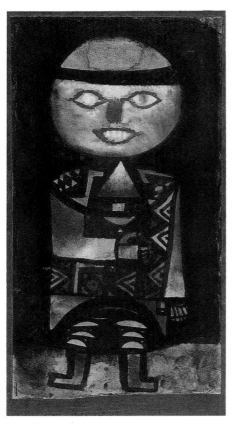

Actor
1923
Oil on wrapping paper
46.5×25 cm
Private collection, Switzerland

Quarry Ostermundigen
1915
Watercolour over pencil on paper
20.2×24.6 cm
Kunstmuseum Berne, Paul Klee Bequest

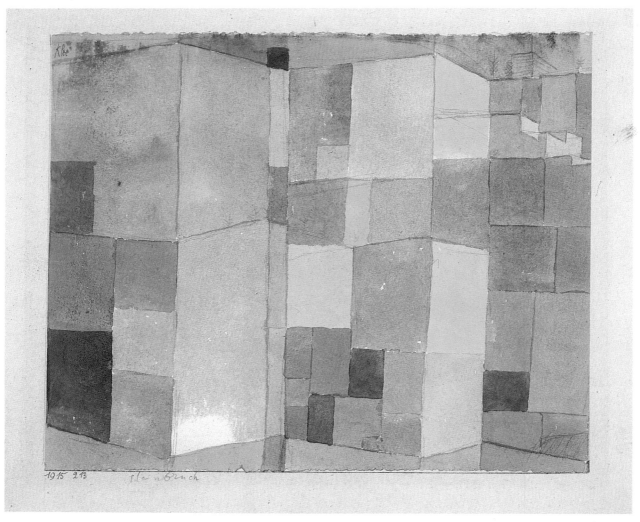

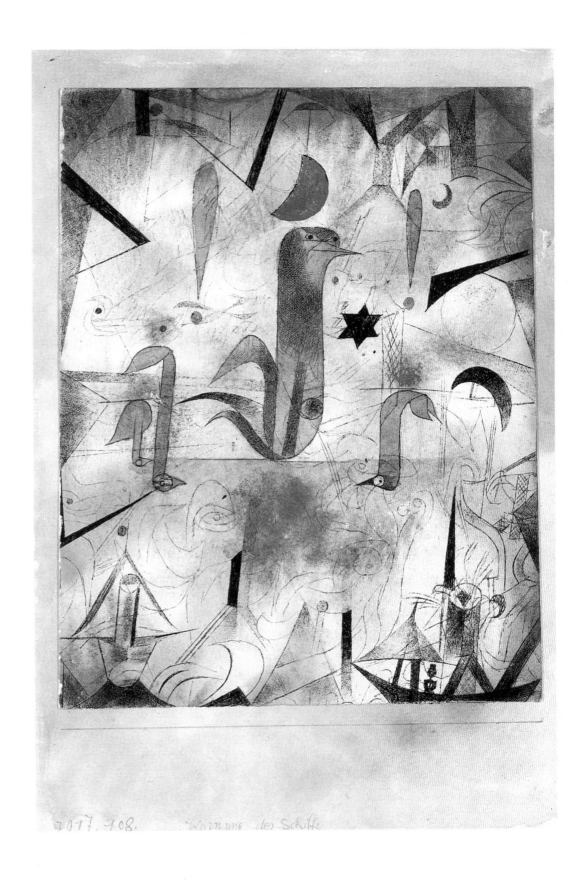

Ships' Warning
1917
Pen and watercolour on paper
24.2×16.4 cm
Staatsgalerie Stuttgart
Graphics Collection

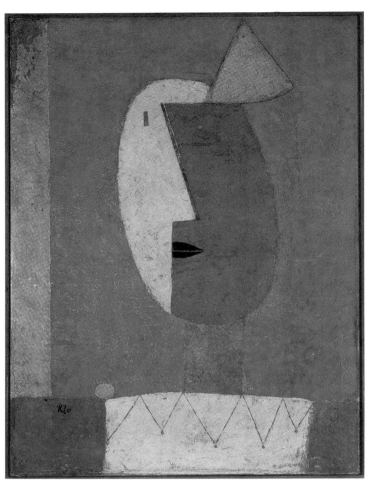

Clown
1929
Oil on canvas
67×50 cm
Private Collection, St. Louis

Still-life
1927
Oil on plaster of Paris
45.1×64.1 cm
The Metropolitan Museum of Art
New York, The Berggruen
Klee Collection, 1984

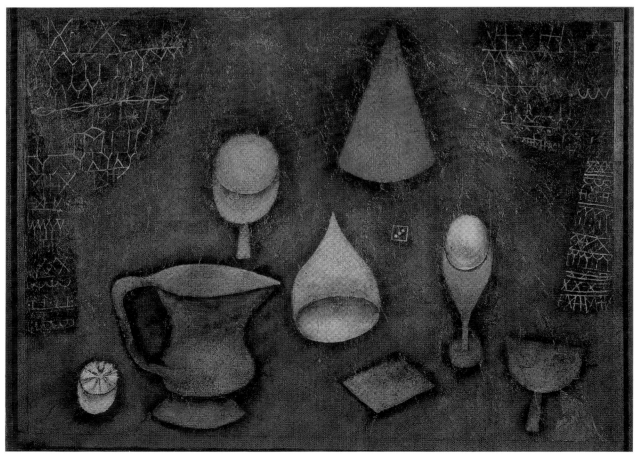

Young Man
Resting (Self-portrait)
1911
Brush and ink on paper
13.8×26.2 cm
Private collection
Switzerland

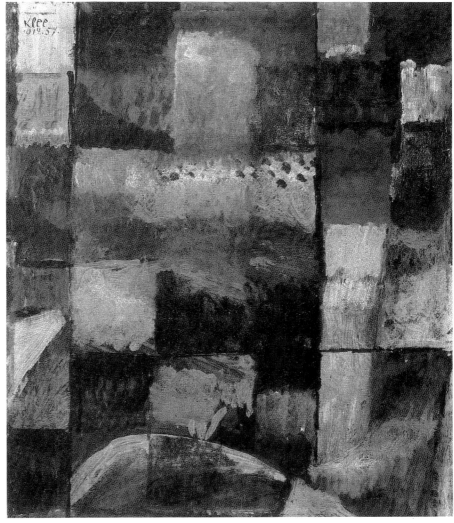

On a Motif
Hammamet House
1914
Oil on board
27×22 cm
Kunstmuseum, Basle

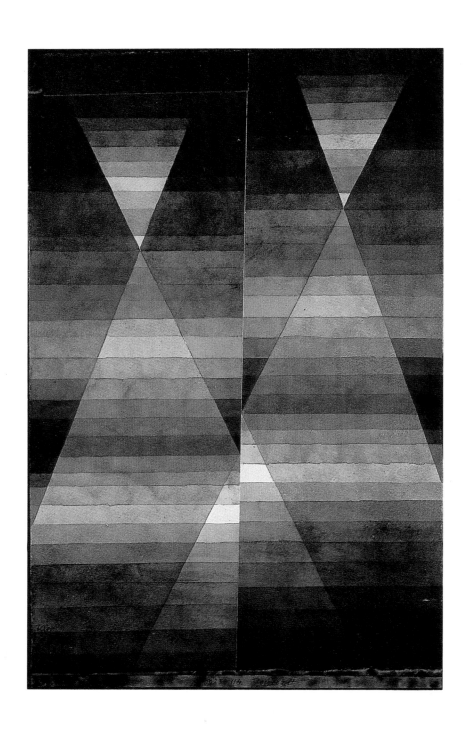

Double Tent
1923
Watercolour on paper
50.6×31.8 cm
Rosengart Collection, Lucerne

Architecture
1923
Oil on board
57×37.5 cm
Staatliche Museen Preussischer
Kulturbesitz,
Nationalgalerie, Berlin

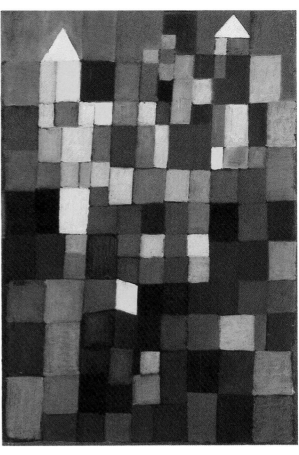

Destroyed Labyrinth
1939
Oil and water-based paint
over oil base on paper
54×70 cm
Kunstmuseum, Berne, Paul Klee Bequest

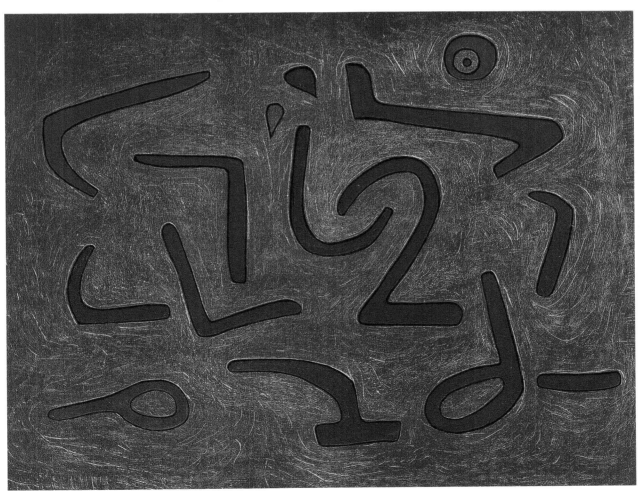

Two Men Meeting, Each Supposing the Other to
be of Higher Rank
1903
Etching
11.7×22.6 cm
The Museum of Modern Art,
New York,
Gift of Mme Paul Klee

Winged Hero,
2nd state
1905
Etching
25.4×15.9 cm
The Museum of Modern Art,
New York,
Purchase Fund

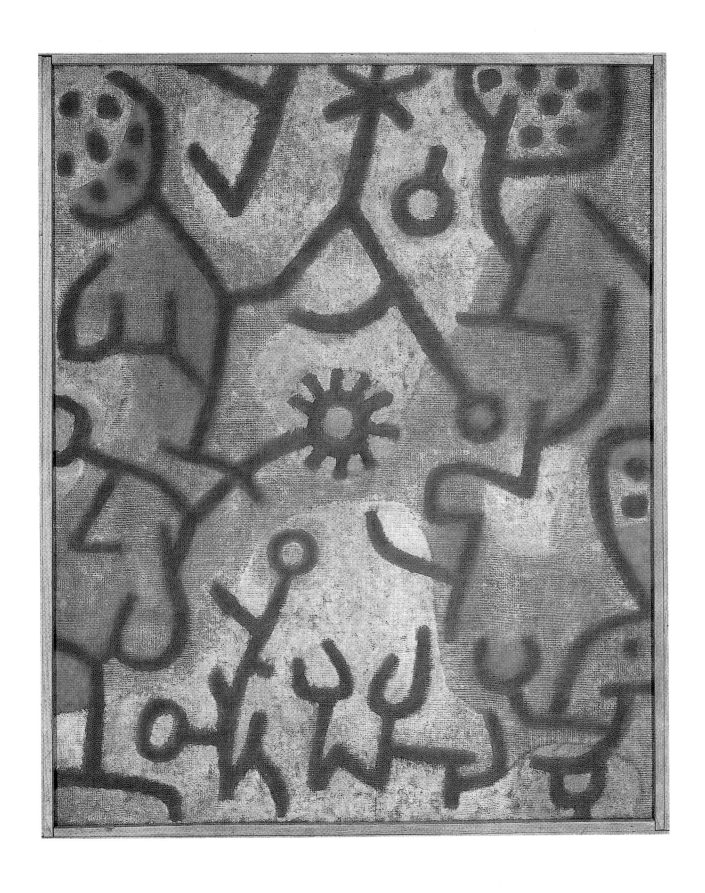

Rock Flora
1940
Oil and tempera on sacking
90 × 70 cm
Kunstmuseum, Berne, Paul Klee Bequest

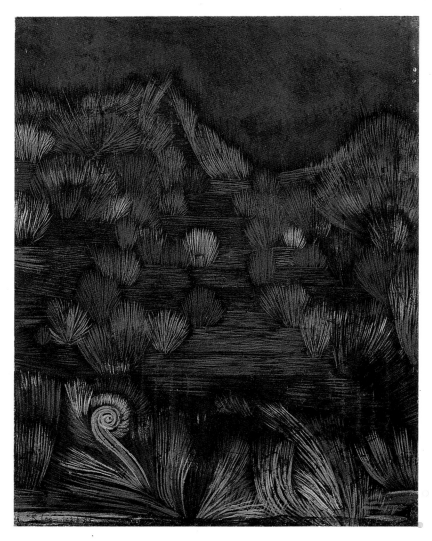

Dune Picture
1926
Oil and tempera
on paper
32×25 cm
Private collection

Cat and Bird
1928
Oil and ink over
chalk on canvas
38.1×53.2 cm
The Museum of Modern Art,
New York
Gift of Sidney Janis
and gift of
Suzy Prudden
Sussman and Joan
H. Meijer in memory
of F. H. Hirschland

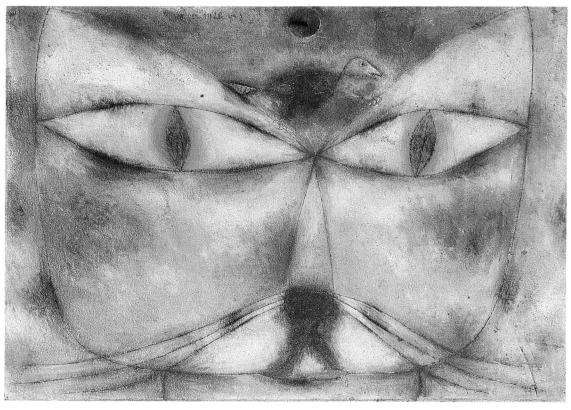

Florentine Townscape
1926
Oil on board
49.5×36.5 cm
Centre Georges Pompidou, Paris
Musée National d'Art Moderne

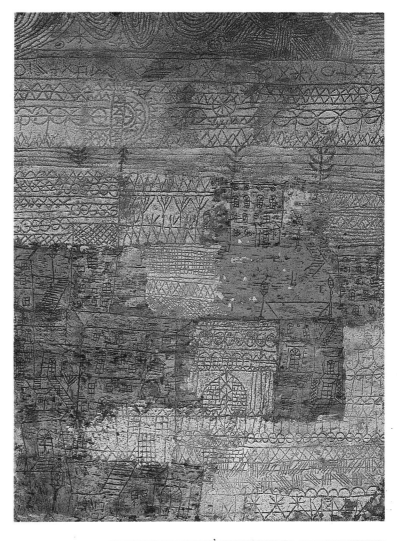

Romantic Park
1930
Oil on board
33×49.8 cm
Rosengart Collection, Lucerne

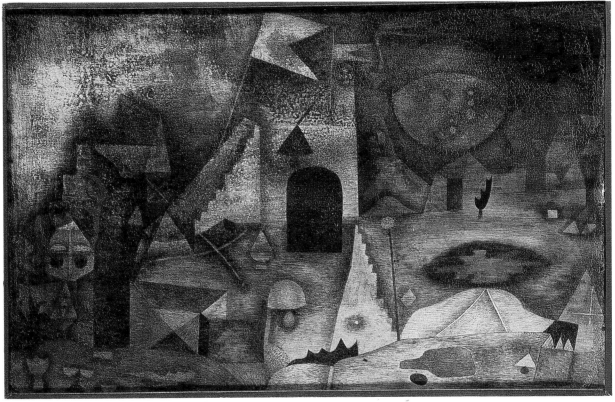

Cy Twombly

Zurich – Madrid – Paris – Düsseldorf – London

Oils, works on paper and sculptures, all were represented in the retrospective devoted to the work of *Cy Twombly,* an artist who has lived for many years in Rome. Born in 1927 in Lexington, Virginia, *Cy Twombly* is a contemporary of *Robert Rauschenberg* and *Jasper Johns*. In the words of *Harald Szeemann,* the organizer of the exhibition and author of the catalogue, these artists are the heirs of the first truly American art form, Abstract Expressionism, and of its fundamental contribution on the development of art. With this they inherit its freedom from pictorial images and composition, its recognition of the importance of the artist's own physically motivated gesture as object and subject, its complete opening up of the field of vision and its acceptance of the colour materials as the basic substance of painting which almost demand the large format.

Cy Twombly has gone even further along this road. Although *Rauschenberg* and *Jasper Johns* both had their fling with gestural painting, they have since moved towards figurative realism. *Cy Twombly* has never become the slave of the object — not even in his sculptural work. He has taken the gestural painting of Abstract Expressionism to an entirely new level. What he produces is no longer a gesture inspired by personal emotion, but a gesture that has been neutralized, made objective and distanced from the person. It is not *Cy Twombly* who determines the picture, but the line itself. It moves in a direction which will make the picture complete — if one can speak of completion, that is. Every picture by *Cy Twombly* is a "non finito", for ultimately the line cannot end but only trail off towards infinity. *Twombly* himself has said that the line is the immediate experience of its own internal history. It does not explain, but is the sign of its own personification.

Lines, scribbles, lettering form the substance of his pictures, usually on white or partially white backgrounds. Sometimes spread sparingly over the picture area, sometimes covering the whole area, these systems of lines have their own meaning, although to the observer the meaning can be unclear. He has to allow himself to come under their spell if he wants to enter their world. So these pictures represent something unintelligible, something inexplicable; secrets remain secret. To understand this painting you have to love poetry and to be able to allow yourself to be led and carried away by the poet. This poetic feeling which imbues the paintings is also found in *Twombly's* sculpture. They are made from recognizable everyday objects. But all the objects have been dematerialized by painting them white. "Transmitters of light, transmitters of silence, transmitters of poetry" is how *Harald Szeemann* describes them. Painting them has changed the objects, removed their banality. They have become ennobled. The commentary in the exhibition catalogue makes a great play on poetry and metamorphosis, often quoting the classical gods. *Cy Twombly* cannot be explained analytically within the history of art. Another dimension of words and interpretation is called for. It is certainly not easy for the observer to understand *Cy Twombly's* work. All he can read from the canvas are numerals or words drawing upon a repertoire of mythical or literary names which set off a train of associations in both the painter and his audience. In the final analysis, however, it is the paint and colour materials that give the picture its aura. *Twombly* works with layers of colour, with oil and gouache, and collage. Overpainting follows overpainting to produce a non-space without illusion, with no reference to reality. All this colour is merely a background into which sink his ideas, themes, associations with the past, coming together to form a unified statement — a statement about painting. Everything else is hallucination — nothing more than a *Fata Morgana.*

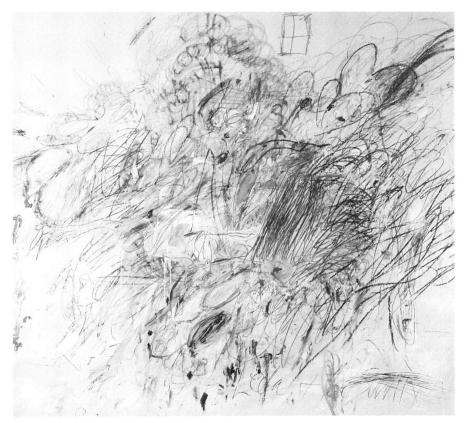

Leda and the Swan
1961
Oil, chalk and pencil
on canvas
190.5×200 cm
Property of the artist

Untitled
1961
Oil, chalk and pencil
on canvas
164.5×200 cm
Marx Collection, Berlin

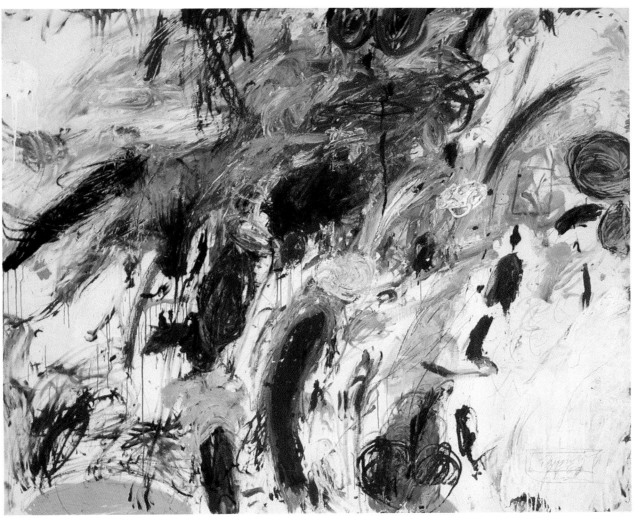

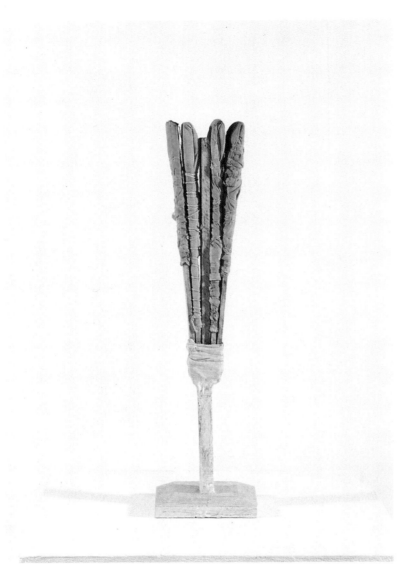

Untitled
1955
Wood, fabric, string
and oil-based matt paint
56.5×14.3×13 cm
Property of the artist

Triumph of Galatea
1961
Oil, chalk and pencil
on canvas
294.3×483.5 cm
Property of the artist

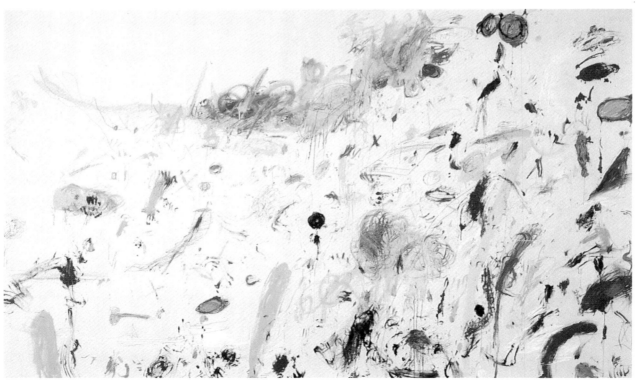

Cycnus
1978
Painted bronze
41×23.5×6 cm
Karsten Greve Collection, Cologne

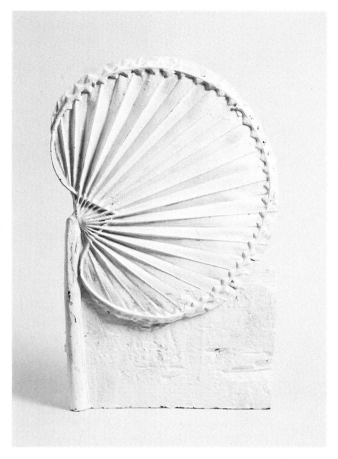

Untitled
1954
Oil, chalk and pencil
on canvas
174.5×218.5 cm
Property of the artist

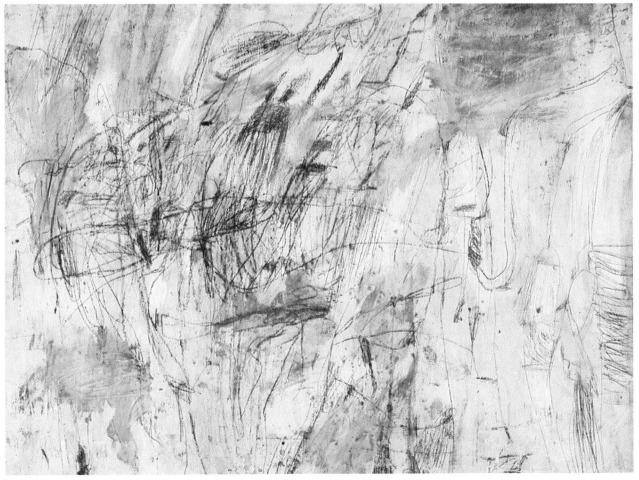

Anselm Kiefer
Paintings 1980–1986

Amsterdam

The exhibition of paintings by *Anselm Kiefer* put on at the Stedelijk Museum, Amsterdam, was not a touring exhibition. The paintings were lent from various collections, both public and private. Accompanied by an informative catalogue by *Wim Beeren,* the exhibition contained 64 paintings from the past six years, many on enormous canvases of 380×560 cm. While many of the pictures had previously been exhibited elsewhere, it was fascinating to have them all brought together under one roof.

Every exhibition by the 40-year-old German painter automatically raises the question: who is this painter? What is he trying to do? *Anselm Kiefer* is unmistakeably a German painter in the same way as *Markus Lüpertz* or *Georg Baselitz* are. In other words, his painting is firmly established within German tradition and culture. *Kiefer* was one of the first to achieve recognition abroad and to be acclaimed as one of the new representatives of the young German generation — long before the "wild young things" took the international art scene by storm, bursting upon it with a speed, the like of which is difficult to find.

Anselm Kiefer likes to paint German history and German mythology. He digs up themes that have long disappeared into obscurity or which were taboo. Who else, after the war, dared to talk about Brunhilde or Hermann's battle against the Etruscans? He paints history as a tragic series of errors, as a reflection of injustice, but also as a recognition of the inexorable passing of time. *Wagner* and the heroes of German history become clichés in a common terrestrial universe, whose fate becomes non-fate since there is no escape. There is an unmistakeable fatality about these pictures which make no attempt to spare the tragic moment. Enormous withered landscapes, snow-covered graves, deserted monuments spread before us, with no human figure to bring them to life. The heads which border the "Road to wordly wisdom: Hermann's Battle" are purely symbolic. They are symbols of history and historic events. *Kiefer's* world is without life and without nature.

The "Grave of the Unknown Painter" lies in the unreality of a world in which all life has been extinguished.

Where there is no life, there is no colour. Tones of ochre, black and grey are the colours *Kiefer* uses most often to express the sadness of a lost world which is as far removed from the present as it is from the history it represents. For it is not real history. In the final analysis, the mythical images of the distant past represent the present. A present that has already been swallowed up by the past until it too is no more than a distant memory. One great *Memento Mori* of a world from which man has long disappeared.

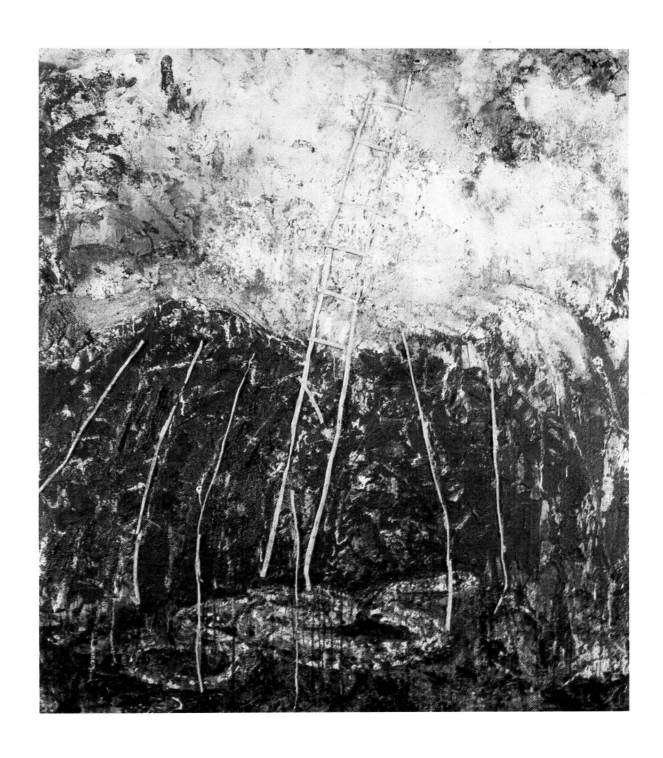

Bilderstreit
1980
Book
59×43×9 cm
Private collection

Untitled
1984
Oil-emulsion and shellac
on canvas, ladder assemblage
280×245 cm
Anthony d'Offay Gallery, London

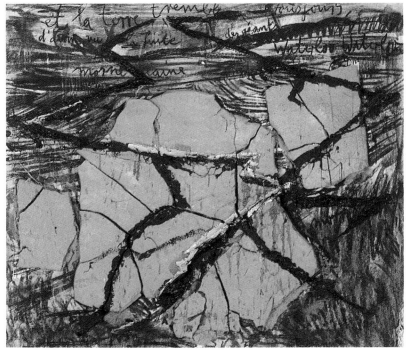

Waterloo
1982
Charcoal, acrylic, oil on canvas
with clay assemblage
120×135 cm
Private collection

Interior
1981
Oil-emulsion and shellac
woodcut on paper,
mounted on canvas
285×310 cm
Stedelijk Museum, Amsterdam

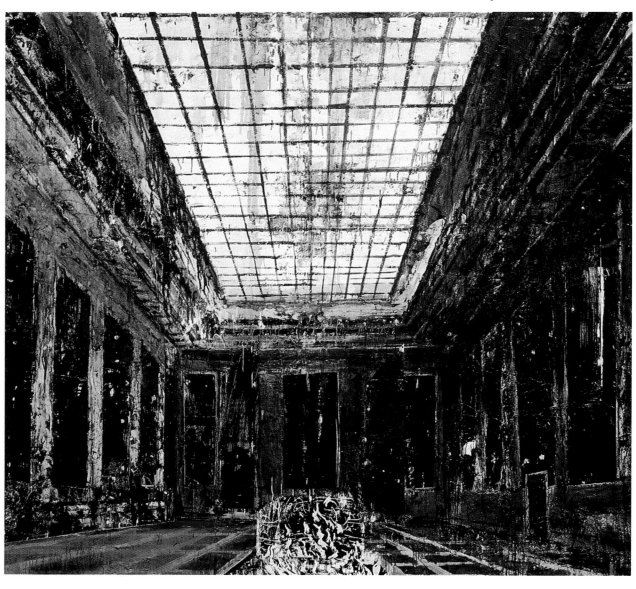

The bronze snake, 1982–5
Oil-emulsion, acrylic, resin, woodcut on paper
mounted on canvas, two parts
420×280 cm, Private collection

The inexhaustible vision Art of our time through the eyes of Berlin

Berlin

The Martin Gropius Building is one of Berlin's most interesting exhibition halls. This imposing building, built during Gropius' lifetime and now situated close to the Wall, has continued to develop its reputation as an exhibition centre since the opening "Zeitgeist" exhibition in 1982. This year *Christos M. Joachimides,* who together with *Norman Rosenthal* was responsible for the opening exhibition, has provided a look at contemporary art as represented in Berlin's private collections. The collectors remain discreetly anonymous. Their collections, however, contain names to conjure with. These private collections reveal much about the city of Berlin. They are by no means restricted to Berlin artists but reveal the international environment which confronts artists in Berlin.

In the last twenty years Berlin has made a great leap forward. Culturally, the city has, in every respect, become an important focus of activity. The collectors, for their part, have ensured that contemporary art does not lack for patrons. They have collected young artists "with inexhaustible vision" and committed themselves to artistic trends yet to become established and accepted. They have naturally tended to concentrate on art produced in Berlin. Collections of works by native Berliners, now internationally recognized, and others who have chosen to live part of their lives in Berlin, abound here, as in no other city. *Markus Lüpertz, K.H. Hödicke, A.R. Penck, Georg Baselitz,* and the younger generation in *Rainer Fetting* and *Pierre Chevalier,* are all admirably represented in these collections.

But the collectors of Berlin are just as interested in what was going on outside the city. Nowhere else are there comparable collections of young Italians like *Enzo Cucchi, Sando Chia* or *Francesco Clemente.* Also well represented are the now "classic" American modern artists like *Rothko, Clyfford Still, Ad Reinhardt, Morris Louis* or *Frank Stella. Rauschenburg, Oldenburg, Warhol*–there is scarcely a well-known name missing from this exhibition. It was for the courtyard, so well suited to exhibition purposes, that *Beuys* created his "Stag Monument" installation for the "Zeitgeist" exhibition. This year it contains a sculpture specially created by *Richard Serra* for the exhibition. This sculpture, "Berlin Curves", consists of two solid steel hemispheres which dominate the exhibition area revealing once more the impressiveness of *Serra's* work with its almost puritanical simplicity.

Until 1933 Berlin had every reason to consider itself an international centre of art and culture. A chapter in the catalogue by *Nicolaas Teeuwisse* refers to the once lost tradition of art collecting in Berlin. The city has now recaptured its former glory. "As an artistic centre Berlin is still the secret capital of Germany with its wealth of museums... theatres, concert halls, cinemas, galleries, studios, workshops and other meeting places for the living arts. The art works from Berlin's private collections which this exhibition brings together are evidence of the upsurge of a new, independent interest in collecting after 1945 and are a clear indication of the reborn vitality of this city." This warm declaration of love for Berlin is completely justified. It is not by chance alone that so many foreign and German painters make their home here. Many are those who came for a brief stay on a DAAD bursary, and ended up staying for ever. It is this generation of young or middle-aged artists which form the bulk of the private collections. Collectors have bought works by their contemporaries, in the literal sense of the word. They have supported what was going on in Berlin and helped to restore the city's cultural reputation. The collections were built up so avidly that many began to outgrow the available space, so that today many of the pictures on permanent loan to museums originate from Berlin collections.

Markus Lüpertz
Judgement of Paris
1985
Oil on canvas
270×400 cm

Robert Rauschenberg
Pilgrim
1960
Oil on canvas,
collage, chair
200×143×60 cm

Edward Kienholz
A Star is Birthed
1963
Various materials
174×122×127 cm

Kenneth Noland
Untitled (Chevron)
1963
Acrylic on canvas
260×408 cm

David Smith
7 Hours
1961
Painted steel
214.5×122×45.5 cm

Rainer Fetting
Self with Red Hat
1986
Oil on canvas
175×140 cm

Enzo Cucchi
Fish on the Back of the
Adriatic Sea
1980
Oil on canvas
206×273 cm

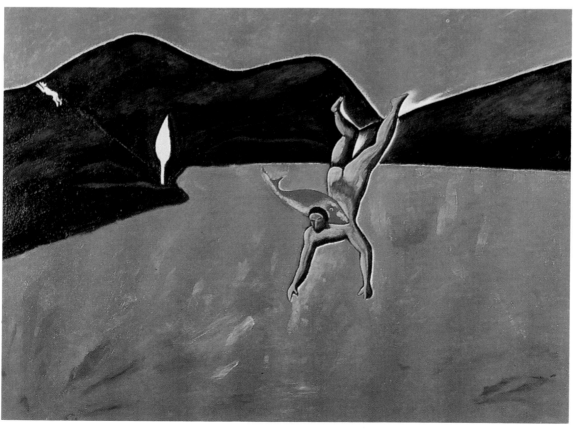

Martin Disler
The Yellow Shoe
1984
Oil on canvas
128×208 cm

Georg Baselitz
Black Mother with
Black Child
1985
Oil on canvas
330×250 cm

Walter Stöhrer
We tell each other
Fragments of our own
strange biography
No. 1
1978
Mixed media
on canvas
260×200 cm

Markus Oehlen
Untitled
1984
Dispersion and wax
on muslin
200×300 cm

Walter Dahn
Bed
1983
Dispersion on muslin
202×142 cm

K.H. Hödicke
Rest
1978
Synthetic resin on canvas
155×190 cm

Le Corbusier Drawings from the Ahrenberg Collection

Frankfurt – Lausanne – Alborg – Helsinki – Pori – Lund – Linz – Mexico

It was the year of *Le Corbusier*. To mark the centenary of his birth some 135 exhibitions were staged throughout Europe, ranging from the comprehensive retrospectives in London and Venice to small shows elsewhere, all commemorating the great architect, the founder of the "Esprit nouveau" in architecture, the creator of Chandigarh, Ronchamp and the Ville radieuse.

An exhibition of especial interest was the one organized by the Musée cantonal des Beaux-Arts in Lausanne and which enjoyed an extensive tour. It showed an unknown *Le Corbusier*, a graphic artist whose work holds many surprises. Neither architecture nor painting allowed *Le Corbusier* the opportunity to express himself fully, but drawing was for him a medium free from all restraints of style or classification and one in which he could truly express himself as an artist. His life was inconceivable without drawing. There existed at one time thousands of sheets of paper on which the artist's whole vitality was expressed. It was this fund of graphic representations of reality that he was able to build on when he turned to the abstract mathematical forms of architecture or to his formally composed and stylized paintings. In his drawing lies the basis of his creativity. One theme runs through his graphic work like a leitmotif—woman. Woman dancing, fighting, bathing; his eye searches out woman loving and lying. There are masterful portrait studies in silverpoint and ink before he once more abandons himself to rounded corporeality in an attempt to capture life in its entirety.

One outstanding feature of this work are the collages. Here we no longer have odd sheets of sketches, but well-thought-out major compositions of a pictorial nature. Often here he goes back to earlier drawings reworking them with elements of collage. Towards the end of his life his figures lost their vital corporeality. While still retaining their volume, they became subordinated to a principle of surface area determined by line. It is in these last sheets from the late Fifties that his graphic work appears at its most modern. The 180 works that make up the exhibition are all from the same private collection, the Ahrenberg Collection. *Le Corbusier* himself built up this collection with Ahrenberg and one can say, with no exaggeration, that they are amongst the best drawings ever produced by him. The "laboureur secret", as *Le Corbusier* liked to refer to himself when speaking of himself as a graphic artist, reveals himself in all his breadth in this collection. The drawings were the fertile soil from which his architectural work sprang. For *Le Corbusier* there was an unwritten law that the architect must familiarize himself with the being for whom his architecture is created—man. His graphic work, which is devoted almost exclusively to mankind, is ample proof of this. It is surely no coincidence that this flowering into corporeal reality occurred only after *Le Corbusier* had embarked on his career as an architect. In 1918 together with *Amédée Ozenfant* he wrote the manifesto "Après le cubisme" (After cubism), in which he set out his concept of a new architecture. In 1920 he founded the review "L'Esprit Nouveau". From this moment on he became the chief inspiration behind the architectural revolution which was sweeping Europe and the United States. At this time, as the architect *Le Corbusier*, he was one of those struggling to improve the standard of living of mankind, while, as a painter, he continued to be known as *Charles-Edouard Jeanneret*. It was only when he had been able to carry through his idea of a new, adequate environment for mankind that the painter also took on the name of the architect. Now the painter could no longer stand in the way of the architect.

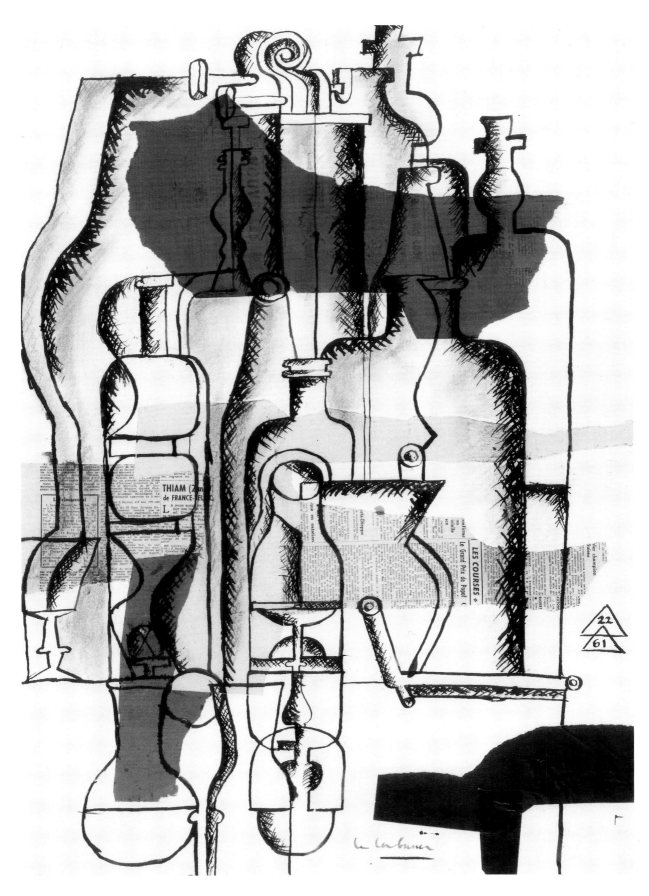

Composition
1922–61
Collage, ink, pencil
70.5 × 50 cm

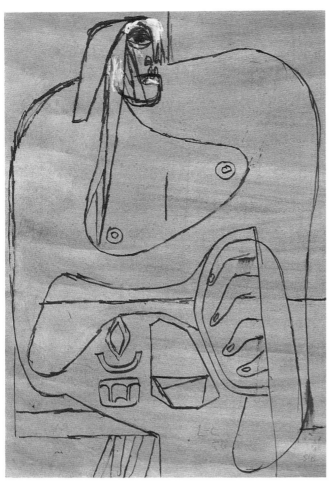

*Woman with folded hands
1950
Watercolour, gouache, ink
40×27.5 cm*

*Photo right-hand page:
The open hand, 1948
Gouache, ink, chalk
47×31 cm*

*Two nude figures
1932–1962
Collage, ink
42.5×60 cm*

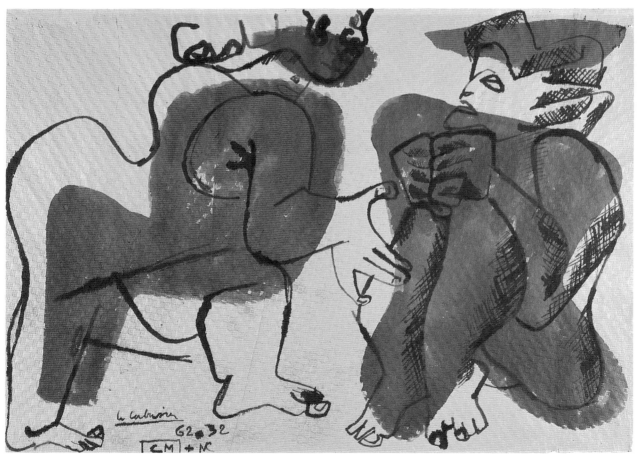

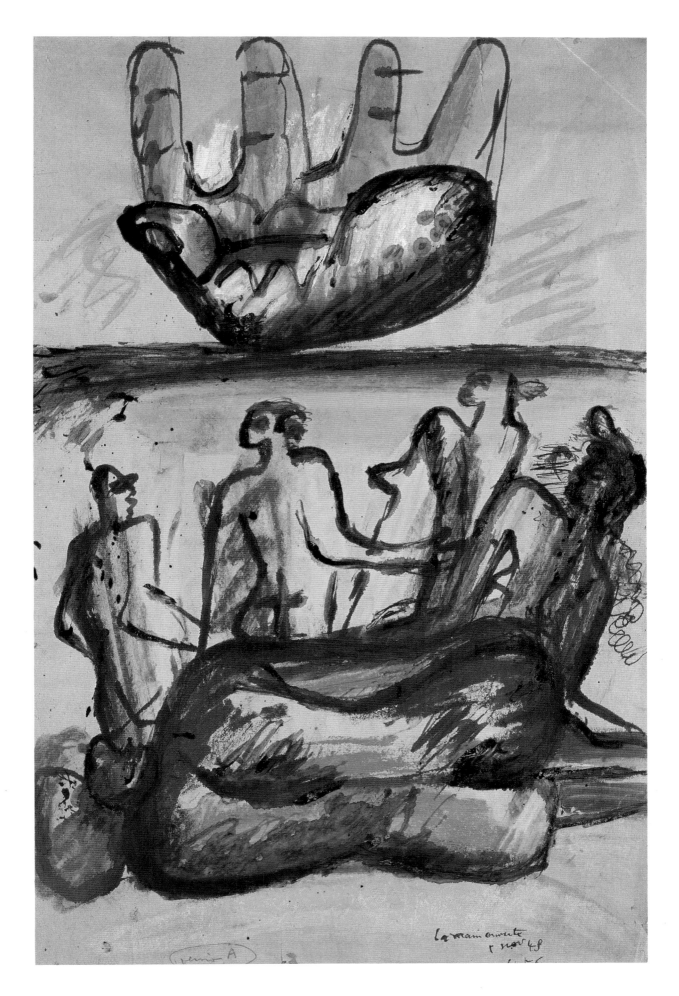

la main ouverte
1 nov 48

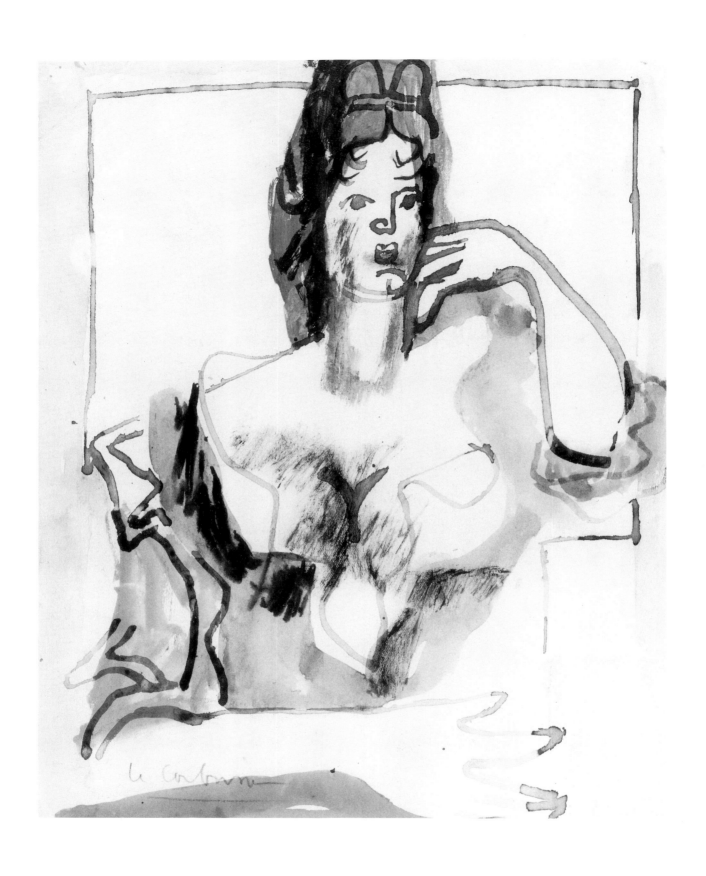

Woman at the window
Watercolour
25.6×21 cm

Still-life, guitar
and bottle
1922
Pencil
18×14.5 cm

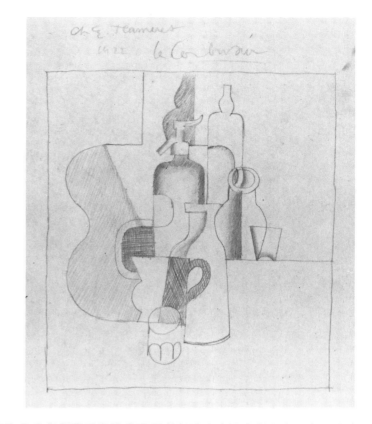

Three women in
bathing costumes
1932
Pencil
22×22.5 cm

Person at table
1939–1952
Collage, gouache, ink, pencil
103×69.5 cm

Two women
1953
Gouache, chalk, pencil
34.2×42.2 cm

Composition
1953
Gouache, chalk, pencil
34×42.5 cm

Exhibition 135

Oskar Schlemmer

Baltimore – New York – San Diego – Minneapolis – Amsterdam

Amongst the great names of the Bauhaus, like *Paul Klee* and *Wassily Kandinsky,* belongs that of *Oskar Schlemmer*. It was in 1921 that he joined the Bauhaus where he became head of the sculpture workshop and the department of theatrical design. He had a particular affinity with the ideas of the Bauhaus, his painting was noted for its architectural and constructivist elements. Yet one should make no mistake about it; this apparently well balanced and rational painter also had his mystical and emotional sides. The exterior order of things was no more than a method of work and development which he employed to bring order to the impassioned expressions of the soul. Even as a young man, *Schlemmer* recorded in his diary: "Ever and again—Dionysian conception and Apollinarian construction."

The artist who thus described himself had a passionate interest in the theatre and had himself trained as a dancer. It was to him that a number of American museums dedicated a retrospective that in Europe was to be seen only in Amsterdam. An exhibition such as this was long overdue in the United States in the wake of Bauhaus exhibitions, retrospectives of *Kandinsky* and this year's *Klee* exhibition. In Europe it is primarily in Germany that *Schlemmer's* paintings, sculpture and theatrical work are known and loved, for it is German museums and private collections that contain most of *Schlemmer's* major works and above all the Schlemmer Archive in Stuttgart, the artist's hometown.

Schlemmer's painting and sculpture can best be understood through his theatrical work. Theatre contains the key to an understanding of his artistic personality. In his "Triadic Ballet" which had its premiere in 1922 in Stuttgart before being performed in Weimar in 1923, he laid down what interested him primarily in the plastic arts. In an imaginary artistic space he made stereotyped human figures appear as pure artistic creations. From his theatrical experiences he drew the theme for his paintings; the "figure in space". For him man was not a being of nature but of art. These contrived figures, semi-figurative and semi-abstract, became the actual metaphor of his pictures. Static, puppet-like, they stand in space, firmly rooted or travelling through it. Even the space itself is not actually real but is reminiscent of *De Chirico's* metaphysical spaces. "In abstract spaces of the future, of transparency, of reflection, of optics, the diverse figurization of man" was how *Schlemmer* described his work.

He made great demands on his art. His aim was nothing less than to capture the spirituality of man in combination with his origins in nature, as a "symbol of the oneness of nature and spirit". What Schlemmer managed to achieve in his paintings was basically a poeticization of Cubism and its geometric elements. They are peaceful, sensitive works that the Bauhaus teacher has left to us. In 1937 he was branded a decadent artist and some of his finest works were burnt. In recent years world-wide interest in *Oskar Schlemmer* has developed. This man who was painter, sculptor, draughtsman, stage designer and teacher, has come to be seen as a major figure in the development of modern art. In 1961 *Walter Gropius,* the man who appointed *Schlemmer* to the Bauhaus, wrote of his work: "In his paintings there is a new spatial energy... it awakes in the mind of the viewer the idea of a future culture of oneness, a culture which will once again bring all the arts together." This idealized concept of a total work of art was to remain a fiction even for later generations and yet *Schlemmer* was able to realize it for himself and to combine the various aspects of his artistic work into a synthesized whole.

*Photograph from a performance
of "The Glass Dance"
1929*

Head with cup
1923
Oil on paper
57×38 cm
Daimler-Benz AG, Stuttgart

Company at table
1923
Oil on canvas
64×101 cm
Private collection

Group with ecstatic figure in blue
1931
Oil on muslin
121.5×66 cm
Hamburger Kunsthalle, Hamburg

Figurines in space
c. 1924
Gouache, ink, enamel and photography
57.5×37.1 cm
The Museum of Modern Art, New York
Gift of Lily Auchincloss

Abstract head, working drawing for
a wire sculpture
1923
Pencil, ink
56.9×42.2 cm
Staatsgalerie, Stuttgart

Group of fifteen
1929
Oil and tempera on canvas
178×100 cm
Wilhelm Lehmbruck Museum, Duisberg

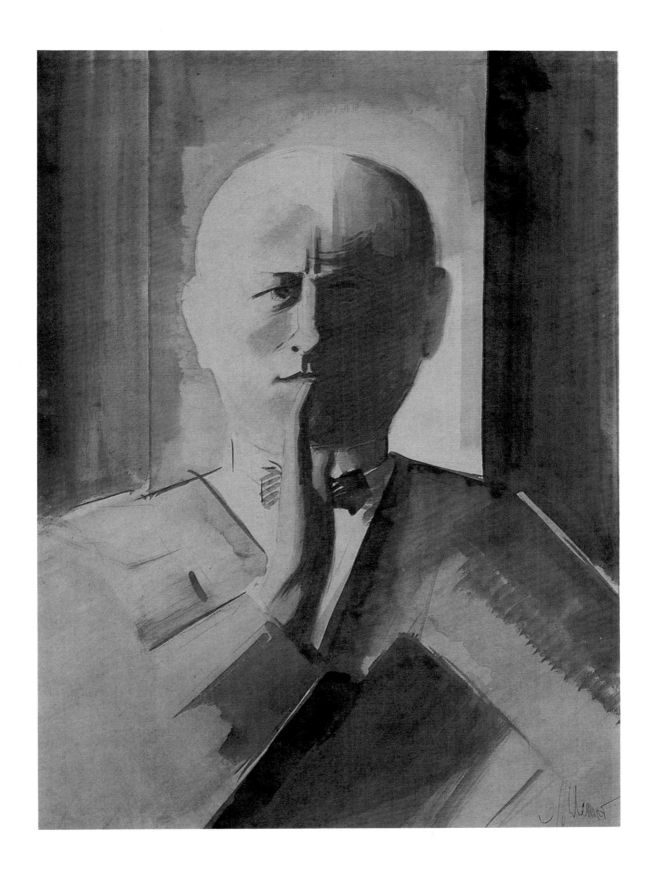

Self-portrait with raised hand
1931–2
Watercolour
54×39.5 cm
Peter Kamm Collection, Zug

Prospect 86
An international exhibition of present-day art

Frankfurt

The city of Frankfurt has not up to now been known for its exhibitions of present-day art. There was nowhere large enough to allow for a wide overview of contemporary trends—nor was there a lot of interest. Today Frankfurt is making up for lost time! With its great number of new museums it is fast becoming one of the foremost centres on the exhibition circuit. Generous municipal grants to the various cultural institutes promise a golden age for this city on the River Main. This city, whose only claim to culture after the war was the time-honoured institution of the Städl, and whose only claim to international fame was the annual presentation of the peace prize in the Church of St. Paul, can now pride itself on having become one of the most go-ahead and lively artistic centres in the world—and all within the space of a few years.

Never before in Frankfurt had there been an exhibition like Prospect. The Art Society, having tried for decades to bring contemporary art to the people of Frankfurt, could at last find somewhere large enough to present a comprehensive view of art today, thanks to its vicinity to the new "Schirn" exhibition building. Divided between two institutions, Prospect was in fact an attempt to rival this year's Documenta in Kassel and even to outdo it as far as quality is concerned.

Peter Weiermair invited 92 artists from over 12 western countries to take part. They all submitted work produced between 1983 and 1985. The accent was upon the immediate present, even as far as the birth-dates of the artists was concerned. With few exceptions, all were born in the Fifties. This ruled out the modern "masters" like *Baselitz, Penck, Lüpertz* or *Immendorf,* whereas "youngsters" of more recent renown were well represented.

There was *Miguel Barceló* from Spain, who has become so highly collectable in recent years; *Jean Michel Basquiat,* famous for his graphite paintings and in recent years extremely popular, in the USA at least, for his work with *Andy Warhol; Siegfried Anzinger,* an Austrian painter now living

in Vienna and Cologne; and also two French artists, *Jean-Michel Alberola* and *Jean-Charles Blais,* who have put France back on the map of present-day art, a scene from which she had long been missing. But there were also many new names who made a good impression in this exhibition.

Peter Weiermair's aim of making the choice of exhibits (which he himself selected) provide a glimpse of the new, was fully achieved. The main emphasis of the exhibition was on painting and sculpture. After a brief interval of conceptual and minimal art, the pendulum has swung back to content and imagery. Even here there is much talk of "post-modernism". This term, originally applied to architecture, can be used for practically everything for no-one has been able to define precisely what it means. It remains to be seen whether with historical hindsight it will at some future date be applied to present-day art.

Although post-modern aptly describes present-day art, the work of this young generation of artists also provides keys to the past, the past constituting anything up to 10 or 20 years ago. It is almost impossible today to say what contemporary art is, although many works exhibit a striking tendency towards the distinctly beautiful and stylized.

The pluralism of styles, of which there has been much talk in the past, is not really a useful way of summarizing present-day art. Nowadays pluralism is much more a distinguishing feature of the individual artist. Today every artist, as *Peter Weiermair* writes, employs the most varied methods and approaches. Pluralism has, in a certain sense, become the personal style of the individual.

Jack Goldstein, Canada/USA
Untitled
1986
Acrylic on canvas
152×305×14 cm
Gallery Metro Pictures, New York

Luigi Ontani, Italy
Son testa, son paessaggio turrito
1986
Ceramic
Lucio Zanetti Collection, Bologna

Jean-Michel Basquiat, USA
Skinflint
1986
Acrylic, oil on canvas
218×173 cm
Bruno Bischofberger Gallery, Zurich

Jean-Charles Blais, France
For the stars
1985-6
Paint on torn poster
240×300 cm
Buchmann Gallery, Basle

Manfred Stumpf, Germany
The entry into Jerusalem
1986
Drawing in the "Schirn" rotunda
21×29.5 cm

Anish Kapoor, India/England
Mother as a mountain
1985
Wood, plaster, pigment
145×200×145 cm
Private collection, Courtesy Lisson Gallery

Ecce Arcimboldo

Venice

Jean Goujon (attributed)
Woodcuts for Horus Apollo's
"Hieroglyphica", Paris, Kerver, 1543
Bibliothèque de l'Arsenal, Paris

Convex mirror, 16th century
∅ 120 cm
Kunsthistorisches Museum,
Schloss Ambras Collection, Innsbruck

Giuseppe Arcimboldo, that bizarre artist of the late renaissance, was the subject of an exhibition held in the spring at the Palazzo Grassi in Venice. This painter, whom art historians include amongst the Mannerists, was the inventor of those grotesque portraits made up of assorted objects. His allegories of the seasons, which he turned out in a number of different versions, have become world famous: Spring with a head of flowers and leaves; Summer, a wealth of fruit and vegetables; Autumn with its head of corn, grapes and mushrooms; Winter made entirely of knotted roots. 15 paint-

ings from *Arcimboldo's* limited output, mostly from private collections, formed the centrepiece of the exhibition. A further 280 pictures demonstrated how far *Arcimboldo's* idea of portraying the human countenance has inspired other artists. Four hundred subsequent years of art have been searched for heads, in which any human form had either disappeared completely or been modified almost beyond recognition.

The organizer of the exhibition, *Yasha David,* found 120 artists spread over the centuries who had either made up the human face from foreign

René Magritte
The Rape (Le viol), 1935
Chalk on paper
36.5×25 cm
The Menil Foundation, Houston

objects or reduced it to individual details so that any claim to realism was lost. In the years immediately following *Arcimboldo* these phantasmagorical constructions were often of a jokey nature, as in the anthropomorphic landscapes of the 17th century in which the face is often so well concealed that only by turning the picture through 90° can it be discerned amidst the landscape. Interest in this art form was, however, more marked in the 19th and 20th centuries. Here we find many examples and an increasingly original treatment of the subject. The influence of *Arcimboldo* was developed in the 20th century into true creativity, which ultimately had little connection with *Arcimboldo*, and his imitators. Nevertheless, 20th-century artists thought highly of *Arcimboldo* and appreciated his inclination towards the grotesque. In this sense the exhibition paid the great master the tribute due to him. For the first time *Arcimboldo* was set within the context of the 20th century.

Arcimboldo, whose works are regarded by many art lovers as amusing, surprising curiosities, emerges from this exhibition with his reputation enhanced, as the inventor of an art form which 400 years later developed into an important form of artistic communication. The route from one to the other is traced in historical examples, in pictures which are either little known or which have been of little interest up to now. They came from both major museum collections and small provincial museums. And this was itself one of the major attractions of the exhibition!

It goes without saying that the Dadaists and Surrealists were well represented in this exhibition. They treated reality as if it did not exist, and took liberties in their treatment of reality such as *Giuseppe Arcimboldo* would never have believed possible at the end of the 16th century.

It was possibly the photographers who contributed most to the new vision of the human face. The experiments of *Louis Ducos de Hauron* must surely mark the beginning of a path that eventually led to the Rayograms of *Man Ray*. In a series of "Anamorphic self-portraits" taken in 1889, he distorted his face by means of mirrors. *Man Ray* in fact had a picture by *Arcimboldo* in his own private collection. The ghost of his predecessor must have been a familiar friend to him. For he used a medium, intended to give an exact replication of reality, in precisely the opposite manner. He was able to discover photography's greatest secret of all and demonstrated in his Rayograms that it was possible to photograph the realm of fantasy, the element that is completely lacking in reality.

If we consider the alienation of the face in 20th-century art, the first period of great creativity comes with Cubism. In Cubism the portrait is portrait no longer, but a composition made up of surface areas. Constructivism then turned the human face into a pure abstraction of "technical" forms. Dadaism and Surrealism discovered hitherto unimaginable ways of turning the face into a source of fantasy and imagination. There followed a play upon isolated features, with *Andy Warhol* symbolizing *Marilyn* by her lips alone. But hadn't *Arnold Schönberg* in 1910, and *Odilon Redon* too, already reduced the face to a single eye? Since *Arcimboldo* such ideas have turned repeatedly throughout art history to demonstrate what this exhibition made fascinatingly clear—the Arcimboldo effect.

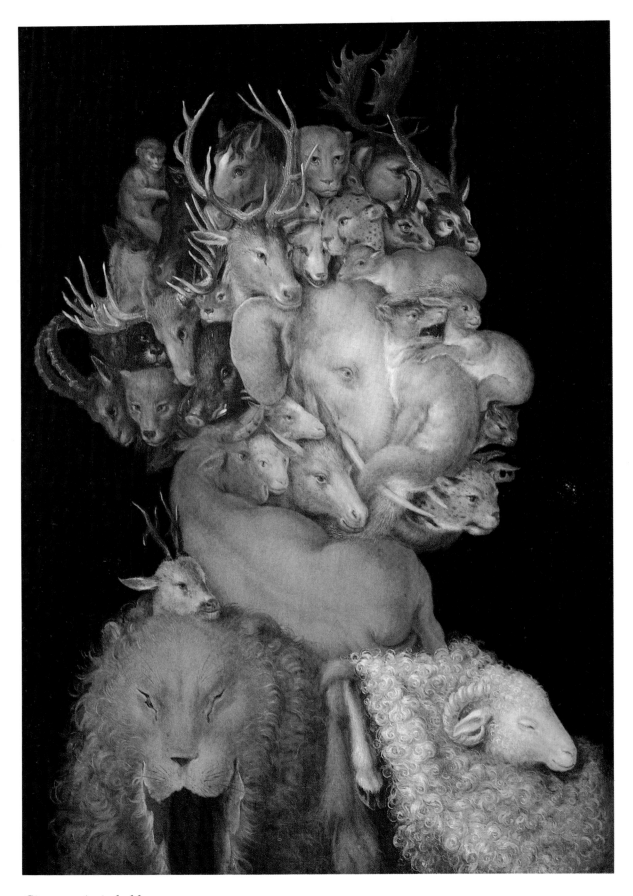

Giuseppe Arcimboldo
Earth, 1570
Oil on wood, 70.2×48.7 cm
Private collection

Giuseppe Arcimboldo
Fire, 1566
Oil on wood, 66.5×51 cm
Kunsthistorisches Museum, Vienna

PRIMAVERA ESTATE

AVTVNNO INVERNO

Anonymous
Spring and Summer
Autumn and Winter
Engraving
16.3×23.1 and 17.3×23.5 cm
National Museum, Stockholm

Odilon Redon
Everywhere Pupils Flaming
(Partout des prunelles flamboient), 1888
from: The Temptation of St. Anthony
Lithograph
20.4×15.8 cm
Bibliothèque National, Paris
Print Room

Giuseppe Arcimboldo
Winter
1573
Oil on canvas
76×64 cm
Musée du Louvre, Paris

Giuseppe Arcimboldo
Autumn
1573
Oil on canvas
76×64 cm
Musée du Louvre, Paris

Giuseppe Arcimboldo
Summer
1573
Oil on canvas
76×64 cm
Musée du Louvre, Paris

*Photographic reproduction of
the painting "The Librarian"
by Giuseppe Arcimboldo
Part of the General Inventory of Art
Treasures in Sweden, catalogued by
Olof Granberg*

*Salvador Dalí
Mythological animal, 1930
Ink drawing on plaster ground
21.3×20 cm
Gala-Salvador Dalí Foundation
Teatro-Museo Dalí, Figueras*

Marcel Duchamp
Allégorie de Genre (George Washington)
1943
Assemblage
52.2×40.5 cm
Private collection, Paris

Salvador Dalí
The Endless Enigma
1938
Oil on canvas
114.3×144 cm
Gala-Salvador Dalí Foundation
Teatro-Museo Dalí, Figueras

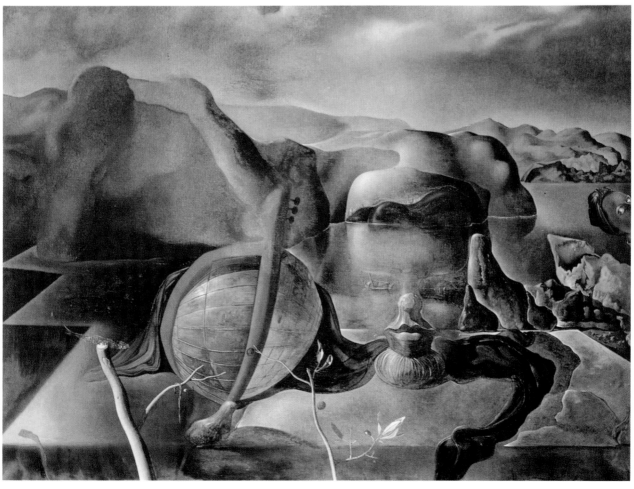

Max Ernst
Cocktail Drinker, 1945
Oil on canvas, 116×72.5 cm
Kunstsammlung Nordrhein Westfalen, Düsseldorf

Odilon Redon
There was perhaps a First Vision tried in the Flower
(Il y eut peut-être une vision première essayée dans
la fleur), 1883
In: Origins (Les Origines)
Lithograph
22.3×17.2 cm
Kunstmuseum, Winterthur

160 *Exhibition*

Salvador Dalí
Birth of Paranoic Furnishing, 1937
Black chalk and gouache on paper
62.2×47 cm
Private collection

Salvador Dalí
Paranoic Metamorphosis of Gala's Face, 1932
Ink drawing, 29×21 cm, Boris Kochno Collection,
Paris

Marcel Duchamp
The Bride, 1912, Oil on canvas, 89.5×55 cm
Philadelphia Museum of Art, Philadelphia
Louise and Walter Arensberg Collection

Mimmo Paladino
Works on paper 1973–1987

Salzburg – Krems – Graz

Untitled
1987
Pencil, tempera
30×40 cm

Untitled
1977
Chalk
28×22 cm

Untitled
1986
Pastel
31×23 cm

One of this year's touring exhibitions in Austria was devoted to the Italian painter and draughtsman *Mimmo Paladino* who, along with *Chia, Clemente* and *Cucchi,* represents the new school of Italian painting. He must surely be considered one of the most important painters of the contemporary art scene. *Paladino* has always shown a marked predilection for drawing and it is therefore understandable that the Austrian organizers of this touring exhibition should have decided to devote it entirely to works on paper. The catalogue includes contributions from *Achille Bonito Oliva,* who discovered the artist, and *Dieter Kœpplin,* an expert on contemporary drawings. In the foreword, *Otto Breicha,* the man chiefly responsible for the exhibition, outlines what he particularly likes about *Paladino:* "His work is a plea for sensual creativity and against rationality in whatever form."

Mimmo Paladino has been drawing since 1973, with charcoal, pencil, pen, brush or graphite. He has mastered the techniques with all the grace of a dancer and with a perfection that has made him a true master in the field of drawing. What does one find on these sheets of paper, now sparsely, now thickly covered with forms right to the very edge of the page; what is it that gives life to his drawings? Figures, heads, solitary objects, symbols, which enter into a relationship one with the other to create a strangely foreign world of archaic origin. Many drawings are mere sketches, others are like finished paintings. What they all share in common is a silent communicativeness, a total beauty of mood which robs them of any similarity with reality. They are like islands, not only in the bustle of the everyday world, but also within the realm of contemporary art. They are completely lacking in the brutality and violence which characterizes the paintings of his German contemporaries. They are gentle works, perfectly attuned to something hidden in the depths of our consciousness. One art critic has written of *Paladino's* drawings: "Here the world is not only beautified, here the world is sanctified." Could there be any better way of describing the inner peace of these drawings?

Untitled
1987
Pastel
29.7×21 cm

Untitled
1985
Mixed media
30×40 cm

Untitled
1980
Mixed media
23×31 cm

British Art in the 20ᵗʰ Century

London – Stuttgart

In the wake of the sensational joint exhibition of German art in the present century, the Royal Academy in London and the Staatsgalerie in Stuttgart have now produced their second project, a wide-ranging view of British art in the 20th century.

Here once more there was much that was new to be discovered. Who on the Continent knows anything about the British avant-garde prior to the Second World War other than the familiar names of *Ben Nicholson* and *Paul Nash*. And how many of those who are interested in Surrealism are familiar with names like *Roland Penrose* or *Eileen Agar* (neither of whom are in fact represented in the exhibition)? We know a little more about the post-war years. *Henry Moore's* popularity was mainly achieved through works produced after 1945. But *Francis Bacon* too belongs to European art history. Pop-art, *Gilbert and George,* Art and Language, *David Hockney, Richard Long, Anthony Caro*—here we are on firmer ground.

So what was to the British a retrospective of all that was best in British art in the 20th century, was to the continent of Europe an exhibition of discovery. The main question seemed to be whether British art of the first half of this century was really important enough to make European history. This is a question that everyone must answer for himself. For the most part the British artists of the avant-garde period cannot compare with their more famous European contemporaries. But one should not condemn them on these grounds. Theirs has been a different history, theirs is a different mentality. The cool understatement that prevails in everyday life is not a mask behind which emotions are hidden. British art of the first half of the century remains uncommitted, slightly bloodless, and as a rule one can discover the great masters—*Picasso, Matisse,* the Blaue Reiter together with *Brancusi* or *Braque*—in pale British imitations.

As far as the first half of the century was concerned new discoveries were therefore difficult to find. But this was amply made up for by the post-war period during which several representatives of British art made major contributions to the international art scene. Towering above them all—as one might expect—is *Francis Bacon,* far and away one of the greatest painters of our time. Even though *Frank Auerbach* achieved international fame in 1986 through his contribution to the Venice Biennale, he will never occupy the same position in modern art as *Bacon,* his elder by more than a generation. *Francis Bacon* has, for a whole century, ensured the place of British art in the international art scene.

One of the present-day artists who never fails to impress is *Richard Long* whose stone emplacements have reawakened our awareness of ancient cultures, mystery and magic. Here we have, possibly, an artist who understands the primeval traditions of his origins and who has managed to make them relevant to life today. *Barry Flanagan* is another sculptor who has been able to carve out his own path. His works provide the real highlights of the exhibition! In complete contrast to the works of *Long* and *Flanagan* stands the painting of the Seventies, the pictures of *R.B. Kitaj* and *Malcolm Morley* with their reliance on colour and expressivity. Both became known in the Sixties when, along with *David Hockney* and *Richard Hamilton,* they led the New Figuration movement. Of all of these *David Hockney* is the most talented and has become the most international painter of his generation. He has always remained true to the narrative style from his first works in the early Sixties up to his pictures of the present day. As well as painting he has always had an interest in photography. While providing him with themes and styles for his paintings, this interest has made him a first-class photographer in his own right.

Barbara Hepworth
The Cosdon Head
1949
Blue marble
63×33×51 cm
Birmingham Museum and Art Gallery

Overleaf:
Philipp King
Call, 1967
Fibreglass, painted
steel, two parts
442×15×15 cm
Juda Rowan Gallery

Henry Moore
Draped Reclining Figure
1952–3
Bronze
109×164×74 cm
The Henry Moore Foundation

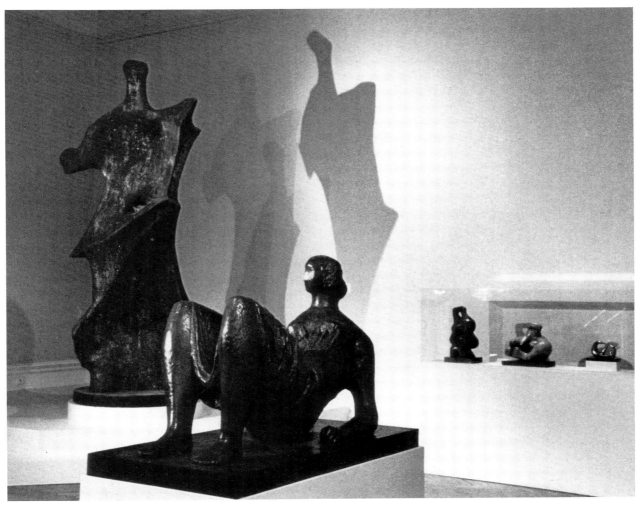

David Hockney
Sun Bather
1966
Acrylic on canvas
183×183 cm
Ludwig Museum, Cologne

Richard Hamilton
Towards a Definitive
Statement on the
Coming Trends in Men's
Wear and Accessories
1962
Oil and collage
81×122 cm
Private collection

John Walker
Conversation
1985
Oil on canvas
214×169.4 cm
Arts Council of Great Britain

Richard Hamilton
Homage to Chrysler Corp.
1957
Oil, metal foil, collage
122×81 cm
Private collection

R.B. Kitaj
An Early Europe
1964
Oil on canvas
152.4×213.4 cm
Private collection

Bruce McLean
Untitled, 1986, Acrylic, enamel, collage on canvas
284×198 cm, Courtesy Anthony d'Offay Gallery, London

Simultaneity of the "other"

Berne

This exhibition was seen only at the Kunstmuseum in Berne, and yet it was a truly European event. In this year of the Documenta, in which there has been much lively discussion of all the latest trends, *Jürgen Glaesemer,* the organizer of the Berne exhibition, has struck a calmer note. Accompanied by a book which had more pretension to being a work of literature than a catalogue, this was an exhibition based on the personal experiences of a man who has been involved with the modern art collection of the Kunstmuseum in Berne for over 15 years. This is the man who looks after the Klee Collection and who has a sensitive feel for connections, be they between cultures, epochs or artists. It is difficult to describe this exhibition in mere words—it has to be felt.

This was *Glaesemer's* guiding principle in compiling the exhibition. It was not so much an exhibition of contemporary art as a demonstration of the contribution made by contemporary artists towards an awareness and appreciation of "the other". But what is meant by "the other"? This too has to be felt. It involves a recognition of different states of the soul, elementary experiences of life and death, of eroticism and love. It involves the "animation of all things" and the "omnipotence of thought".

This was, then, an exhibition which attempted to take art back to its origins in mystery and magic. It was about ritual and myth. The artists were chosen for the sensitivity with which they perceived the "other" and integrated it into their art. It goes without saying that a central place in the exhibition went to *Joseph Beuys.* Who of all the artists of our time has been closer than he to the mystical? His "Honey-pump in the work place" was included in order to transpose ideas and to stand as a materialistic symbol of the "other"—the "Honey-pump" as a spiritual power station, *Beuys* himself a transformer—turning reason into mythology and mythology into reason *(Alois Müller).*

Ulay and *Marina Abramović* have lived and worked together since 1975. Visits to Australia have added an ethnological aspect to their work. This is not only an important feature of their work in recent years but also in the overall concept of the exhibition. Not only for them, but for many artists working today, the ambivalence of certain outward cultural manifestations runs like a leitmotif through their work. Their Australian photos of 1986 harmonize well with the work of *Michael Buthe* who has spent many years of his life in Morocco and who weaves oriental culture into his work. "Articulation of an artistic ritual, expression of excessive forms of behaviour—like rapture, extravagance, ecstasy, magic, destruction—which are becoming increasingly lost in our profit-orientated world", was how *Stephan von Wiese* once described *Buthe's* work. These are words that could be applied to many of the artists in this exhibition. *Martin Disler, Walter de Maria, Leonore Mau, Hubert Fichte* and immigrant artists like *Adolf Wölfli* or the Mexican *Martin Ramirez,* all established this realm of the ultimately "wonderful". Wonderful in the sense that scientific progress has distanced us hopelessly from the "other". In this sense *Jürgen Glaesemer's* exhibition has been of paramount importance. He was trying to put the public back in touch with things that cannot be experienced in material terms. What we were concerned with here was not aesthetics or the ability to understand the subject matter of art, but the innermost heart from which art develops. It was an exhibition of hope—hope that we would regain our consciousness of what makes art and culture, a consciousness of what makes mankind.

Martin Disler
Poem for the Exhibition, 1987

LEBENSLAUF / Todestages

Ich trinke trinke trinke
trank erst die mundige Milch
trank den Wein des Schriftens ...

da fiel Regen in meinen Mund
das Brackwasser der stinkenden Luft
grauer Schnee schmolz unter meinen Fersen
Blut trank ich aus euren Pappbechern
trank immerfort und trank
trank nachtdunkles Licht
trank DEINE Tinkturen geliebte
das Weihwasser deiner aufrayenden Brust
ich trank Kerosin aus den zerbrochenen Flügeln
des gefallenen Engels

trank und trank
und hinke hurtig dem hüpfenden Bachs hinterher
ich stürze mich ins glas
des verzerrten Spiegels
der gebrochenen Augen
die sich auf mich richten

EIN SCHUSS

EIN VERSCHÜTTETER

WUNSCH

Walter de Maria
Beds of Spikes
1968-9
Sculpture
Stainless steel
5 parts with steel prongs
each 6.5×200×107 cm(bases)
26.8×2.5×2.5 cm (spikes)
Private collection

Rebecca Horn
Ballet of the Woodpecker
1986-7
Room installation
with mirrors,
small hammers and
a painting machine
330×230 cm (4 mirrors)
330×125 cm (4 mirrors)
Eric Franck Gallery, Geneva
and Property of the artist

Martin Disler
Untitled, 1986
Triptychon
Oil on canvas, 176×110 cm
Property of the artist

Michael Buthe
Diaries from the Cupboard
Installation
In progress since 1985
Property of the artist

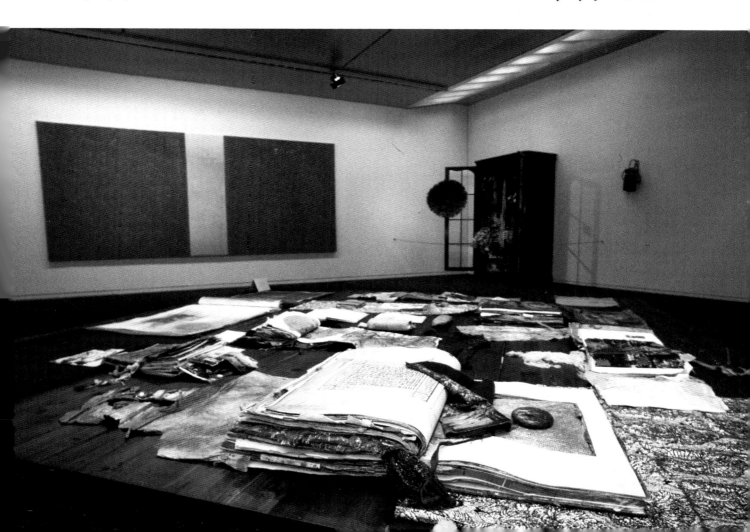

Francesco Clemente
Watercolours

Basle – Groningen – Essen – Lausanne

Watercolour VII, 15.7×23.8 cm

The Museum of Contemporary Art in Basle received from the Ciba-Geigy company a gift of a watercolour cycle painted by *Francesco Clemente* from August to October 1985 in Adayar in Southern India. The watercolours were produced as a sort of daily meditation exercise to form a series of 108, a number sacred to Hindus and Buddhists. 108 links make up the Japamala, a prayer chain on which 108 prayers can be counted off. Accordingly, the series of 108 watercolours is inspired by oriental philosophy, symbolizing beauty and harmony—concepts central to *Francisco Clemente's* outlook and fundamental to his work. *Dieter Koepplin*, the curator of the print room in Basle, decided to exhibit this series of watercolours, which give the impression of all being from the same mould, and to send them on tour before consigning them to the many years of careful storage that their fragility requires.

States of mental excitement are given expression in the 108 leaves through colour alone. Through his amazing ability to identify with oriental philosophy, *Francesco Clemente* has succeeded in entering into the art of Tantra and filtering it through his western heritage to produce an unparalleled synthesis of East and West. In a metaphorical sense *Klee* and *Tantra* are united in these watercolours. They are full of light and a "spiritual quality"; they have an inner glow all of their own.

Watercolour XIII
14.5×23.6 cm

Watercolour XXXVI
18.6×26 cm

Watercolour LXVIII
24.9×23 cm

Watercolour LXXVI
14.5×20 cm

Watercolour LXXXVII
14×22.1 cm

Documenta 8

Kassel

Its original conception was as an exhibition of 1,000 possibilities, celebrating art as a phenomenon of life embracing the whole space in which we live. It includes installations, design, video, architecture, and sculpture both inside and in the open. Painting is not a feature of the exhibition. It is not excluded completely but relegated to the fringes. The organizer of this year's Documenta, *Manfred Schneckenburger*, obviously has little interest in painting as an expression of the spirit of the times, which is a pity, for, heavily weighted towards design and strange furniture installations this Documenta touches only the surface of art. It leaves one with the impression that art has become just one more consumer article and that there are no longer any artists who see art as conveying a message or fulfilling a purpose. Without the *Joseph Beuys'* installation, "Flash of lightning with light shining on stag", and the fine room devoted to *Anselm Kiefer*, one would have to ask oneself why one bothered coming to Kassel at all. The Kassel Documenta, first produced in 1955 by *Arnold Bode*, has for over 30 years featured amongst the major art shows of the world. It has always echoed the spirit of the times and highlighted artistic trends and emphases. It has been both a barometer of the present and a guide to future developments. It has had absolute hegemony, influencing everyone who has anything to do with art-museums, gallery-owners, and collectors.

The exceptional importance of the exhibition means that each successive Documenta organizer has to be aware of the responsibility he automatically assumes in staging this international exhibition. In the case of Documenta 8 one is left wondering for the first time what has happened to this sense of responsibility. If this is supposed to be a sample of the artistic creation that is going on around us at the present time, one should have no illusions about the future; together art and exhibitions are achieving little more than a cattle-market. From the introduction and interviews it would seem that *Manfred Schneckenburger* had

one concept in mind when planning Documenta 8; more a perspective than a concept. "A perspective of art that relegates art to the background. A perspective of the artist that art best provides. A perspective of ourselves, of contemporary questions and problems, that art brings within the scope of the Documenta." This would seem to imply that art must be committed. Such an outlook would, however, be a completely new direction for a whole string of artists, such as *Haacke, Kruger, Longo, Golub* or *Goldstein*. It is difficult to see any connection between this concept and the witty, occasionally bizarre pieces of furniture on show in the Orangerie. And how do the more weighty works of *Beuys* and *Kiefer* fit into all this? The installations of *Nikolaus Lang* and *Giuseppe Penone* also leave one with the feeling that one has seen something worthwhile. Both work elementally with nature and bring it into the installation as a creative force.

Interesting and fascinating to watch are the video sculptures of the Brussels artist *Marie-Jo Lafontaine*; her "Steel Tears" satirizing the fitness training of young men who turn into machines to the rhythm of music.

Both the meadow in front of the Orangerie as well as buildings in the town were used to show off sculpture.

Ian Hamilton Finlay's "Guillotine" was the most talked-about exhibit in the Documenta; the eye passes through four guillotines placed one behind the other to light upon a small classical temple. At least this was one exhibit that set every visitor thinking. Irony and hidden meaning—perhaps that is the key to Documenta 8.

Klaus vom Bruch, Germany
Coventry
1987
Video installation on pipes
450×640×560 cm
Music by Benjamin Britten

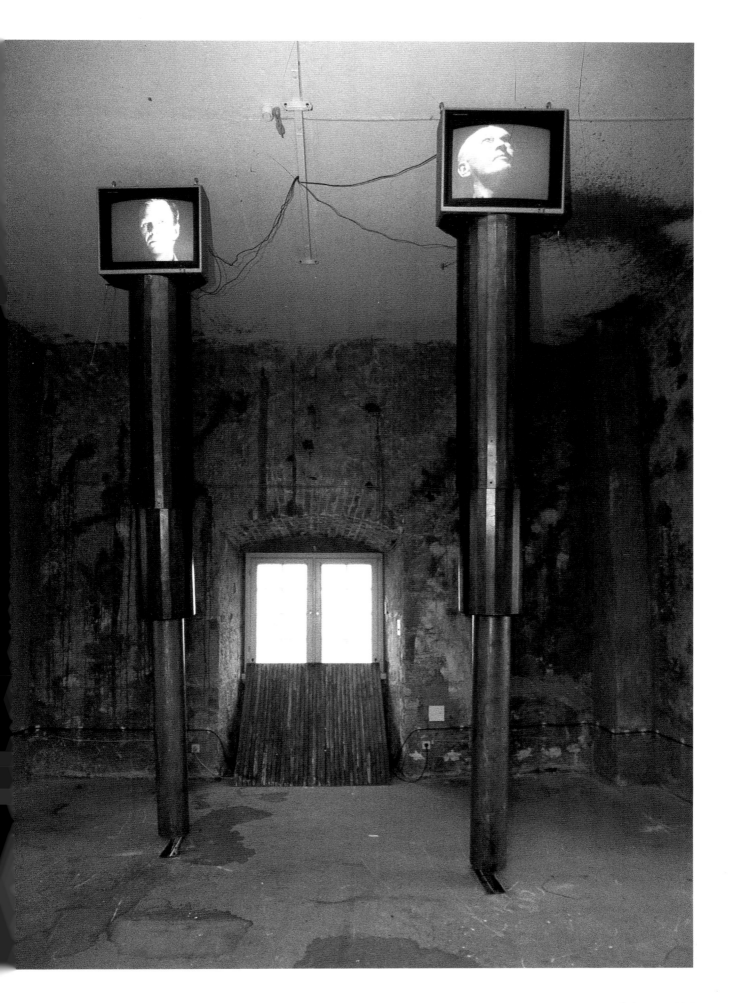

Lapo Binazzi, Italy
Neon-fiction-machine
1987
Painted metal, plexiglass, neon tubing
220×180×30 cm

Paolo Deganello, Italy
Standard lamp
1985
Manufactured by Ycami Collection
Aluminium, cast iron, crystal glass
254×225 cm

Right-hand page:
John Armleder, Switzerland
Furniture sculpture FS 148
Enamel on canvas
wooden shelf unit
Nächst St. Stephan
Gallery, Vienna

Denis Santachiara, Italy
Sofa and "Tina" chair-robot
1986
Metal, fabric, electronic components

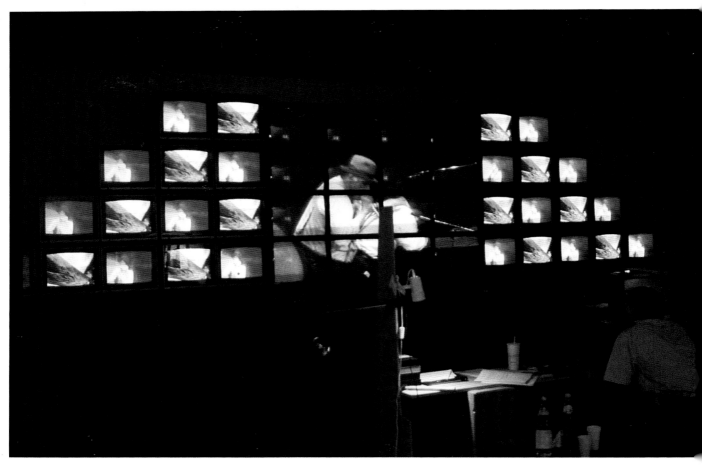

Nam June Paik, Korea
Beuys/Boice
1987
Video sculpture with 50 monitors
and 5 projectors
390×770×100 cm

Guiseppe Penone, Italy
Landscape with four
vegetable gestures 1987
4 bronzes, plants,
flower pots with soil

Eric Fischl, USA
Portrait of a dog (detail)
1987
Oil on canvas
286×434 cm
Museum of Modern Art, New York

Vitali Komar and
Alexandr Melamid, USSR
Winter in Moscow (reverse side)
1977
26 parts
Mixed media
Front side "Yalta"
366×1830 cm
Ronald Feldman Gallery, New York

Sculpture project

Münster

In the year of Documenta the town of Münster in Westphalia organized a rather special event. Fifty-six sculptors and painters were invited to change the face of Münster for three months with works on the theme of "Sculpture in public places". Fifty-six works—sculptures, environments and objects—completely transformed the town and led many to hope that sculpture need no longer serve as monument but that even now it could provide a form of aesthetic revival and help to relieve the sombre concrete buildings of our cities. There were two inspirations behind the project, the well-known exhibition organizer, *Kaspar König*, and the Director of Münster's Westfälisches Landesmuseum, *Klaus Bussmann*. The idea of asking artists to work within a specific building situation was one that paid off admirably here. Often, critics and visitors found Münster more exciting than Kassel, even though many artists were on show at both venues.

The artists invited to take part were all highly respected in the international art scene. There was some generation-overlap with *Keith Haring*, born in 1958 and internationally popular for his graffiti work, exhibiting alongside the classic among the Moderns, Italian artist, *Mario Merz*. *Richard Serra* from the USA was also there, along with *Daniel Buren* of France. As is now so often the case in most international shows, Buren was his country's sole representative. Switzerland was represented by *Thomas Huber*, born in 1955, who, like many of his compatriots, now lives and works abroad, having made his home in Düsseldorf. *Peter Fischli* and *David Weiss* from Zurich gave a sample of the inexhaustible imagination with which they lampoon the modern world. In an open space between a cinema and a sausage kiosk they erected a mini version of a vast administration building. Another source of amusement for the people of Münster was the object exhibited by Germany's *Thomas Schütte*, born in 1954. In the middle of a carpark stood his "Monument to Cherries", a pillar topped by large red cherries. Another sculpture that was a source of fun was a

play on an old Münster story, *Keith Haring's* "Red Dog for Landois", which was erected in the old zoo.

Richard Serra, who had previously received an angry reception in other parts of Germany, was once more a source of controversy. His two-part steel sculpture, erected in front of the baroque bailiwick's court built by the Westphalian architect *Johann Konrad Schlaun*, brought protests from the building's owners. Nevertheless this sculpture, which was in fact the most attractive work in the open-air exhibition and which, more than any other, set up a real dialogue with the historical architecture that surrounded it, was allowed to stay in place until the end of the exhibition.

The castle grounds provided the opportunity for a number of artists either to come to terms with nature or to take elements of the baroque castle as their source of inspiration and to give a topical interpretation of an historical monument. One such was the Dane, *Per Kirkeby*, who has for some time now been concentrating on sculpture in addition to painting.

It is not yet clear what will become of the temporary exhibition. The public response it enjoyed leads one to hope that many of the sculptures will be allowed to remain in the setting for which they were created, for conditions could not be better. At last a town would have "monuments" designed specifically for it, notwithstanding the bonus of acquiring an impressive collection of contemporary works. When could such an opportunity ever be repeated? That which eluded Berlin's "Sculpture Boulevard", has been achieved in Münster as public and contemporary art enter into a positive dialogue one with the other.

Thomas Schütte, Germany
Cherry column

Peter Fischli/David Weiss, Switzerland
House

Keith Haring, USA
The red dog for landois

Carl Andre, USA
Ground sculpture

Nam June Paik, Korea/USA
TV buddha for ducks

Ludger Gerdes, Germany
Ship for Münster

Images of Mexico
Mexico's contribution to
20th-century art

Frankfurt

While the retrospective of the best-known of all Mexican painters, *Diego Rivera,* was being shown in London as the last stage of its American-Mexican-European tour, a unique exhibition opened at the Schirn-Kunsthalle in Frankfurt. "Images of Mexico", pretentiously subtitled "Mexico's contribution to 20th-century art", was an attempt, not only to provide the first overview of Mexican painting ever staged in Europe, but also to investigate its place within the 20th century.

This year the Pompidou Centre staged an exhibition, already reviewed in this volume, of the 20th-century Japanese avant-garde, where we discovered that Japanese artists modelled themselves on the European avant-garde, often developing a totally un-Japanese style. As far as Mexico is concerned one can rightly claim that the country has made its own contribution to 20th-century art. Perhaps this is surprising when one considers that the élite of Mexican artists travelled to Europe and the United States to learn about and to study art. However, all returned home and began developing their own styles inspired by the artistic and cultural traditions of Mexico.

Mexican culture, born from Spanish and pre-Columbian traditions, and since blended into an independent culture, became, in the 20th century, a source of inspiration for a whole generation of artists. These were artists who were open to the influences of their own world of Mestizo and Indian stamp. Up to this point all Mexican art had been colonial art often with a congenial dash of Indian motives. It had no interest either in the ancient high culture nor in the country's distinctive folk art. It was only with the 1910 Revolution, which gave free rein to the national consciousness that had been awakened during the 19th century, that the way became open for a self-confident Mexican art, firmly rooted in its own traditions. This aesthetic revolution passed almost unnoticed in Europe, although we are familiar with the great triumvirate of Mexican art, *Diego Rivera, José Clemente Orozco* and *David Alfaro Siqueiros,* through works which are impossible to bring to Europe: their great murals. These Muralists who in the 20th century developed the art of wall painting founded by Dr Atl to its highest level, are mostly familiar to us through reproductions alone. The 1982 exhibiton at the Nationalgalerie in Berlin was one of the few exhibitions in Europe to show original works by these artists.

We tend to think that 20th-century Mexican art consists entirely of murals. This is a misconception corrected by the Frankfurt exhibition. It brings together over 200 easel pictures from 20th-century Mexico and also includes many artists who are almost unknown in Europe but who formed a fertile soil within the development of Mexican painting from which the country's art grew.

What then has been Mexico's contribution to 20th-century art? It is a contribution unique to the country, deeply rooted in the Mexican people themselves. It is a form of self-communication of those creative forces so long suppressed. The Revolution released forces in the artistic area too. It is a return to the gods, a return to Indian traditions and to the people who still make up the majority of the Mexican population, the South American Indians. But it is by no means a romanticized return to a restored Paradise. The reality of life, in all its brutality as well as its beauty, still remains an important leitmotif.

The individuality of Mexican artists has contributed to the varied nature of Mexican art. *Diego Rivera* aestheticized man and nature in his easel pictures. *Orozco* and *Siqueiros* followed their passionate natures so that their canvases explode with colour. In *Frida Kahlo,* who has become something of a cult figure since the exhibition's European tour, personal fate combines with traditional elements from her background. Another female painter, a contemporary of *Frida Kahlo,* was one of the exhibition's discoveries. It was the first time that a series of paintings by *Maria Izquierdo* was shown outside Mexico. In complete contrast to *Frida Kahlo* her work revealed the individual artistic viewpoint, which determined

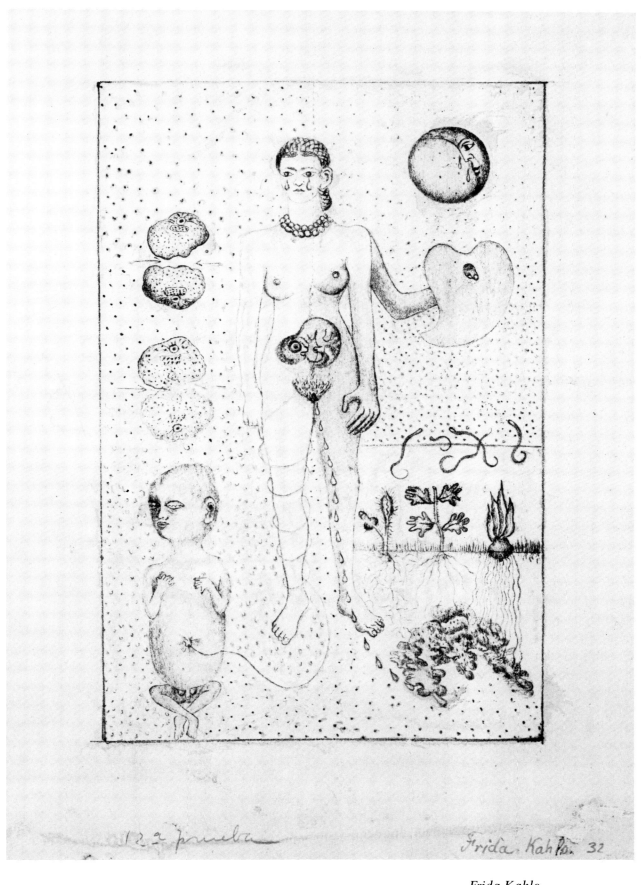

Frida Kahlo
Frida and the abortion, 1932
Lithograph
Private collection, USA

Maria Izquierdo
Ofreda
1943
Oil on canvas
60.5×50 cm
Galeria Arte Mexican
Collection, Mexico City

David Alfaro Siqueiros
El diablo en la iglesia (The devil in the church)
1947
Oil on canvas
219×156 cm
Museo de Arte Moderno, Mexico City

Ramon Camo Manilla
El Globo
1930
Oil on canvas
126×143 cm
Museo Nacional de Arte, Mexico City

the 20th-century art of Mexico. Most of the pictures were from private collections in Mexico and it will be a long time before many of them can be seen again. One of the real surprises was provided by the paintings of *Rufino Tamayo*, previously unknown until now even in Mexico, which transformed his Indian inheritance with a crystalline transparency. Along with *Francisco Toledo*, one of the young generation of painters, he is one of the greatest living painters in Mexico today.

The Mexican paintings were complemented by examples of folk art which occupies a central place in the life of the Indians and which is a frequent source of inspiration to painters. A collection of photographs extended the theme of the exhibition into the area of photography. Mexican photographers are arguably amongst the best in the world. *Manuel Alvarez Bravo* is the greatest of them all, but many of those who came after him have helped to give Mexico a foremost place in contemporary photography.

Olga Costa
Vendedora de frutas (Fruit-seller)
1951
Oil on canvas
195×245 cm
Museo de Arte Moderno, Mexico City

Maria Izquierdo
Mi tia, un amigo y yo, 1942
Oil on canvas, 138×87 cm
Private collection, Mexico City

Rufino Tamayo
Comedor de Sandias
1949
Oil on Canvas
99.2×80.3 cm
Private collection, Monterrey

Woman and Surrealism

Lausanne

There have been an amazing number of exhibitions on Surrealism recently. "*Paul Eluard* and his friends", an exhibition at the Pompidou Centre in Paris in 1985, formed a kind of prelude tackling the whole complex problem of Surrealism. Last year the same museum put on the wonderful exhibition "Explosante Fixe" which went on to London under the title "L'amour fou". The catalogue to this exhibition brought out for the first time the decisive part that photography played in the artistic experiments of the Surrealists. This year it has been the turn of Switzerland to stage a number of exhibitions on the Surrealist theme. The Ermitage in Lausanne showed a cross-section of *Magritte's* work. Geneva opened its doors to "Minotaure", an ambitious exhibition project celebrating the most famous Surrealist journal, "Minotaure", published in Geneva by *Albert Skira*. This exhibition was organized by the curator of modern art at the Musée d'art et d'histoire in Geneva, *Charles Georg*, who spent much time and effort in bringing together the original pictures which caused such an uproar when they were reproduced in the various numbers of the review that appeared between 1933 and 1939. The exhibition is to go on to Paris and will be discussed in more detail in next year's edition of Art-Expo.

In Lausanne the Musée cantonal des Beaux-Arts collected together material on a subject in which the artists of the Surrealist movement were passionately interested: woman, whom they idealized, demonized, anathematized, loved, worshipped. *Dalí* painted his wife not only as the Madonna but also as the suffering Christ.

The inspiration behind the exhibition was unusually wide. Not only were we given woman as seen by the Surrealists but also the women who played an active part in Surrealism, so that the exhibition had two parallel themes—woman as portrayed by painters, photographers, object makers and sculptors alongside the works of women who were themselves surrealist artists. Often they were married to Surrealist painters, writers or poets, but in every case they were close to them. They lived, worked and exhibited together. It was this unique creative atmosphere, inspiring the work of both men and women, that the exhibition attempted to reproduce.

Many important works were included: *Max Ernst, Picasso, Magritte, Dalí, Miró,* the forerunners of Surrealism, together with those artists that the Surrealists allowed into their Pantheon, *de Chirico, Picabia, Paul Klee* for instance, all were there to illustrate the theme. But possibly even more interesting was the fact that so many lesser-known artists were also included in the exhibition, artists who became known as the movement spread its roots further afield. There were collages by the painter-poet *Jacques Prévert* and *Georges Hugnet* to be discovered. *Marcel Jean,* a follower from the outset and the author of an important book on Surrealism, *Marc Eemans* an almost forgotten Belgian Surrealist, *Roland Penrose;* all names that belong to Surrealism even though one may find it difficult to connect them with specific works of art.

Of special interest were the female artists who were inspired to produce important art works by their meetings and dialogues with their partners. *Meret Oppenheim,* the Swiss artist who came across the Surrealists in Paris in 1932, had a liaison with *Max Ernst* for a time and who during this time created her famous "Déjeuner aux fourrures", a fur-covered coffee cup and saucer, was well represented with objects, paintings and drawings. Another of *Max Ernst's* companions was *Leonora Carrington* who emigrated to Mexico and has since been little seen in Europe. It was amongst the female artists that the main discoveries were to be made. Who in Europe knows *Kay Sage,* the wife of Tinguy, as a painter? *Dorothea Tanning* is recorded as having been *Max Ernst's* last companion, but it is a little-known fact that she too was creative. *Unica Zürn,* the wife of Hans Bellmer, is known both for her writings and paintings. But here "known" signifies "known to a dedicated narrow circle". It is only extremely recently that serious attention has been paid to her

artistic activities. The same is true of the Czech artist *Toyen,* who is overlooked by many books on Surrealism despite the fact that she was much admired by *Breton,* the inspiration and motivation behind the movement.

Photographs were also used to underpin the basic concept behind the exhibition. These authentic photographs help to recall the atmosphere in which the art of Surrealism developed. The exhibition was primarily an exhibition of works of art, but it also sought to conjure up what the followers of Surrealism were ultimately seeking—to be able to aim towards a new life, in which art was an important element but which aimed above all at changing living conditions. In this new life love, sentiment and eroticism in a continual game of sexual role-swapping played an important part. Surrealism was not an art style but a life style. And it originated in the credo embraced by artists, both male and female, of the Surrealist movement. They believed the promise made to them by *Apollinaire* who, as early as 1917, five years before the publication of *Breton's* first Surrealist manifesto, said that one should "remodel art and life in universal joy". It was also *Apollinaire* who coined the word "sur-réalisme". The definition of Surrealism —"the transporting of reality to a higher level"—is entirely in line with the sense in which *Apollinaire* used the word. The Surrealists not only lived "on the other side of painting" but also "on the other side of real life".

Man Ray, A l'heure de l'observatoire–les amoureux, 1936
Photograph, Ludwig Museum, Cologne, Gruber Collection

Max Ernst
Moon over Sedon
Kent Gallery, New York

Jane Graverol

Man Ray
Kiki
Photograph
Ludwig Museum, Cologne
Gruber Collection

Georges Hugnet
Le Catalan Restaurant, from the series
"Les Spumifères", 1948
Private collection

Marcel Jean
Profile of a woman
1936
Stephen Robeson Miller Collection,
Boston

Max Ernst
The garden of France (Le jardin de la France)
1962
Centre national d'art et de culture
Georges Pompidou, Paris

Jane Graverol
Crystal ball in a cave (Boule de Cristal dans une Caverne)
1964
Oil on canvas
81 × 100 cm
Isy Berachot Gallery, Brussels

Wilfredo Lam

Eugène Delacroix

Zurich – Frankfurt

In Zurich the exhibition was opened personally by the President of France, *François Mitterrand*, and was the highlight of the June arts festival, this year devoted entirely to French Romanticism. At the Städel in Frankfurt, the exhibition established a direct dialogue with the German Romantics which are well represented in the museum's collections. In neither city was the exhibition an isolated event. At both venues numerous exhibitions on the themes of Romanticism and 19th-century France prepared the public for their meeting with the greatest French master of the 19th century whose grandiose visions marked the beginning of modern art. He was a major inspiration to the generation that followed. *Cézanne* and *Monet* copied him; *Gustave Moreau* adopted his literary concept of painting and developed it into Symbolism. The term "Romantic" served as a starting point for this exhibition, thus raising the question of whether *Eugène Delacroix* was in fact a Romantic. Without doubt the young *Delacroix* was an adherent of Romanticism. It was he who created the key Romantic painting "Liberty leading the people" — a picture of the Revolution which echoes the mood of French Romanticism in a masterly way and which stands in complete contrast to German Romanticism as represented in painters like *Caspar David Friedrich* or *Runge*. These artists embody the main features of German Romantic art, inwardlooking, sentimental and ethereal.

Merely from these opposing concepts of the Romantic picture it becomes evident that Romanticism can be interpreted in various ways and that the term covers a variety of art forms. *Delacroix* in fact thought of himself as a Classicist. While publicly defending his Romantic contemporaries, *Géricault* or *Gros*, he disowned them in his private journal.

Harald Szeemann, responsible for selecting the paintings for this exhibition, sees *Delacroix's* work as "a monumental nostalgia for the comprehensive view, for a pact with the Ancients in which choice of subject matter is determined by a hierarchy of themes — contemporary themes for the easel pictures, mythological and religious themes for public commissions. It is his longing to be rooted in the Ancients and to see 'anew', that we have to thank both for his large-scale battle scenes painted for churches and palaces, but also for his smaller images of the Revolution, of the overthrow of an absolute monarch who took everything he loved with him into death, of the heroic struggle of the Greek people against the Turks, of imaginary scenes and lion-hunting, of the tragedy of Medea . . ."

Delacroix was a literary painter (for which he was criticized by *Cézanne*). The subject matter was the most important thing to him and when we think of his work it is the dramatic themes that first come to mind: the death of Sardanapalus, the massacre at Chios, Greece dying on the ruins of Missolonghi, the above-mentioned "Liberty Leading the People", and "The Barque of Dante", twice copied by *Manet*.

The exhibition also brought us much more intimate works: portraits, odalisques, genre pictures and of course the religious and historical scenes of his later years. The fact that *Delacroix* was first and foremost a gifted artist whose work, as *Walter Friedländer* once wrote in one of his essays, is "based on colourful and dynamic movement", was central to the exhibition. Ultimately the answer to the question of whether *Delacroix* was in fact a Romantic remains unanswered. He was, as *Th. Silvestre* wrote in 1858, "un peintre de grande race" with "sun in his heart and a whirlwind in his brain".

Rabelais, 1833
Oil on canvas, 186×138 cm
Ville de Chinon, on exhibition in the Musée des
Etats-Généraux

The Moroccan and his horse, 1857
Oil on canvas
57×61 cm
Szépmüvészeti Museum, Budapest

Médée furieuse
1862
Oil on canvas
122.5 × 84.5 cm
Musée du Louvre, Paris

The barque of Dante
1822
Oil on canvas
189 × 246 cm
Musée du Louvre, Paris

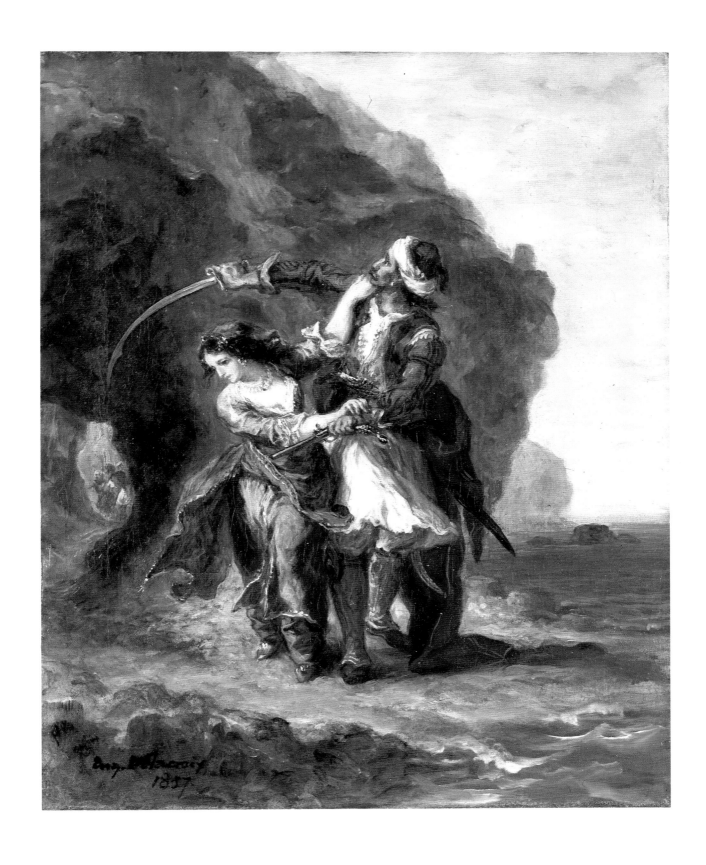

Selim and Zuleika, 1857
Oil on canvas
47×38 cm
Kimbell Art Museum, Fort Worth, Texas

Magic of Medusa
European Mannerism

Vienna

When *Werner Hofmann*, Director of the Kunsthalle in Hamburg, organizes an exhibition on a specific theme, one can be sure that he will not restrict himself to presenting a kind of thematic history of art compartmentalized either chronologically or stylistically. For his previous great exhibition cycles have shown how for him, in his own words, "Style is an insufficient basis around which to plan an exhibition". For this year's Vienna Festival he staged an exhibition which demonstrated his concept of what makes an interesting exhibition more clearly than ever before—an exhibition conceived on the lines of artistic and intellectual history. For this demonstration he chose an investigation of Mannerism in European art from its origins onwards. This was not an exhibition of Mannerism as a stylistic concept, which would have restricted him to the 16th century, but of Mannerist interpretation as found in artists of every century. He chose for this exhibition the promising title—"Magic of Medusa".

"Medusa" in fact enchanted the visitors who flocked to see it in their hundreds of thousands. *Werner Hofmann* had hit upon a subject which is one of the curiosities of art history. Mannerism is a theme that has been much in the air in recent times. The 1986 Venice Biennial included the "Wunderkammer" which was to prove the most successful show in the entire festival. Again in Venice, only a few weeks before the Vienna exhibition, the Palazzo Grassi opened its doors to the "Ecce Arcimboldo" exhibition. In addition to *Arcimboldo* a whole series of artists were represented in both shows.

What is Mannerism? The title of the exhibition explains it all. Medusa is a metaphor for an art form in which the beautiful is coupled with the ugly. Medusa, "of exquisite beauty" in Ovid's poetry, was ravished by brutal Poseidon for which she was punished by Pallas Athene who took her most beautiful feature, her hair—"for nothing

about her could equal the beauty of her hair"—and turned it into snakes. This much we learn from ancient legends. From this point on art becomes polarized into the beautiful and the ugly, both of which can become opposing or complementary aspects of a work of art. In this exhibition Werner Hofmann was portraying the "mythical picture of the uncertainty of beauty". For there is more to the story: for the loss of her beauty Pallas Athene, the goddess and protectress of the arts,

Antonio Fantuzzi
Nymphs bathing, 1543
Engraving, 26.3×19.2 cm
Print Room, Kunsthalle, Hamburg

gives Medusa a fatal power. Her gaze turned anyone she looked upon into stone. Perseus cleverly overcame her deadly power by approaching her with a mirrored shield so that the Gorgon, Medusa, gazed upon her own image. At this moment she was beheaded and her face, showing all the fear of death, was preserved for ever in stone.

The artist emulating Perseus can capture Medusa's image for all time. The image of Medusa was an artistic theme as long ago as *Leonardo*. But more significant still is the problem that Medusa embodies—the ambivalence of beauty and ugliness, of nature, and anti-nature, of art and kitsch. This is the main theme of the exhibition; and the extremely complex catalogue which runs to over 600 pages seems likely to stand as the standard work on Mannerist trends in European art for generations to come.

The Mannerist vision negates the artistic ideal of classical beauty of Greek art. Every type of Mannerist beauty, that is, what nature pretends to be beauty, alters the concept of what beauty is. At the moment when such breakthroughs in the interpretation of art become possible, barriers are also lifted and there are no longer any restrictions on art's handling of ugliness as though it were beauty and the adoption of art forms which had not previously figured in the European artistic vocabulary. The Mannerist way of looking at things therefore alters one's perception of art, extending it into areas of the imagination which would have been unthinkable but for Medusa. It goes without saying that, but for this change in the way art was viewed, the development of 20th-century art would have been impossible. Would Surrealism have been possible without this freedom of vision? What would have happened to Füssli, Symbolism or Art Nouveau if Medusa had not been punished by Pallas Athene?

Based on this specific theme, the exhibition, with its 600 pictures, objects and pieces of applied art, demonstrated the presence and history of Mannerism as a concept of consciousness rather than a stylistic phenomenon. No one could take exception here to the bringing together of *Peter Paul Rubens* and *David Hockney*. Art history was coalescing with art—and in this the exhibition can be said to have achieved the most that one can ask of any exhibition, an achievement that one comes across all too rarely.

The exhibition was a lesson in art history par excellence. It renewed our acquaintance with major works while placing them within a new context. In compiling the exhibition *Werner Hofmann* was guided by two figures from Roman mythology who embody opposing concepts: Mars the

god of war and Venus the goddess of love. This surrounded the visitor with an electric field of dialectic conflict and provided a leitmotif that spanned the centuries. The world of the ruler, the leader, the man of violence, contrasted with the "feminine" aspect, with the triumph of the arts, with the portrayal of the goddess of love. Here erotic, though godlike, liaisons lead on to the duality of the artistic principle, a duality which is admittedly fictional and ultimately has its being in artistic form. Mannerism as the art of artistic consciousness—message received and understood.

Urs Graf
Jester and prostitute with a child, 1523?
Pen and ink drawing, 18.6×14.9 cm
Print Collection, Basle

Hans von Aachen
Bacchus, Ceres and Cupid
c. 1600
Oil on canvas
163×113 cm
Kunsthistorisches Museum, Vienna

Joseph Heintz
Diana and Actaeon
c. 1590–1600
Oil on copper
40×49 cm
Kunsthistorisches Museum, Vienna

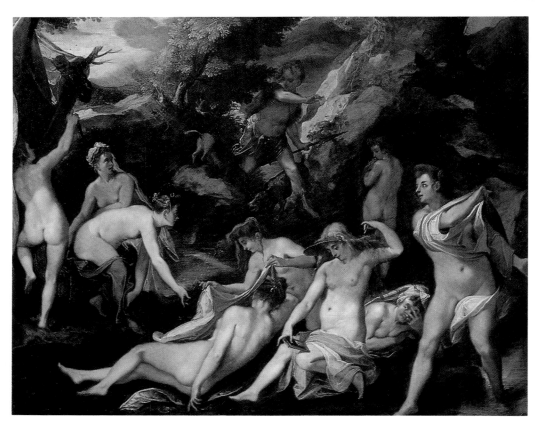

Maerten van Heemskerck
The erection of the bronze serpent
1549
Oil on canvas, 100×66 cm
Private collection, Amsterdam

Frans Floris
The Last Judgement
1565
Oil on canvas
164×220 cm
Kunsthistorisches Museum, Vienna

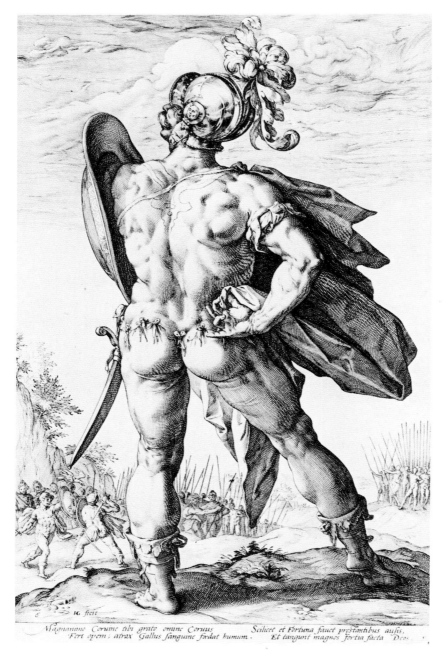

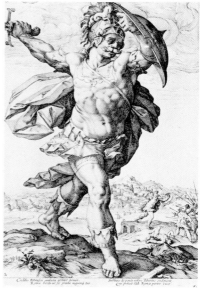

Hendrik Goltzius
Marcus Valerius Corvinus
1586
Engraving
35.5×23.3 cm
Staatliche Museen der Stiftung
Preussischer Kulturbesitz, Berlin
Print Collection

Hendrik Goltzius
Horatius Cocles
1586
Engraving
35.7×23.5 cm
Staatliche Museen der Stiftung
Preussischer Kulturbesitz, Berlin
Print Collection

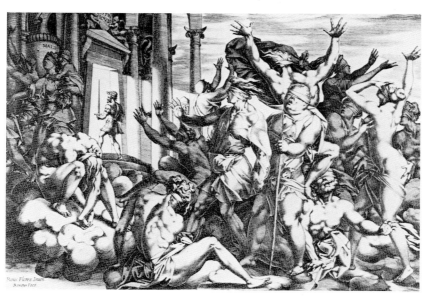

René Boyvin
The pursuit of ignorance
after Rosso Fiorentino
Engraving
27.8×42 cm
Albertina, Vienna

French
c. 1600
Mars and Venus
Bronze
Height 51 cm
Herzog Anton Ulrich Museum,
Braunschweig

Italian?
2nd half of the 16th century
Bronze
Height 32.5 cm
Städtische
Galerie
Liebighaus Frankfurt

After Giambologna
Astronomy
or Venus Urania
Bronze with black lacquer
Height 34.5 cm
Stiftsmuseum Chorherrenstift
Klosterneuburg

Studio of Giambologna
Nessos and Dejanira
Bronze, black lacquer
over red varnish
Height 44.5 cm
Kunsthistorisches Museum, Vienna

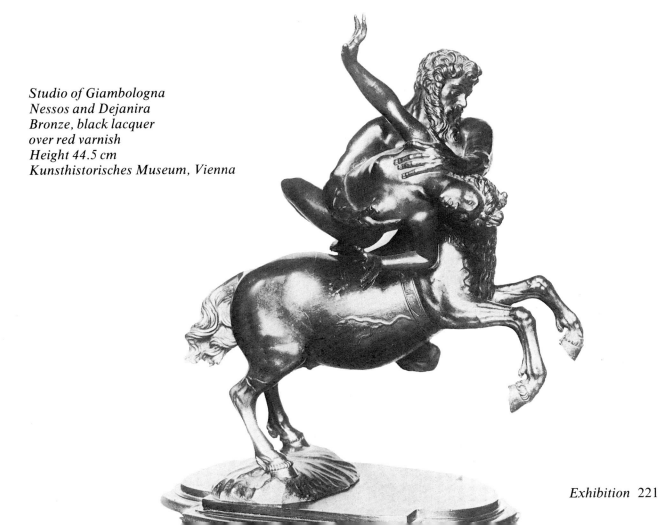

Gustav Klimt
Pallas Athene
1898
Oil and gold on canvas
75×75 cm
Historisches Museum, Vienna

Ernst Fuchs
Perseus and the Nymphs
1976–8
Mixed media
100×43 cm
Property of the artist

Alfred Finot?
*Table lamp in the figure
of a naiad*
c. 1900
Silvered brass, shell
Height 9.8 cm
Private collection, Basle

Anton Lehmden
Image of war
1954
Oil on wood
73×92 cm
Museum Moderner Kunst
Vienna

Paul Delvaux
Gaiety
1970
Oil on wood
122×152 cm
Groeningemuseum, Bruges

Jacques Bellange
The three Maries at
the sepulchre
Engraving
44.5×29 cm
Albertina, Vienna

Jacques Bellange
Adoration of the Magi
Engraving
60×43 cm
Print Room, Kunsthalle Hamburg

Albert Paris Gütersloh
Salome's dance
1923
Watercolour with masking fluid
Private collection, Vienna

Albert Paris Gütersloh
In the labyrinth of love
1960
Gouache
15×17.4 cm
Private collection, Vienna

Leo Putz
Girl in the mirror
c. 1902
Oil on wood
55.3×26 cm
Städtische Galerie
im Lenbachhaus, Munich

Gustav Adolf Mossa
The satiated siren
1906
Oil on canvas
81×54 cm
Musée des Beaux-Arts

Francis Picabia
Four Spanish ladies
1924
Oil on canvas
101×86 cm
Brusberg Gallery, Berlin

Victor Prouvé and René Wiener
Book cover for Flaubert's "Salammbô"
Watercolour
42.1×35.3 cm
Musée de l'Ecole de Nancy, Nancy

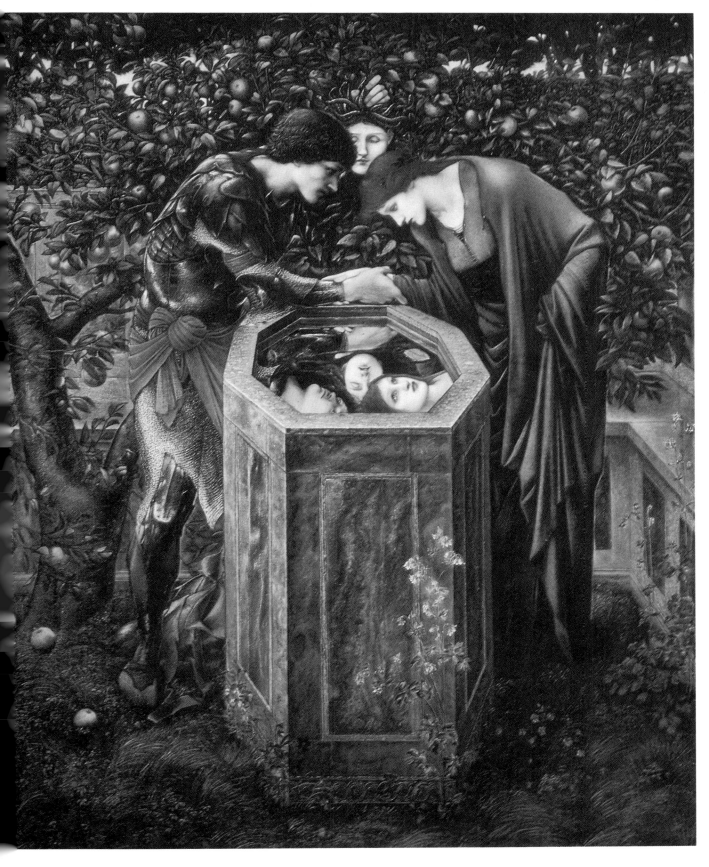

Edward Burne-Jones
The baleful head, 1887
Oil on canvas
155×130 cm
Staatsgalerie, Stuttgart

Rudolf Hausner
Large Laocoon
1963–7
Tempera and resinated oils on canvas
200×184 cm
Private Collection, Vienna

Ernst Fuchs
The Antilaocoon
1965
Pencil on chalk ground with fabric
and paper
200×150 cm
Property of the artist

Rudolf Hausner
Aporic ballet
1946
Tempera, resinated oil on board
53.5×105 cm
Property of the artist

Kurt Seligmann
Large waters
1946
Oil on canvas
Carl Laszlo Collection, Basle

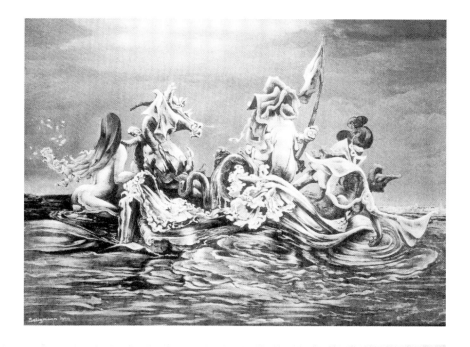

Dorothea Tanning
Of what love
1970
Fabric, fur, metal
Musée National d'Art Moderne,
Centre Pompidou, Paris

Werner Tübke
On the shore of Ostia II
1974
Mixed media on wood
91×65 cm
Property of the artist

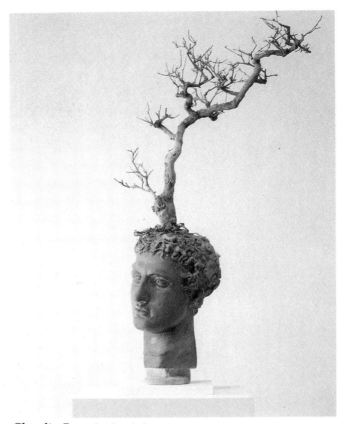

François Rupert Carabin
Armchair
c. 1900
Wood, iron
120×66×70 cm
Musée d'Art Moderne de la Ville de
Strasbourg

Claudio Parmiggianini
Alchemy
1982
Painted plaster, twig
Height 90 cm
Liliane et Michel Durand-Dessert
Gallery, Paris

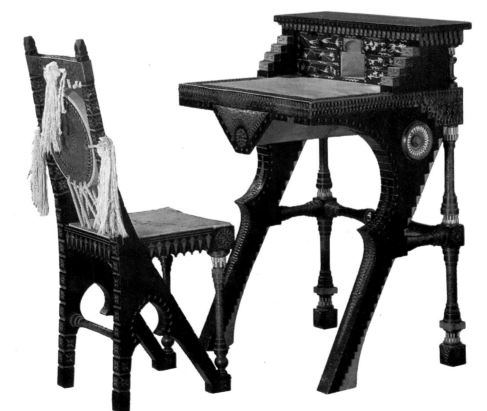

Carlo Bugatti
Lady's desk
with chair
c. 1895
Museum für Kunst
und Gewerbe,
Hamburg

Paul Wunderlich
Aurora (Homage to Runge)
1964
Oil on canvas
160×130 cm
Kunsthalle, Hamburg

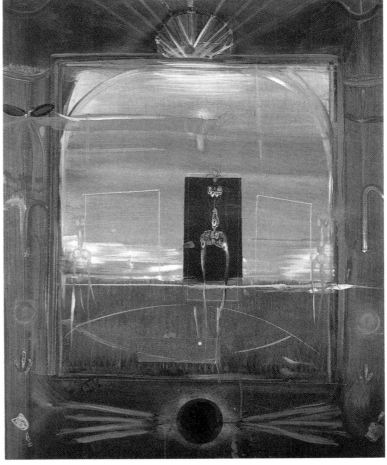

Max Ernst
Triumph of love
1937
Oil on canvas
54.5×73.5 cm
Private collection, Hamburg

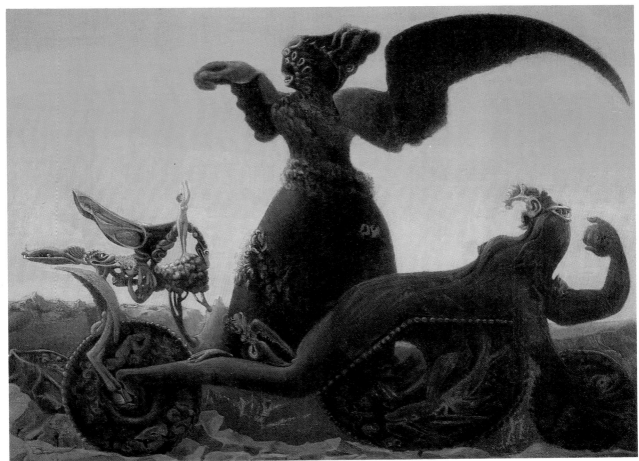

A great man dies: Andy Warhol

On 22 February 1987 *Andy Warhol* died at the age of 58. The world caught its breath—one of its great stars was dead, an artist who was more than a painter or a stager of happenings. He was the image of an entire generation and in him was personified the lifestyle of the young. He had seemed

Andy Warhol, 1978

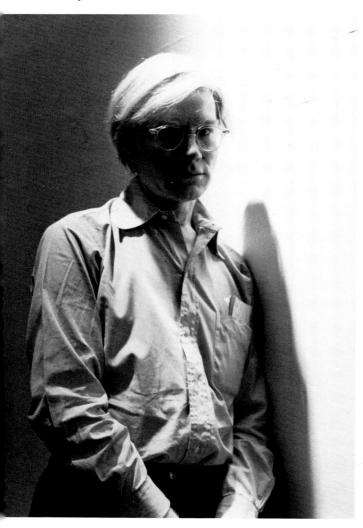

immortal behind his own image through which, and for which, he lived. His art encompassed his life, the public and his stardom. Though approaching 60 he wore the mask of eternal youth. What has he left the world, now the poorer for the death of one of its truly innovative artists? What will become of his factory where, with a group of associates, he organized all those things that contributed to his idea of art-making: paintings, silkscreens, films, literature, the magazine "The Interview", his management of the rock group Velvet Underground and his commissions as high-society portrait painter. Here, like any industrial magnate, his telephone never stopped ringing. In this respect *Andy Warhol* was an artist like no other.

He was the most popular of all the artists of his generation. His name is well-known even to people who have no connection with contemporary art and for a whole generation he is still the embodiment of Pop Art however one defines it. His work and his personality could not be ignored. Even those who vehemently disliked him could not help but agree with his admirers that he was one of, if not *the,* leading actor on the art scene since the Sixties. In scarcely any other artist are the man and his work so closely linked. His art was a development of his life and his lifestyle was based on the artistic, motivated by what *Walter Muschg* in his "History of Tragic Literature" calls "fame", not simply personal fame but the fame enjoyed by artists. Artistic success is a path towards "honour, enjoyment and power ... Every age has its celebrities who gamble with high stakes and who win. They know how to make themselves appear interesting and can exploit the interest in their person to further their career until they are internationally acclaimed and covered with all the honours the age has to bestow". (*Walter Muschg*) This striving after success is common to many artists, but not all succeed in reaching the top. *Warhol* is one who made it. One can say of him what was said of Voltaire: "For him mankind consists of those who admire him and others whom he

leaves cold or repels." Success follows "the laws of mass psychology. It does not depend upon any powerful idea that changes the world or any world-shattering deed. It is no more than a rumour, living and growing on hearsay alone. Since the world is always grateful for something new to talk about, it is not difficult for a clever man to focus attention upon himself for a moment. The thing is to take advantage of this moment, to repeat it as often as possible and to heighten its effect." All of this applies to *Andy Warhol* who said himself: "everyone ought to be famous for five minutes of his life". He was famous for twenty years. His fame came not from his work alone but from his personality and is part and parcel of his charismatic lifestyle. It is no accident that in this book, as in all previous works about *Warhol,* the text and reproductions of his works are accompanied by more photos of *Warhol* himself than would be usual or even possible with other painters. No other contemporary artist was photographed as much, no other face appeared as frequently in newspapers, magazines and on television as that of this reserved, shy-looking young man with the white or silvery hair. For the curious it was not enough to be able to look at *Warhol's* work. People wanted to see the man himself. His image became the property of the media. The masses had as much a right to him as they had to the stars that he often painted. Today he is almost as popular as the stars whose photographs filled the world's press and whom he turned into art: *Marilyn* and *Elvis, Liz Taylor, Jackie Kennedy* and *Marlon Brando.* He himself became as much a superstar as those he portrayed; often people seeking the public eye and wanting to be seen as part of his artistic personality. He gave the public what they wanted, satisfying their demands to share his life and enter into his personality. The innumerable gossip columns in which he appeared, the countless TV films that were made about him, the thousands of photos that spread his image around the world, all went into creating the myth of *Andy Warhol,* but as Goethe said, "a person becomes famous because the stuff of fame is in him." His early exhibitions in Los Angeles and New York both shocked and fascinated. As early as 1962 *Lawrence Alloway* gave a seminar on Campbell's Soup Cans at Bennington College. In 1976 two dissertations were published on the work of Warhol, *Rainer Crone's* "Andy Warhol—the pictorial work" in Berlin and *Lawrence St. Johns'* "A Radical Theological Study" at the University of Berkeley. Here too is a sure measure of success! *Andy Warhol* the commercial artist had become a painter.

He was also a film-maker, putting as much, if not more, effort into this as into his art, and he had yet other interests. In 1965—6 we find his name mentioned in connection with Velvet Underground, the rock group he made famous. It was for them

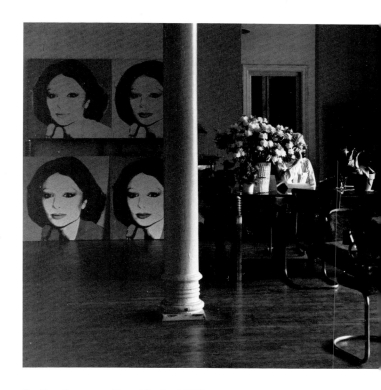

In the Factory, New York, 1978

that he opened the Erupting Plastic Inevitable discotheque in St. Mark's Place, East Village. It was here that he staged the first multi-media shows in New York, using music, light, dance and film simultaneously to surround the visitor with a complete sensual experience. *Warhol* was searching for the total work of art. While the happenings staged by the Pop artists of the time came close to his, *Warhol* was after something more, something that would involve all the senses. What he achieved was an enormous assemblage of events which heralded a new type of entertainment. "Eat" was put on here, as well as "The Couch or Banana" and "Harlot". *Gerard Malanga* and *Mary Woronow* danced. *Warhol* worked the projector himself and was present every evening at every performance. Erupting Plastic Inevitable went on tour in America and he went with them. In Detroit he handed out bananas and paper birds 'as an invitation to get high". With his fame as an artist established, he designed record sleeves for Velvet Underground, the Rolling Stones, Count Basie and Paul Anka. He did cover designs for "Esquire" and "Time" magazine and in 1966 designed the first case for "Aspen", a hard-cover magazine on art and the art world.

He wrote a column in "Kiss", a pornographic magazine produced by artists. In its lay-out it can be considered as the forerunner to *Warhol's* own magazine "Interview", first published in 1969 and devoted to the cinema. It began as a true film magazine but now presents famous personalities from many walks of life. He made an advertising film

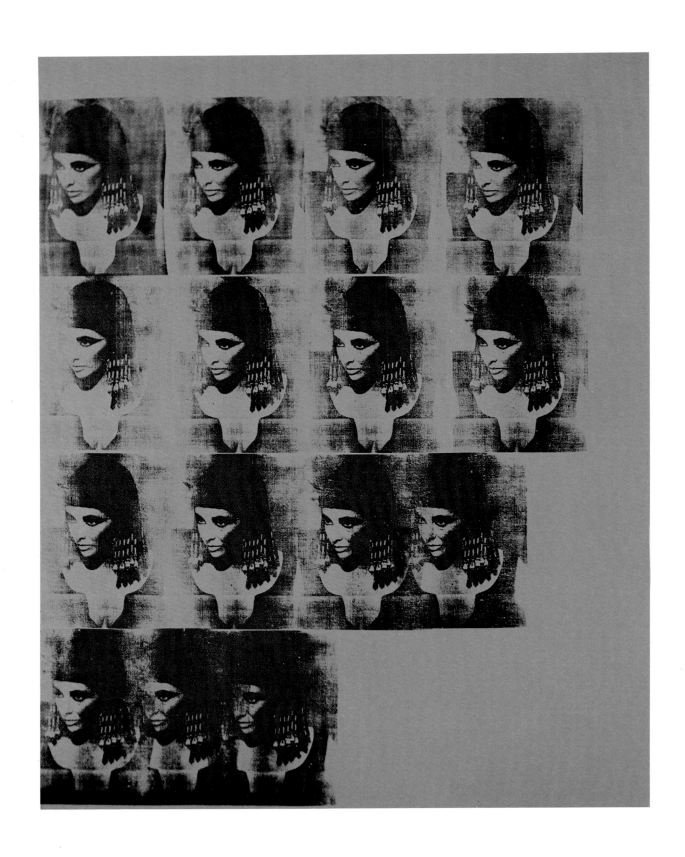

Liz as Cleopatra
1962
Silkscreen
182.9×152.4 cm
Private collection

for Shrafft and in 1969 designed the advertising for Braniff airline. He wrote a novel, "a", recorded unedited on tape at the Factory, as prosaic as a court record, authentic and direct, like the photographs on which he based his silkscreens. Finally he formulated his own personal view of the world in "The Philosophy of Andy Warhol". Is there anything that *Andy Warhol* has not turned his hand to? He collected folk art and attractive stones and furnished the Factory with Art Deco, with Ruhlmann and Bugatti. But what is this Factory?

It is one of those fantastic inventions which seem to characterize his life. It is the decision not to have his own studio but rather to bring together friends and others of like mind to form a factory where art is manufactured. Naturally *Warhol* is the initiator and animator of its products, but production is a joint effort. Images which he has made into silkscreens are painted by members of the Factory, for he believes that no one need have his own style and his greatest wish is for everyone to be able to do everything. How far this idea has been followed in his most recent work is open to debate, but the pictures of the Seventies appear to be much more *Warhol's* own personal work. In many years the Factory produced over one thousand pictures. *Rainer Crone* has listed them all in his book, "The Revolutionary Aesthetic of Andy Warhol". 1964, the year of the flower pictures, was one of the most fertile of all. 1,002 flower paintings alone left the Factory that year. What has become of them all? Of the hundreds of Brillo Boxes produced that same year only three were available for the Zurich exhibition. The few that we have in Europe (Ludwig Collection) were too fragile to travel.

But back to the Factory. With *Warhol's* interest in film-making, it was from the outset a film studio — its first production was "Kiss" in 1963 — with every member of the Factory involved. In the Sixties the "closed circle" around *Warhol* included intellectuals from the New York Underground. *Paul Morrissey* was a film-maker and was head of the Factory. *Ronald Tavel* was a writer and his script-writer. *John Wilcock,* the founder of numerous Underground magazines and publisher of "Other Scenes" (an Underground magazine first published in 1967 and dealing in its own way with art, cinema, photography, pornography, sociology and politics) was another member of the team. One of the most interesting was *Gerard Malanga,* a writer and film producer. He worked closely with *Warhol.* His book "Chic Death" was both inspired by *Warhol's* disaster pictures and illustrated with them. In co-operation with *Andy Warhol* appeared "Screen Tests / A Diary" of 1967 and an anthology of Underground literature "Intransit the Andy Warhol-Gerard Malanga Monster Issue". His book "Self-portrait of a Poet", published in 1970, has much in common

Brillo Boxes
1964
35.6×43.2×43.2 cm
Private collection

Nancy
1961
Ink on cardboard
122×122 cm
Private collection

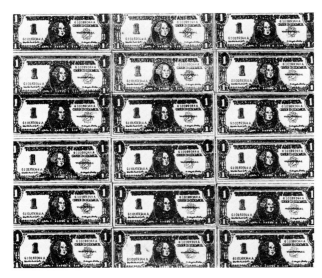

One Dollar Bills
1962
Silkscreen
61×76 cm
Ströher Collection, Darmstadt/Frankfurt

with the climate created by *Andy Warhol* and his Factory. Despite his enormous public success and "fame", this close relationship with this famous Underground literary figure makes *Warhol* an important figure in the Underground of the Sixties—and any future publication or exhibition on *Warhol* will need to throw light upon his central position amidst the Underground. Other permanent members of the Factory included the Superstars as he christened them: not people who had been made into stars by the cinema but for whom stardom was an accepted attitude of life. People who saw life as role-playing, who narcissistically lived out their wishes and concepts of life and who gave real substance to the cliché invented by the cinema. Among them was *Mario Montez* who had already been turned into a star by *Jack Smith,* the first great Underground film director who had been a great inspiration to *Warhol* in his film-making. In the Factory he became a Superstar, along with *Viva* and *Ingrid* and *Valerie Solonis* who in 1968, in her anger and frustration at *Warhol's* domination over her, shot and seriously wounded him. This was another aspect of the lifestyle. For a moment the great Pop artist became an involuntary actor in a highly dramatic scene which almost cost him his life. *Avedon* recorded his scarred body for posterity. The world was invited to join in the drama. The world press reported it. Whose fault had it been? When one

discusses *Andy Warhol's* pictures one cannot ignore this backgrond. For they are part and parcel of the creative processes that define these people. Who is to judge whether or not his art is more important than his commitment to Velvet Underground? Both are part of the world with which *Andy Warhol* surrounded himself and which covered every aspect of his life: his attitude to the world around him (for who knew who *Andy Warhol* really was when he was alone at home with his two dachshunds), his artistic work from his paintings to his film-making, his writings, his participation in everyday American life as depicted in his now historic "picture cycle" of the Sixties.

Andy Warhol worked during the Fifties as a designer and at this time was producing drawings inspired by naïve art, folk art and popular art, but in 1960 he produced his first painting. From the outset his professional training as an advertising designer remained relevant to his work. He drew and painted advertisements and advertising brochures, cans, Coca Cola, and an advertisement for nose operations "Before and after". There were comic strips too which he lighted upon quite independently from *Lichtenstein,* but which he immediately abandoned when he saw *Lichtenstein's* pictures and realized that *Lichtenstein* had reproduced the style of the comic strip better than he. Then came the do-it-yourself pictures, the

Dance diagrams and the first Soup cans. Hand-painted, it must be stressed.

Sometime in 1962 *Andy Warhol* turned to the silkscreen and from then on painted no more pictures by hand, which in itself was nothing new. It has been recognized since *Duchamp* that art does not necessarily have to be hand-made. The age of the reproducable art work—now handled in a completely different way from any *Benjamin* could have imagined—had arrived. Reproducability not in the form of a reproduction, for *Andy Warhol's* picture is itself the reproduction, but in the form of unlimited production such as the silkscreen technique facilitated. From this point on photography became an important artistic source for *Andy Warhol*.

He began to specialize, was no longer satisfied with using any old reproduced image, be it an advertisement, the front cover of a magazine, or the design of a paintbox, but began to chose his subject matter very carefully. He took the press photo, the image of mass communication which is the most widely seen of all, reaching the whole world.

At the same time he chose the most anonymous of photographs, looking not for famous names but interested only in the subject matter. He read newspapers and illustrated magazines, looking at the pictures. And he saw labels on cans which he turned into pictures, and hoardings advertising not people but human objects. All these came together to form one enormous unified whole, to give a pictorial world in which *Monroe* was interchangeable with a soup can and in which the electric chair was as beautiful and as uncontroversial as the flowers in a nondescript photograph in a magazine. *Warhol* created a world of absolute equality of content and value. He created a world from which the individual has disappeared and in which he, *Warhol* himself, in his self-portraits is no more than a mask created by the picture industry. He did not exclude himself from this consumer market approach to art. He made it his own and painted himself in the same matter-of-fact way as *Monroe* or *Liz*. With no signature. With no individual style. He wanted no individuality. And yet every picture bears the handwriting that he wanted to efface. The originality lies in the choice of image. For *Warhol* the creative act is choice. And this is a viewpoint that takes him beyond the Pop Art scene into the area of conceptual art. For him the act of selection, the idea that leads to it, is more important than the art work itself. That is why he can be content to reproduce the chosen photograph in silkscreen and then let anything happen to it, for the act of creation has already taken place. The ability to select from thousands of pictures the one that has "power", the one that puts an image across, is without doubt one of *Warhol's* most creative gifts. The strength of the image is confirmed in his pictorial world

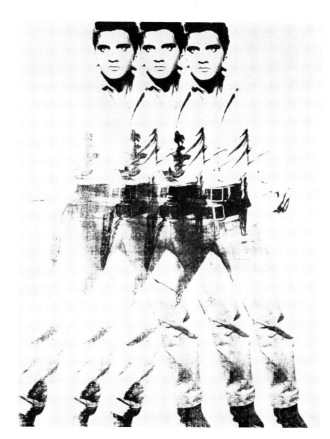

Elvis
1964
Silkscreen
208.3×152.4 cm
Private collection

and its impact on the real world. *Warhol* no longer manipulates photography. He uses it as he finds it. He does not choose details, fragments added to painting like many of his Pop Art contemporaries, but he enlarges the photo he sees and uses it to get his message across. In this type of treatment of photography he anticipated photo-realism. The photo-realists projected a slide on to a screen whereas *Warhol* enlarged the photographic image and reproduced it in silkscreen. They are two different technical processes which produce the same result.

Amongst the themes that *Warhol* treated—and these were few in number — when he was not fobbing the public off with his cans and Cola bottles, he returned repeatedly to images connected with death. With the morning newspaper the daily accounts of disaster and tragedy land on our breakfast tables, usually accompanied by a press photo so that even the illiterate cannot escape

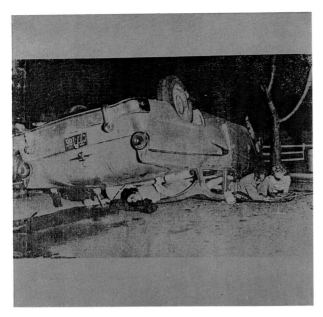

Orange Disaster
1963
Silkscreen
76.5×76.5 cm
Private collection

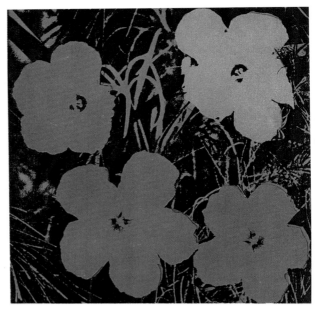

Flowers
1964
Silkscreen
61×61 cm
Private collection

their impact. A road accident, a suicide, a nuclear explosion—all are news. *Warhol* has isolated them for us from the everyday context of the newspaper, taken them out of context and hung them on the wall. There they are hanging in museums, dining rooms and drawing rooms. They were disturbing enough as newspaper photos, but now they are blown up and beautified with additional colour. Maybe they lose some of their gruesome directness in the process but they provide a new visual awareness. The image of the car crash and the woman jumping out of a window—*Warhol* apparently came across the photo snapped by an alert reporter in "Esquire", his favourite illustrated weekly of the Sixties—now remain fixed in our consciousness. And also his "13 most wanted men" which he took from photos on police posters displayed in every post-office in America—criminals, but at the same time, men.

Warhol was fascinated by *Jackie Kennedy* during the most dramatic moments of her life. Her photographs went around the world. *Warhol* caught her at the time of the death of *John F. Kennedy* when the eyes of the world were upon her, using a human countenance to portray a historical event. Many portraits were painted after the death of the subject. *Marilyn Monroe* was already dead when

she first interested him although her face still smiled disturbingly down from the cinema posters. "Every photograph is a kind of memento mori. Taking photographs means entering into the mortality, vulnerability and inconstancy of other people (or things). The very fact that you use photography to seize a moment and fix it in time means that many photographs reveal the relentless passing of time", writes *Susan Sontag. Warhol* has created one such memento mori. No other photo of *Marilyn Monroe* stays in the mind to the same extent—an empty photo from a cinema poster has conquered time by being turned into a silkscreen and coloured, as *Warhol* coloured all his portraits. *Liz Taylor's* familiar smile was painted at a time when the actress lay dangerously ill. It is once more a hommage to death, death which was so central to his life. But, like all *Warhol's* silkscreen pictures, they have an almost merciless realism. They should not make us weep. Emotion is not what the artist wanted.

Marilyn Monroe
1964
Silkscreen
101.6×101.6 cm
Private collection

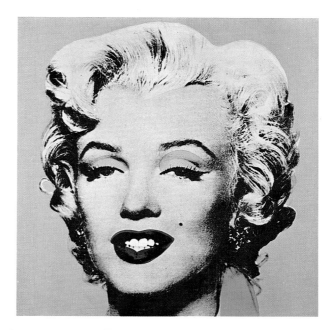

Self-portrait
1966
9 panels/Silkscreen
57.2×57.2 cm
Private collection

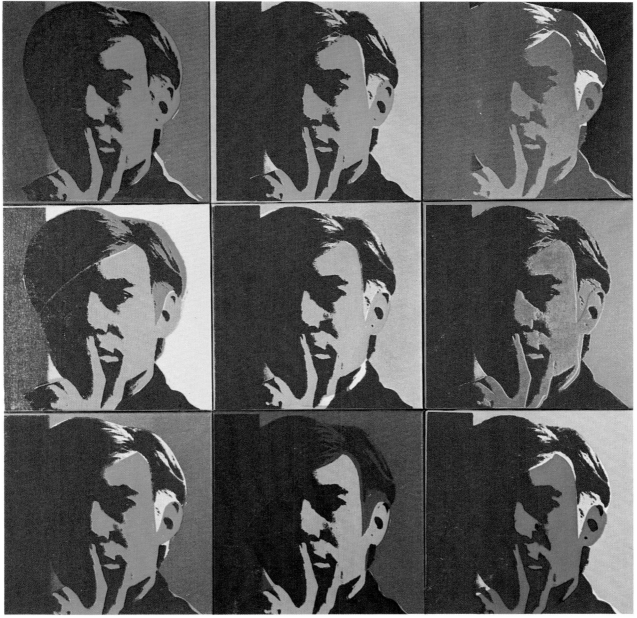

Jim Dine

In *Edward Lucie-Smith's* book "Movements in Art since 1945" which, on its publication in 1969, was one of the first attempts to analyse and historically define art from 1945 to Pop and Minimal Art, *Jim Dine* is classed with *Claes Oldenburg, James Rosenquist, Roy Lichtenstein* and *Andy Warhol* as one of America's foremost pop artists. Now, twenty years on, one would be reluctant to describe him in this way. Naturally, his earliest works from the beginning of the Sixties showed the same effects as the work of a whole generation of Pop artists and which were often referred to as Neodadaism: assemblages of consumer objects on the canvas or reproduced in paint. As a stager of happenings he was again following the pattern of Pop Art. It was he who staged one of the first happenings to make history as early as 1960, his now legendary "Road Accident". In this performance the visitor entered a small room full of chairs. On the walls were hung paintings and drawings. Rolls of cork, felt and linoleum were suspended from shelves. Metal pipes and wooden batons leaned against one wall. On the ceiling were stuck red, white and silver cardboard crosses, a motif that is echoed in the paintings. Behind lengths of gauze a girl sat on a ladder. *Jim Dine* himself appeared in a silver-sprayed raincoat, with a silver bathing cap and silver-painted face. Thus attired, he set in motion a twenty-minute happening which was later to inspire a whole series of happenings and Off-Broadway shows. With events like this he was clearly part of the Pop scene. And yet, if one considers his paintings independently of the assemblages with which they reinforce their Pop image, one is surprised by their outstandingly artistic quality. And so I asked *Jim Dine:*

EB: How do you see your work today in the light of your association with Pop Art?

JD: They were my friends, those artists who lived in New York at that time, and we all used similar objects. At a first glance everything seems to be related. But I was never really interested in glorifying the every-day, the "pop culture" of our time.

From the outset I was really only interested in painting which I saw and still see as a long and difficult process. I became famous very young, I was only 25. That did not really help me achieve my ambitions. To be famous means always to have to join in the trends of the time. I wanted to learn to paint not to embody the avant-garde. My friends loathed Abstract Expressionism and always worked as a form of protest. I have always been interested in the work of *De Kooning* who for me is the greatest painter of his generation. But to me *Rothko* or *Clifford Still* were respectable painters too. So, from the very beginning I have always been on the side of painting.

EB: It must be very strange for a painter who is still young—you are now in your mid-50s—to be able to look back on a "classic" period. For the art of the Sixties has now become a historic epoch.

JD: Those years were difficult for me. Continually having to be at the beck and call of the public interfered with my ambition to be a painter. I was like an athlete who always had to have something to offer. Then in 1967 I escaped to Europe, I was able to retire from the world. It was as if I had come from the backwoods. I discovered the Louvre. I was 30. There as an American I saw Courbet's "Studio". And I had always been told that *Pollock* paints big canvases. Suddenly one comes to realize the magnificence of European painting. *Géricault, Delacroix*—they both painted much bigger pictures than *Pollock*. My first visit to the Orangerie with *Monet's* waterlilies was an experience I will never forget. It was then that I realized what painting is and from that time on I have had only one thought in my head: to belong to the tradition of the great painters.

EB: Was the experience perhaps rooted in the fact that you suddenly discovered, or should I say uncovered, your European roots?

JD: It was as if I had arrived somewhere. My

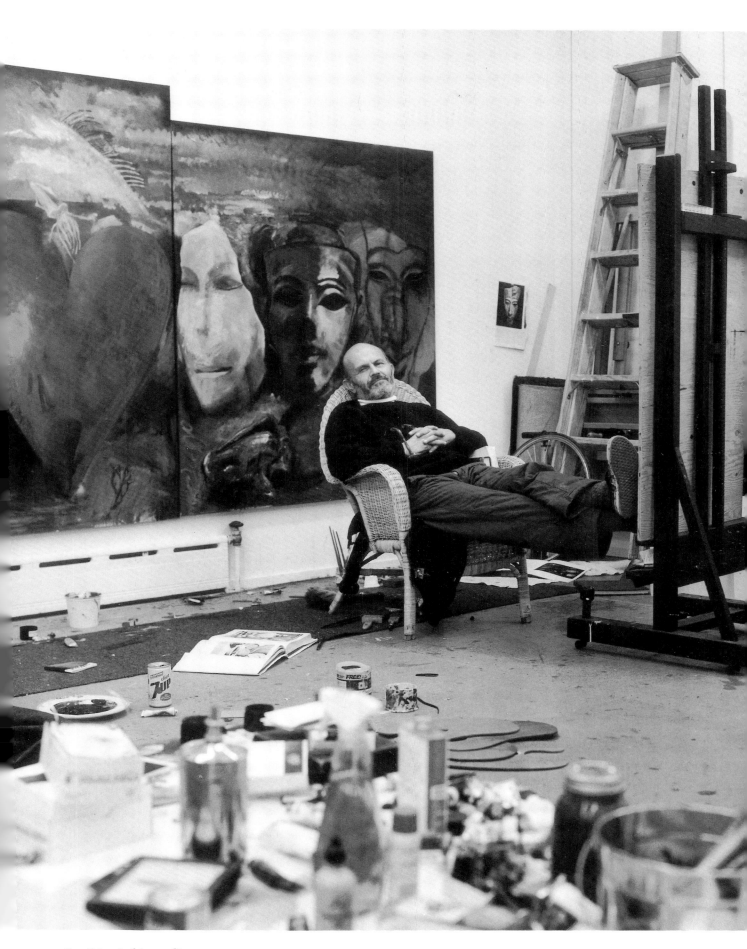

Jim Dine in his studio

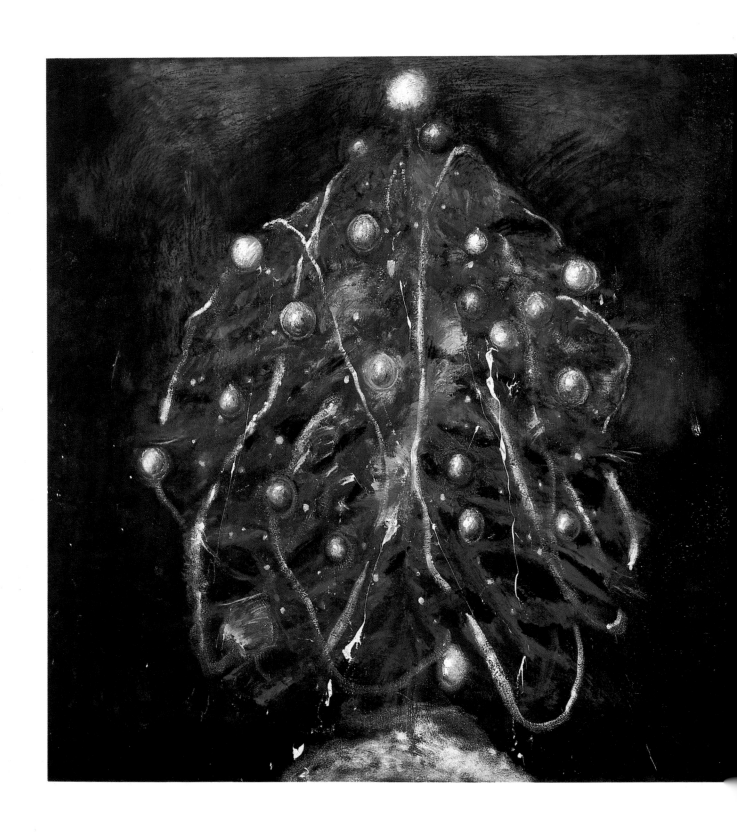

A blossom in the fields
1985
Oil on canvas
200.6×200.6 cm
The Pace Gallery, New York

242 *Interview*

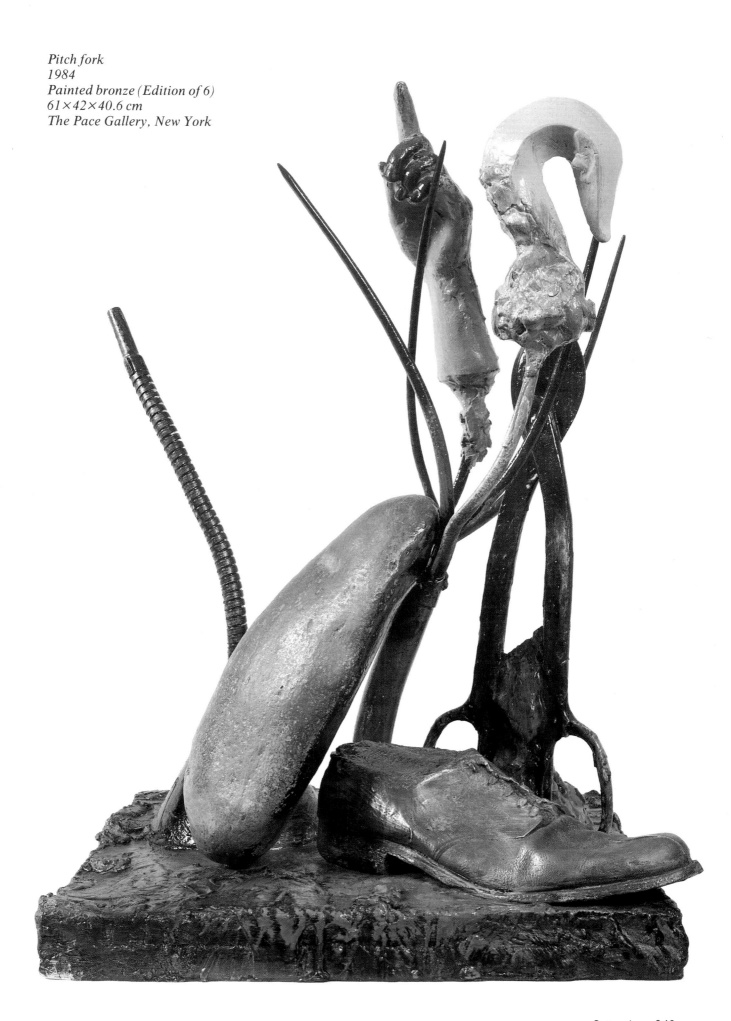

Pitch fork
1984
Painted bronze (Edition of 6)
61×42×40.6 cm
The Pace Gallery, New York

family comes from Eastern Europe. I lived with my grandparents who led European lives. I learned for the first time how differently Europeans and Americans live. Today I am at home in either continent.

EB: How far does your work basically differ from that of other Pop artists who are still working?

JD: I am less attracted by the outside world, by consumerism, by fashionable events. I look for my pictures in my personal world and try to give the public an insight into the history of my ideas.

EM: Many of your paintings are entitled "Self-portrait" even though they are not self-portraits.

JD: For me everything is a self-portrait. Every-

thing is part of my own landscape, of my vision of this world, regardless of whether I am painting a bathing costume or trying to sketch my image in a mirror.

EB: For a long time you have been using the same motifs over and again. There are whole series of swimsuits, hearts, saws, trees. Years can go by, and suddenly there it is again — one of the motifs you have always used. Like for example your "Red Coat". We have one from 1964, 1976, 1979 and 1981—each time with a different title. Depending on the colour mood it can symbolize "Jerusalem Nights", "Desire", a "Cardinal".

JD: For me nothing is ever ended. Even an object is ever present. I never abandon a motif. Once I have taken it up, it is always mine. Why should I abandon it?

Five large heads in London, 1983, Bronze, 292×139.7×114.3 cm, The Pace Gallery, New York

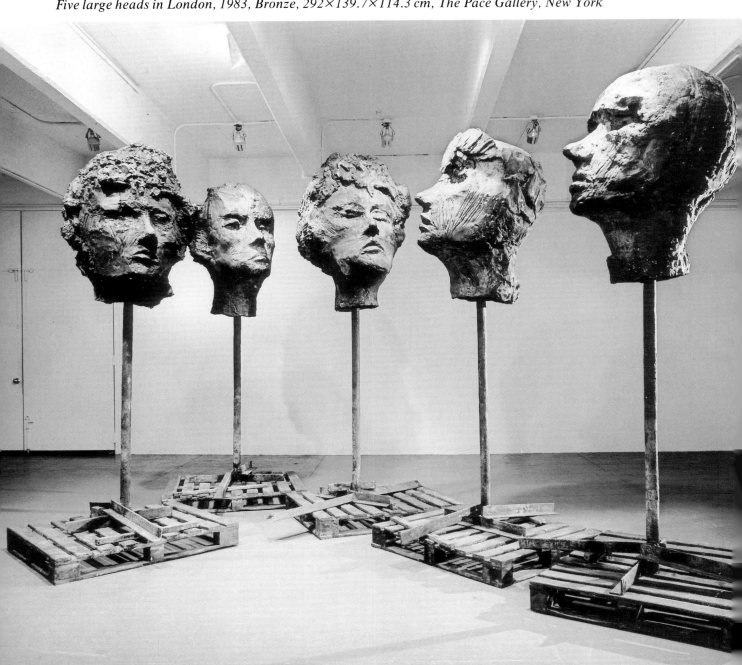

EB: Are the objects you paint symbolic? Is a heart simply a heart or does it stand for something else?

JD: In a certain sense it has to do with mythology. But with a personal mythology. Every object has its own mythology for everything is part of the all-embracing primeval form of mythology. I look on my approach to mythology in a purely abstract sense, not at all a literary or anecdotal sense. An object in a picture must emit power as it would in the mythological sphere. I may have succeeded in achieving this just once, in "Head with the Eye". I must have seen this eye somewhere. Yes, I know where I saw it—I saw it on Iranian Jews in Jerusalem who wear amulets against the evil eye. Something of the magical power of this object comes across in the picture. It was similar with the "Death Heads", which for me are not death heads at all. They are heads with natural beauty and magical power. They are self-portraits of mankind. Since I painted them this death's head belongs to me.

EB: Are there specific reasons for your choice of the objects you want to paint?

JD: I have always loved objects. They have always had magic for me. I choose them spontaneously, or, to put it more correctly, they reveal themselves to me. They become my property. In the long run painting and object are one and the same thing. Every object that has power is right for me.

PS. After this conversation I became convinced that *Jim Dine* had never really been a Pop artist. His starting point is the magic that things possess —and not their popular image.

The crommelynck gate with tools, 1983, 274.3×335.3×91.4 cm, The Pace Gallery, New York

Details from "The Sovereign Life", 1985, Mixed media on canvas with wood beading, 121.9×91.4 cm,

The Pace Gallery, New York

Musée d'Orsay in Paris

The two most spectacular new museum buildings of recent time have only one thing in common — both were preceded by a lengthy building process and much publicity. Following the opening of the two buidings the new museum in Cologne found general favour in the press, whereas many had mixed feelings about the Paris museum, or even serious reservations. Nor were these reservations unmerited. The building — the old Orsay station, built in 1898–1900 and proclaimed a historic monument in 1973 — had everything that one might expect in a museum intended to counterbalance the Louvre. Enormous, expansive rooms were laid out with the best possible lighting. The museum was planned as a museum of French art from 1848 to 1914, bringing together under one roof the Impressionist collection from the Jeu de Paume and paintings, sculpture and *objets d'art* of the second half of the 19th century from the Louvre and the Palais de Tokyo. The task of converting the former railway station into a museum was entrusted to the Italian architect *Gae Aulenti*.

On 9 December 1986, after several days of opening festivities, the buiding opened to the public.

The Musée d'Orsay

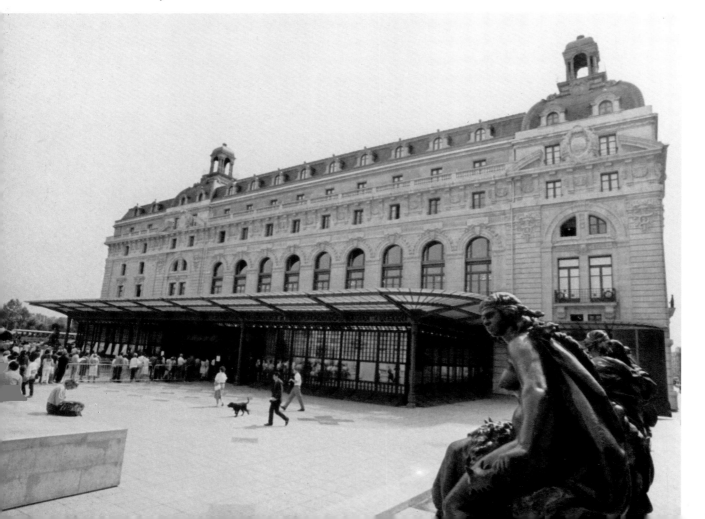

This former architectural glory, a cross between Art Nouveau and Beaux-Arts, had been transformed into a new buiding in the Post-Modernist style, exhibiting throughout the personal style of its creator: *Gae Aulenti* has created her own memorial. What it does for the exhibits is, admittedly, another question. On entering the visitor faces an imposing central avenue lined with sculptures which sets the standard amidst this agglomeration of vaults, vistas and buttresses, but which not so much sets off the art as dwarfs it. Monumental sculptures in the central aisle; paintings in the side aisles and niches; on the upper floor, cramped and amazingly poorly lit, are the most glorious Impressionists—such is the collection of art brought together under one roof here. Tranquil, boring, lacking historical perspective, carefully separated from one another, all now enjoy a calm museum existence, all who were once the most bitter enemies: academicians, "pompiers" and the avant-garde, made up of *Courbet* and *Manet* and their followers, the Impressionists. The drama of these artistic rivalries is lost for ever. In an interview *Gae Aulenti* said that for her the pictures and works of art were central to her plan. "Only the pictures give the interior architecture the right weight. The most important things are the pictures, only at the second glance should one take in the architecture."

She has not, however, followed through her concept. Her desire to create something of her own seems to have gained the upper hand. If the Musée d'Orsay were not a museum, but a buiding with some other purpose or no specific purpose, it would be an amazing example of contemporary post-modern architecture. Are the phenomenal number of visitors who visit the museum every day—we hear of 13,000 per day—attracted by the spectacular building or what it contains? It seems clear that in the not too distant future the Musée d'Orsay will become *the* tourist attraction in Paris, attracting more visitors than the Eiffel Tower or the Pompidou Centre.

In any case what strikes us, even though so many masterpieces are so badly presented that it is often a matter of chance whether the visitor stumbles across them or not, is that we are in the presence of masterpieces. *Gustave Courbet's* "Burial at Orléans" (1849) and his "Studio" (1855), even when relegated to the side walls of a side wing, remain two of the best pictures of the 19th century, and the Impressionists, even on an upper floor, are an amazing visual and artistic experience. In the final analysis art is stronger than any pretentious, obtrusive architectural design.

View of the main gallery of the Musée d'Orsay

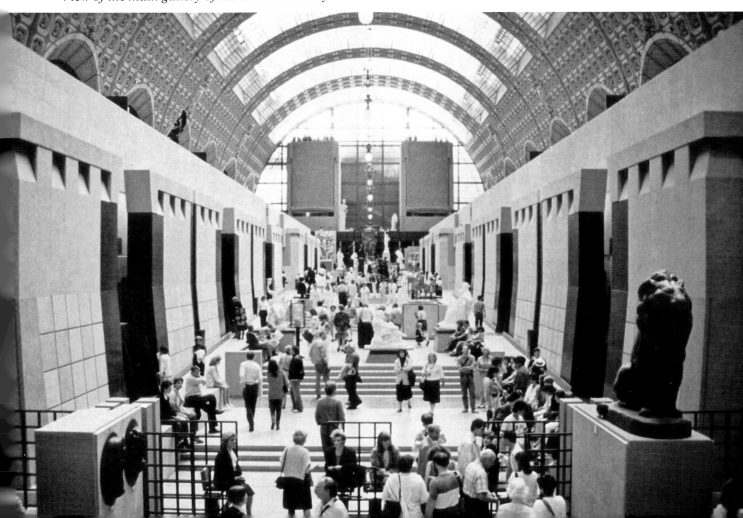

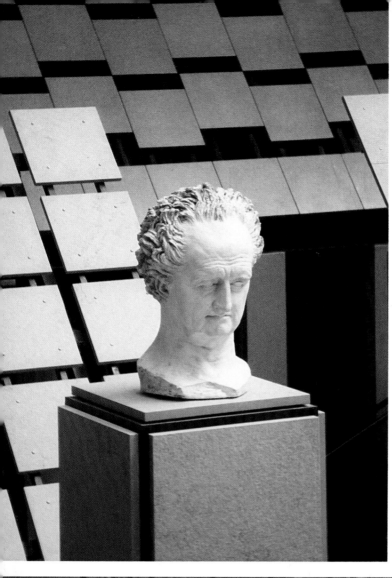

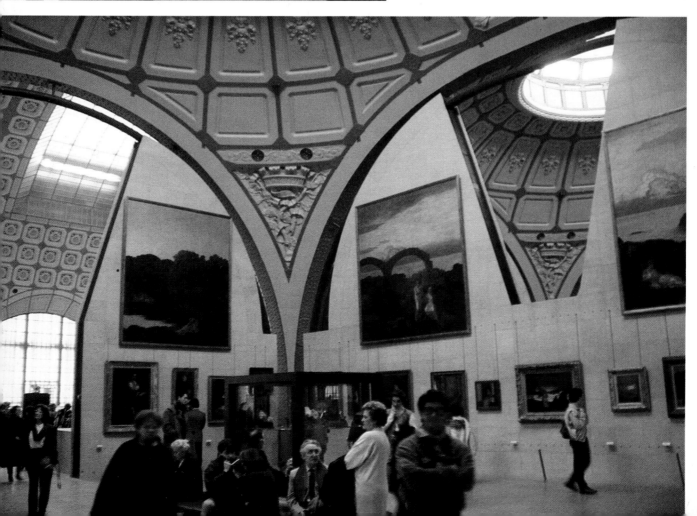

Ludwig Museum in Cologne

The Ludwig Museum, exterior

Views of the interior of the Ludwig Museum

No such criticism can be levelled against the Ludwig Museum in Cologne. The architects, unknown until now, took the opposite approach to Paris. They kept things simple, submitting themselves patiently and sympathetically to their task, not only of building a museum but of fitting this museum into the historic architecture of a city square. The new museum again brings together different periods of art history and different movements under one roof, including the treasures of the Wallraf-Richartz Museum. It stands between the cathedral, the old town, the Rhine and the Rhine bridge. There is no rivalry with the venerable architecture of the cathedral as it descends in terrace fashion to the Rhine. The zinc roofs of the separate wings of the building form an architectural landscape spreading from the river bank to the cathedral.

The interior is entirely in keeping with the rich collections that the building houses. The museum is built around an impressive stairway which links every floor and opens out in all directions so that the collections brought together by *Ferdinand Franz Wallraf, Josef Haubrich* and now by *Peter Ludwig* stand before us like one unified collection. There is uninterrupted passage from the Old Masters to the Moderns.

Harmony is one of the leitmotiv that the new building offers the visitor. The question of light, the main problem for any museum, has been solved admirably. The glass roofs throw unbroken yet filtered light on to the collection of medieval art. In the rooms on the lower floors which rely on artificial light, the light source is a computer-controlled "light shower" where the amount of light can be varied to match requirements. There are vistas, small rooms, long unbroken walls, all providing endless possibilities to show works of art in their true light (in the literal sense). Admittedly, this is not the case throughout the museum despite the ideal architecture. Sometimes the pictures are hung too close together so than none stands out. Several masterpieces, whose quality calls out for space, are hung in small niches, like *Rembrandts's* late self-portrait of 1665.

One critic expressed it particularly maliciously when he spoke of a "clearance sale in a warehouse brimful of bargains". It is a fact that the individual art lover is no longer considered in our new museums. Neither the Pompidou Centre, nor the Musée d'Orsay, nor the Ludwig Museum takes him into account. What really counts nowadays is visitor numbers. And these are mounting! The new building in Cologne is another museum that attracts thousands of visitors every day.

Outside steps

*Museum forecourt with
ground sculpture
by Dani Karavan*

Glimpses

The roofs of the
Ludwig Museum

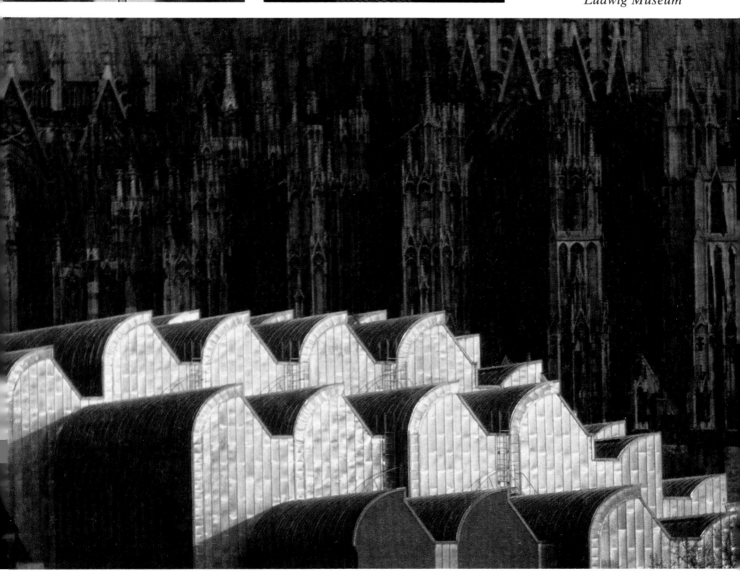

Art in Auction: Christie's

The past season has again been a record one for Christie's. Our international turnover came to an impressive £581,155,000, an accomplishment of which we are proud.

The theme running through our sales this year was collectors and collections. In all our salerooms, whether in Great Britain, the United States or Europe, the range of these collections has been huge – from dolls houses to Old Masters, from stamps to wine, from needlework to Impressionists.

The sale of pictures has, as in previous years, been the mainstay of our auction year. From the Beatty collection we sold in March "Sunflowers" by *Vincent Van Gogh*; it realized £24.75 million, a record price for any work of art. That was preceded in December by the sale from the Samuel Courtauld collection of *Edouard Manet's* "La rue Mosnier aux paveurs" for £7.7 million and followed in June by *Van Gogh's* "Le pont de Trinquetaille" from the *Kramasky* collection for £12.65 million. In July 16 Old Master drawings from the collection at Chatsworth were sold. They realized a total of £6.2 million, with *Federico Barocci's* "Madonna del popolo" fetching a breathtaking £1.7 million.

Picture prices are not always in the multi-million pound category. For example, the *Bernasconi* collection of Italian 19th-century pictures sold in London in March. The total was £3.5 million and the highest price, £93,500, was paid for a "Milan street scene" by *Mosè Bianchi*. The *Goldberg* collection of modern art, which went under the hammer in London in December, realized a total of £4 million, with a painting by *Henri Matisse* of a "Jeune fille en robe blanche" fetching £429,000.

And it's not only pictures which are collected.

Highly important Italian violin by
Antonio Stradivari called The Colossus £ 440,000

The Orpheus clock, South German, 16th century
£ 208,695

There are stamps, of course, and the *Isleham* collection sold in New York in March sold for an impressive $1.2 million. The top price, $20,900, was paid for an 1861 1d blue error. New York was also the venue for the auction of the *Mary B. Rhoads* collection of dolls houses. When it came under the hammer at Christie's East in March the whole collection realized $234,000, with a four-room late 19th-century mystery house going for $15,400.

The *Robert Moore* collection of Korean ceramics was sold in New York in October for a total of more than $700,000. The highest price was $88,000, paid for a Yi dynasty blue and white storage jar, and the success of the sale in general has helped to establish a firm market for the outstanding work of Korean craftsmen. Also in New York in October the *Patino* collection of silver and silver gilt made headlines when it realized $2.4 million; a pair of William and Mary silver gilt salvers changed hands for $220,000.

We at Christie's have a reputation for sales "on the premises". The highlight this year must have been the three days we spent at Tew Park, Oxfordshire, selling the contents of that great house. The mansion was a masterpiece of Regency and Victorian architecture and design, with many of the pieces of furniture made to order by *George Bullock*. The sale made a total of £2.6 million, and the 57 lots of Bullock-designed furniture realized £732,000, putting him firmly on the list of major names.

Wine is another area for which we are well known and in September in Chicago we dispersed two collections: those of the late *Dr James T. King* of Atlanta and of the Culinary Institute of America. Out of the total of $372,920, $8800 was paid for a Jeroboam of 1929 *Mouton Rothschild*.

Not all collectors are individuals. The *Congoleum Corporation*, based in New Hampshire, sold its collection of American paintings, furniture and decorative objects in January. *Arthur Fitzwilliam Tait's* picture of "Duckshooting" realized $418,000 (a record for the artist) and a Queen Anne mahogany high chest of drawers made in Boston, Massachusetts sold for $46,200.

There have been, too, unusual items sold over the past 12 months: a brilliant red diamond realized $880,000 when it was sold in New York in April; the mid-17th-century needlework purse from the *Penn* family (founders of Pennsylvania) collection fetched £55,000 at Christie's South Kensington in June; and a host of items in the reserve collection of the Marylebone Cricket Club, in a bicentenary sale, realized £319,500 in April, also at Christie's South Kensington.

What does it all mean? That in the last centuries collections have been formed and dispersed, and that in the present generation new collections are forming partly out of objects in the earlier ones. This is a cyclical business and one in which Christie's, since its foundation in 1776 right up to the present season, has played a prominent part. We think founder *James Christie* would recognize the quality and attributes of our sales and that he would be proud to have his name attached to them.

George II epergne by Paul de Lamerie £ 770,000

One of a pair of Empire silver gilt double salt cellars designed by Percier, by Martin Guillaume Biennais, Paris, 1798–1809, £ 65,000

Mattia Preti
Saint John Chrysostom
oil on canvas
243.8×189.2 cm
£ 209,000

Thomas Gainsborough
Portrait of Lieut. Colonel Jonathan Bullock
oil on canvas
227.3×152.4 cm
£ 100,000

Melchior d'Hondecoeter
Birds by a stream, classical ruins beyond,
in a wooded landscape
1681
oil on canvas
119.3×142.8 cm
£ 176,000

Adriaen Coorte
Still life with wild strawberries
£ 178,218

Henri Edmond Cross
Le Lac du Bois de Boulogne
£ 374,000

Jacques Emile Blanche
Vaslav Nijinsky in Danse Orientale
£ 110,000

Paolo Caliari, il Veronese
The matyrdom of Saint Justina
£ 605,000

Van Rijn Rembrandt
The ramparts near the bulwark
beside the St. Anthoniespoort
£ 1,375,000

Raphael Sanzio
A soldier running to the right
(and two mounted horsemen)
£ 495,000

Anthony van Dyck
The mystic marriage of
Saint Catherine
inscribed, black chalk, pen and brown
ink, brown and grey wash
18.2×27.9 cm
£ 242,000

Francis Bacon
Study for Portrait II
£ 500,469

Federico Barocci
The Madonna del Popolo
£ 1,760,000

Richard Parkes Bonington
The Palazzi Manolesso-Ferro
Contarini-Fasan and Venier-Contarini
on the Grand Canal, Venice
oil on board
36.8×47.6 cm
£ 374,000

Vincent Van Gogh
Sunflowers
£ 24,750,000

Henri Fantin-Latour
Roses blanches, chrysanthemes dans
une vase; pêches et raisins sur une
table avec nappe blanche
1876
oil on canvas
60.9×73 cm
£ 430,000

Carl Spitzweg
Der Philosoph (Der Leser im Park)
oil on canvas
36.8×27.9 cm
£ 121,000

Pierre-Auguste Renoir
Baigneuse
£ 1,045,000

Edouard Manet
La rue Mosnier aux paveurs
£ 7,700,000

Henri de Toulouse-Lautrec
Au Moulin de la Galette
£ 1,760,000

Vincent van Gogh
Le Pont de Trinquetaille
£ 12,650,000

Egon Schiele
Vor Gottvater kniender Jüngling
£ 550,000

Bartolome Esteban Murillo
The virgin and child
oil on canvas
103.5×82.5 cm
£ 638,000

John Constable
Flatford lock and mill
£ 2,640,000

Art in Auction: Sotheby's

During the 1986-7 season, *Sotheby's* New York auctioned superb single-owner collections in all areas of the fine arts, resulting in the most successful season ever. More than forty works of art were sold for more than $1 million each, an unprecedented number, and records were set in every collecting area. Among the season's significant single-owner sales were the *Ethel* and *Robert Scull* sales of Contemporary Art, the *John Gaines* Collection of Old Master and Modern Drawings, Property from the Estate of the late *James Johnson Sweeney,* Expressionist Watercolours from the Collection of *Charles Tabachnik,* Old Master Paintings from the *Patiño Family,* Impressionist and Modern Paintings from the Collection of the late *Sam Spiegel,* and Important American Paintings from the Collection of *Caroline Ryan Foulke.*

In addition to highlights from these single-owner sales records were set for masters from diverse collecting fields including *Jacques-Louis David, George Stubbs, Jean-Honoré Fragonard, Willem de Kooning, Jackson Pollock,* and *Gustav Klimt,* setting records for all these artists.

Impressionist and Modern Paintings and Sculpture

The Impressionist and Modern Art session on November 18, 1986, set a record for a single sale of art with a total of $42,372,000. The estate of the late *James Johnson Sweeney* — a former director of the department of painting and sculpture at the Museum of Modern Art and, later, director of the Solomon R. Guggenheim Museum — included seven important modern works which reflected the collectors pioneering interest in modern art. *Mondrian's* "Composition in a Square with Red Corner" — one of the sixteen known classic diamond-shaped paintings *Mondrian* created between 1918 and 1944, the year of his death — which was seen and purchased by *Sweeney* when he visited the artist's studio in March 1936, sold for $5,060,000, nearly twice its presale estimate, setting a record

for the artist at auction. Among the works by *Joan Miró* which were offered in this auction "Seated Woman" of 1932 brought $1,017,500, "Composition" of 1933 sold for $1,375,000, and "Woman in the Night" of 1945 set a record for the artist when it sold for $2,530,000. In the various owners portion of the sale which followed records were set for seven artists, among them *Renoir* ("La Coiffure" $3,520,000) and *Moore* ("Reclining Figure-Festival", $1,760,000).

The record for a single session sale of Impressionist art set in November 1986 was subsequently broken on the evening of May 11 when Impressionist and Modern Art from Various Owners and Impressionist and Modern Paintings from the Collection of *Sam Spiegel* brought $63,596,500. In that single evening session thirteen works sold for more than $1,000,000. The highlight of the sale was *Gustav Klimt's* portrait of *Eugenia Primavesi,* whose husband was the backer of the famous Wiener Werkstätte. This painting was sold for $3,850,000 and set a record for the artist. Other highlights were *Picasso's* "La Maternité", 1921, which brought $3,520,000 and *Cézanne's* "Carrière de Bibemus" which brought $3,190,000. In addition, records were set for *Monet,* when his "Pont dans le Jardin" sold for $2,860,000 and for *Rouault,* whose "Clown" brought $1,045,000.

German and Austrian Expressionist Watercolours

The sale of Expressionist Watercolours from the Collection of *Charles Tabachnik* sold well with works of *Egon Schiele, Emil Nolde* and *Oskar Kokoschka* bringing considerably over estimate. A *Schiele* "Selbstbildnis" brought $319,000 (estimate $140,000/180,000); *Emil Nolde's* "Meer mit Abendhimmel und Segelboot" fetched $165,000 (estimate $80,000/100,000) and *Kokoschka's* "Sitzendes, lächelndes Mädchen mit langem, dunklem Haar und gefalteten Händen" sold for $126,500 (estimate $50,000/70,000).

Contemporary Art

The 1986-7 season was one of unprecedented success in the field of Contemporary Art and one that will be remembered for many years to come as the year of the dispersal of the celebrated "Scull" Collections. On the evening of November 10, 1986, with the sale of Contemporary Art, Property of Various Owners, Including Mrs. *Ethel Redner Scull,* the record for a contemporary work at auction and for the work of a living artist was broken when *Jasper Johns'* brilliantly coloured "Out the Window" painted in 1959 sold for $3,630,000, a price nearly doubling the existing record for the artist. *Lucy Mitchell-Innes,* Sotheby's Expert in Contemporary Art commented on the price, "Collectors are willing to pay this kind of price because true contemporary masterpieces such as 'Out the Window' are few and far between." In addition, records were set for *Ellsworth Kelly,* whose "Block Island" sold for $242,000 and *Larry Rivers,* whose "Dead and Dying Veteran" brought $126,500. The old record for *Bruce Nauman* of $26,400 was quite thoroughly broken when an untitled sculptural work sold for $220,000.

The following two days saw the sale of a group of Pop and Minimalist works from the Estate of the late *Robert C. Scull.* The 140 works, which were acquired for the most part directly from the artists by *Scull,* set a record for a single-owner sale of Contemporary Art, bringing $8,639,070. *James Rosenquist's* famous "F-111", brought $2,090,000. It was the largest painting in the group (10 feet high and 86 feet long) and has been called the artist's masterpiece. *Jasper Johns'* "Two Flags", painted for the *Sculls* in 1962 was one of two examples in this sale of *Johns* use of the American flag as a subject. It sold to an American private collector for $1,760,000. A drawing by *Johns* entitled "O through 9"—an exceptionally large and finished work, conceived on the scale of a full-size painting—brought $880,000, setting a record for a drawing by the artist. Records were also set for *Andy Warhol,* whose "200 One Dollar Bills" brought $385,000 and *Mark di Suvero,* whose "Che Faro Senza Eurydice" fetched $319,000.

James Rosenquist
F-111
$2,090,000

Jean-Françoise Millet, Gardeuse des vaches, $ 319,000

Lucy Mitchell-Innes, discussing the three days of sales, said "The *Scull* name and the quality of the work offered had a dramatic influence on the prices realized. The mood in the saleroom was serious and aggressive, people were here to buy, as seen in the results of the sale, where virtually everything sold. Over the last three days, almost $24 million of contemporary art was sold at *Sotheby's.*"

The momentum set in Contemporary Art with the *Scull* sales in the Fall continued strongly into the Spring. Two major "Woman" paintings by *Willem de Kooning* were offered, one from the first "Woman" series done in the 1940s, and one from the series done in the 1950s. The earlier of these, "Pink Lady", was a pivotal work in the emergence of the artist's mature style and brought $3,630,000, matching the auction record for a contemporary work of art and for the work of a living artist. "Woman", from the series done in the 1950s, was one of two major Abstract Expressionist works consigned by the Playboy Enterprises Corporate Art Collection, which was assembled by *Hugh Hefner.* The painting sold to *Kurasawa Ohkawa* for $2,530,000. The other work from the Playboy Collection, *Jackson Pollock's* "Number 26, 1950", displayed the artist's mastery of the drip technique he had begun in 1947 and brought $2,750,000.

The Gaines Collection

One of the finest private collections of Old Master and Modern Drawings formed in recent years — that assembled by *John Ryan Gaines,* a recognized authority and collector of Old Master and Modern Drawings, and the owner of Gainesway Farm, one of the premier thoroughbred breeding operations in the world — was sold at *Sotheby's* in New York on November 17, 1986. The collection, which contained superb examples of the work of *Raphael, Fra Bartolommeo, Rembrandt, Turner, Van Gogh, Matisse* and *Picasso,* and also included one of the last remaining *Leonardo* drawings in private hands, brought a total of $21,288,300 and set drawing records for 26 artists. *Leonardo's* "Sheet of Studies," including "Three Sketches of a Child Embracing a Lamb", drawn on two sides of one sheet, is a compendium of all the creative interests of this Renaissance genius — art, nature, machinery and religion. This important example of *Leonardo's* extraordinary skill as a draftsman, combining sfumato effects with pure line drawing, was sold to a London dealer for $3,630,000. Also from the Renaissance, *Fra Bartolommeo's* exquisite "Holy Family", drawn on pink prepared paper, brought $440,000, considered by many observers to be the bargain of the sale. The later Italian schools sold well also, with *Il Parmigianino's* "Virgin and Child" bringing $286,000 and *Canaletto's* "Warwick Castle" sell-

ing for $715,000. Among the French drawings, *Watteau's* remarkably fresh lifestudy "Three Studies of a Child's Head" sold for $852,500.

Pablo Picasso's remarkable analytic cubist drawing "Tête d'homme à la pipe" set a drawing record for the artist, selling for $1,650,000 and a colourful scene of ballet dancers by *Degas* "La pas battu" brought $1,100,000. In addition *Matisse's* "La danse" sold for $935,000. This unusual work foreshadows the artist's later interest in the technique of decoupage and incorporates his famous earlier image of the circle of dancers.

19th-Century European Paintings

The year in 19th-Century European Paintings was highlighted by a masterpiece from the artist *Jacques-Louis David:* "The Farewell of Telemachus and Eucharis". Commissioned in 1818 by the German Count *Erwin von Schoenborn,* the painting was one of a group of neo-classical works created by *David* after his exile to Brussels after the fall of Napoleon in 1815. The work sold to the Getty Museum for $4,070,000. The inclusion of the *David* — an important work by a major artist whose works rarely come to auction — added much excitement to the sale, in which many paintings sold well past estimate at all levels of the market. Another picture of historical importance, *Vernet's* "The Start of the Race of the Riderless Horses", epitomizing romantic themes, sold for $484,000, more than four times its high estimate. The work of an artist from the circle of *Degas,* the Italian *Federico Zandomeneghi,* entitled "The Bouquet of Violets", sold for $126,500 (the presale estimate was $30,000/50,000). Barbizon works did well, notably *Millet* whose "Gardeuse des vaches" sold for $319,000 and whose "Femme étendant son linge" sold for $297,000. In addition, "Le moulin à eau" by *Courbet* brought $126,500.

In the field of Sporting Paintings, *Sotheby's* New York had its most successful auction ever on June 4, 1987, with a sale total of $7,720,185. The sale set a record for the work of *George Stubbs,* the acknowledged 18th-century master of animal painters, when the artist's "Baron de Robeck Riding a Bay Cob" brought $2,420,000. This price also represents a record for any sporting painting sold at auction. *Stubbs'* "A Dark Bay and a Grey in a Wooded Landscape" sold for $770,000, exceeding its presale estimate of $300,000/400,000 and a record was set for the artist *Jacques Laurent Agasse's* "Lord Rivers Coursing on Newmarket Heath", when it sold for $385,000. These strong prices are attributed to the active competition between private collectors and the international trade in the salesroom. This energy was felt on all levels of the market, as was evident with *John Ems'* "After the Hunt" which sold for $74,250, exceeding its estimate of $28,000/35,000.

George Stubbs
Baron de Robeck Riding a Bay Cob
1791
$ 2,420,000

Piet Mondrian
Composition in a Square with Red Corner
Bildnis Nr. 3
1938
$ 5,060,000

Leonardo da Vinci
A child with lamb
$ 3,630,000

Important American paintings of Caroline Ryan Foulke

On May 28, 1987, *Sotheby's* offered seven paintings from the collection of *Caroline Ryan Foulke,* a distinguished connoisseur of American paintings and decorative arts and the granddaughter of renowned financier, *Thomas Fortune Ryan.* The seven paintings represented significant moments in the work of six major American artists— *Heade, Sargent, Whistler, Homer, Eakins* and *Prendergast*—all of whom were active in the last quarter of the 19th century. The competition for these works was intense and every work sold well above estimate. The highest price was the $2,585,000 achieved for *James McNeill Whistler's* "Variations in Violet and Green", well above a pre-sale estimate of $500,000/750,000, setting a record for artist whose works seldom appear for sale. Artist's records were also set for *Thomas Eakins,* whose "The Art Student—Portrait of James Wright" sold for $2,420,000 to the Alexander Gallery and for *Martin Johnson Heade,* when his "Crimson Topaz' Hummingbirds in the Jungle" brought $341,000. *Winslow Homer's* "In Charge of Baby" was among the first work done in the medium of watercolour by the artist and dates from the summer of 1873 when *Homer* was on a holiday in Gloucester, Massachusetts. The work set a watercolour record for the artist when it sold for $770,000.

Old Master Paintings and Drawings

The January 1987 auctions of Old Master works were highlighted by a recently discovered *Fragonard* gouache and an important selection of Old Master paintings from the *Patiño Family* Collection. On Wednesday, January 14, a rare *Fragonard* gouache, last recorded in the *Jacques de Bryas* sale in Paris in 1898, sold for $203,500 to a private collector. The brilliantly coloured work entitled "Interior of a Park: The Gardens of the Villa D'Este", was produced by the artist shortly after his return from Italy in 1761. It is *Fragonard's* reduction of his own painting on the same subject now in the *Wallace* Collection.

Then from the distinguished *Patiño Family* Collection, included in the sale of Old Master Paintings on January 15, 1987, came two particularly fine French 18th Century works, which attracted intense attention. *François Boucher's* "Boy With a Girl Blowing Bubbles", a work from the mid-1730s which was in remarkably fine condition, sold for $1,925,000, setting a record for the artist. *Alexandre-François Desportes'* large and beautiful still-life of a chocolate pot, blue and white ware, a bass viola da gamba, a basket of oranges, playing cards, a music book and other objects devised all in a parkland setting brought $341,000. The other highlights of the sale, the property of another

Louis David, *The Farewell of Telemachus and Eucharis*, 1818, $ 4,070,000

owner, was a *Botticelli* oil on panel "The Virgin and Child with the Infant Saint John", dating from the early 1490s, which sold for $539,000.

The offering of "The Rebuke of Adam and Eve" on June 4, 1987, by *Domenico Zampieri,* who was called *Domenichino,* represented a rare opportunity for collectors of 17th-century Italian art to acquire a major work by an artist who occupied a place of importance comparable to his contemporaries *Guido Reni* and *Guercino.* The work was sold in an enthusiastic saleroom to a New York dealer competing against private collectors for $1,540,000, a record for the artist.

Latin American Art

The 1986–7 season in New York saw strong prices for Latin American works of art, which have seen an increasingly widening market in the past few years. A strong market response was seen for the many works of museum quality which *Sotheby's* was privileged to offer. On November 25, 1986, *Rufino Tamayo's* "The Astrologers of Life" sold for $165,000 to a private collector who is founding a museum in Caracas, and who also purchased *Emilio Pettoruti's* "The Soloist" for $99,000. On May 19, 1987, the noted Venezuelan publishers, *Magaly* and *Miguel Angel Capriles* paid $165,000 for *Matta's* 1952 oil on canvas "Sottobosco". The work of *Fernando Botero* sold well in both the Fall and Spring, with "The Bashful Family" selling for $148,500 in November (estimated at $60,000/80,000) and "Still Life with String Bean Soup" (estimated at $90,000/110,000) bringing the same price in May.

New York's most successful Prints sales to date

The May 13–15, 1987, Old Master, European 19th- and 20th-Century, and Contemporary Prints sale represented one of the most important dispersals in years, to which the market responded with enthusiasm, as a sale total of $8,185,265 was achieved. Among the approximately 800 lots was a consignment of more than 100 works from the Kimbell Art Foundation, and major American works consigned by the Estate of *Flora Whitney Miller.* Competition was keen for the Kimbell lots and among the uniformly high prices achieved was $511,500, paid by a New York dealer for *Aibrecht Dürer's* "Melancolia", setting a record for the artist at auction.

In addition, a major selection of colour prints and drypoints by *Mary Cassatt* sold extremely well. "The Letter" is one of a series of ten prints *Cassatt* made in 1891 based on Japanese woodblock prints which the artist had been on exhibition in Paris. Estimated at $60,000/80,000 it sold for $192,500. Another *Cassatt* print "Feeding the Ducks", from the Estate of *Flora Whitney Miller,* estimated at $40,000/50,000, sold for $88,000.

Pablo Picasso
La maternité
1921
$ 3,520,000

Pierre-Auguste Renoir
La coiffure
$ 3,520,000

Willem de Kooning
Pink Lady
1950
$ 3,630,000

Gustav Klimt
Bildnis (Mäda) Primavesi
$ 3,850,000

Jasper Johns
Two Flags
1962
$ 1,760,000

Jasper Johns
Out the window
1959
$ 3,630,000

Dark horses:
Four young painters
from Cologne

The four painters introduced here, *Christiane Fuchs, Ingo Meller, Peter Tollens* and *Ulrich Wellmann,* all graduates of the College of Design in Cologne, are all exponents of a distinctly radical form of painting. In 1984 they exhibited together at the "Presence of Colour—Radical Painting" exhibition in Oberhausen which underlined the programmatic demands of radical painting. Radical painting means the complete reduction of the work to the fundamental phenomenon that underlies every form of painting, namely colour. Colour is elevated to become the sole object and concern of this form of painting. Radical painting examines the question of the very existence of colour in painting. This makes colour, not a material that can be freely used at the artist's discretion, but a kind of dialogue partner which, as an individual also makes demands on the artist. The artist cannot only use it as a means of self-expression, but must place himself at its service so that colour is allowed to fulfil its own purpose.

Ingo Meller
1955 Born in Cologne
1976–80 Studies at the Fachhochschule, Cologne

Ingo Meller paints on unstretched canvas, cut with the weave to give it a slight irregularity. He always begins by laying down a base of unmixed colours, usually with four or five often very different shades. The interaction of colour resulting from this juxtaposition is freely developed in line with the principle of growth. Colour thus spreads almost spontaneously as a result of a free course of action. This is a course of action which stamps itself as a processual mark on the colour. In *Meller's* work there is a colour harmony and also a harmony between the colours chosen and the mood of the artist at a given time. They form a kind of chord like tones in music, which has no meaning other than itself. But just as a single chord is not music, neither does the mere applying of colour make a picture. The chord, which is neutral in itself, begins to work in the artist's mind and to impel him towards action. The composition develops spontaneously, with no preparation, until it takes on the ordered form which is an essential part of any picture. The individual brush-strokes are forms of colour which react with forms of colour already applied and which have still to react with the colours yet to come. The act of painting, therefore, is never arbitrary since each separate step or addition depends on those that precede or follow until the painting is finished.

Ulrich Wellmann
1952 Born in Herford
1970–73 Trains as type-setter
1975–80 Studies at FHS, Cologne

Ulrich Wellmann concentrates on the problem of colour choice, that is on the question of the oblique route that leads from one colour to another. In self-contained, non-representational painting this question is of prime importance. Who or what dictates to the painter when or where he should use what colour? In the final analysis only the colour itself can do this—providing the artist is able to understand its message. Thus the painter does not make an authoritarian choice of colour on his own volition, but draws the basis and justification for his treatment from the colour itself. Before begin-

ning a work he makes no set decision about the use of colour, but allows his choice of colour to evolve on the basis of what precedes it. Each of his pictures starts with a largely homogenous base colour applied in blocks of varying thickness. On this are built up small flecks of another colour, not usually with any sharp contrast in tone or intensity, a related rather than a contrasting colour. These flecks are distributed in small quantities quite arbitrarily over the canvas. There is no evidence of compositional intent to link them one to another. The base colour is applied with rectangular, block-like brush-strokes with a high degree of regularity, but underlying this layer of colour are variations and irregularities which reflect the artist's method of painting. The tension produced has its origins in nothing other than the colour itself. The painter automatically reacts to variations in the micro-structure and immediately goes on to add a second colour to the painted surface so that the rhythm of the work becomes increasingly erratic as the restrained tension which has built up is released. The leap from the first to the second colour occurs organically, it develops out of rather than on the first.

Peter Tollens
1954 Born in Kleve
1970–73 Studies colour lithography
1976–81 Studies at FHS, Cologne

Peter Tollens is another artist who sees colour as potential energy, looking after its own material organization with a little help from the artist. He starts a painting with two colours selected in advance, usually colours which do not contrast too strongly. Both are used more or less simultaneously to cover the canvas and give an initial relatively diffused effect. This produces overlaps giving a variety of intermediate tones which are further emphasised by adding small quantities of new colours to the two original tones. The simultaneity of the process, which allows for no later reworking, contributes directly to the tensions the colours produce in the painter. This tension flows continuously into the picture where it is visually manifested in colour, and organized into its definitive form. The energies contained in colours act like weights which force their way into the work and oscillate, thus acquiring order. An exception to this is found in the proximity of colours to each other for strong contrasts are more striking in small quantities, just like slight accents which round off rather than disturb the organism.

Christiane Fuchs
1953 Born in Iserlohn/Westphalia
1975–80 Studies at College of Design (FHS) in Cologne

Christiane Fuchs paints small monochrome pictures which at first glance seem to portray no distinctive characteristics of their own. But when one looks closer one can observe the micro-structure of the brushwork which makes the viewer unconsciously stand a certain distance from the picture—a similar distance away to that of the artist when she was working on the painting. From this ideal distance the apparently evenly applied paint becomes an organism with a complicated structure which makes clear the entire process of painting. The carefully mixed colour is applied in a disciplined fashion, starting from a chosen point and radiating out to the edges of the canvas. In doing so the colour is neither applied intentionally thinly nor in a thickly textured manner. It is applied calmly stroke by stroke and left as it comes off the brush with no retouching. While the even application of colour requires a high level of concentration, the difficulties increase as one approaches the edges of the picture, for the painter must recognize in good time that the brushstrokes have to coincide with the picture format. To this end the colour application can be varied by scarcely perceptible nuances. If the painter has chosen a colour with which she feels in harmony at that particular time, the application of colour, with all its hesitations, harmonies and disharmonies, takes on all the significance of a psychogramm. The brushstroke becomes an indicator of the momentaneous state of being during the act of creation— a state of being which could not exist without colour. This painting speaks to one of artistic treatment, namely of a form of surrender appropriate to the conditions determined by the colour.

These four young artists from Cologne each present in their painting an unusually consistent, radical, highly original and analytical questioning of the artistic method, but which—in contrast to the so-called analytical painting of the Seventies—is very tightly linked to subject matter of the artist.

Ingo Meller
1986
Oil on canvas
35.6 × 24.1 cm
Private collection, Cologne

Christiane Fuchs
1984
Oil on cotton
80 × 70 cm

Peter Tollens
1987
Oil on canvas
72 × 55 cm

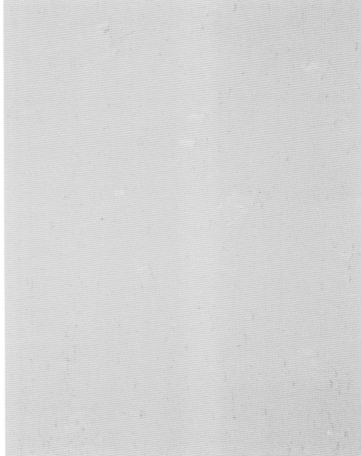

Ulrich Wellmann
1987
Oil on canvas
73.5 × 67.4 cm
Private collection, Kassel

Biographies

Giuseppe Arcimboldo

1527 Born in Milan.
1549 Arcimboldo's name is first mentioned in the "Annali della Fabbrica del Duomo di Milano", which tells us nothing more than that he was employed in the workshop of Milan Cathedral.
1558 Arcimboldo finishes working for Milan Cathedral and designs tapestries for Como Cathedral.
1562 Arcimboldo is summoned to the court in Vienna where he works as a portraitist and copyist.
1563 Paints the first series of "Seasons". In the same year the Imperial Governor writes to Ferdinand I describing the paintings and singing the praises of "Master Joseph".
1565 Arcimboldo is named in

court records as court portraitist.
1566 Arcimboldo paints the "Jurists" and begins another series of "Seasons". He visits Italy.
1568 Begins cooperation with Giovanni Battista Fonteo.

1569 As a New Year gift, Emperor Maximilian II is presented with the "Seasons" and the "Elements" together with a poem by Arcimboldo and Fonteo.
1570 To mark the marriage of Elisabeth, the daughter of Maximilian II, to Charles IX of France, Arcimboldo is involved in the preparations for a tournament in Prague.
1573 Maximilian II commissions Arcimboldo to paint the third and fourth series of "Seasons for the King of Saxony".
1575 Rudolf II is crowned king in Prague. Arcimboldo is involved in the festivities. Birth of Benedetto, the illegitimate son of Arcimboldo and Otilla Stummeri. Emperor Maximilian signs the act of legitimacy in Prague.
1579 Rudolf II ennobles Arcimboldo's family.
1584 Publication in Milan of first work in which Arcimboldo is named, Lomazzo's "Trattato dell'Arte della Pittura".
1585 Arcimboldo presents Rudolf II with a series of drawings of costumes, hairstyles and ornaments.
1587 Arcimboldo leaves Prague to return to Milan. He receives 1,550 guilders from the Emperor.
1589 Arcimboldo sends his painting "Flora" to Prague.
1591 Arcimboldo sends the portrait of Rudolf II in the mask of Vertumnus to Prague.
1592 Appointed palatine by Rudolf II.
1593 Arcimboldo dies in Milan.

Fernando Botero

1932 Born in Medellin, Colombia.
1951 Goes to Bogotá.
1952 First visit to Europe; lives in Barcelona and Madrid. Models himself on Velázquez and Goya.
1953–54 Visits Florence, discovers Italian Renaissance.

1955 Returns to Bogotá.
1956 Moves to Mexico City. Influenced by Mexican murals, he develops his own style.
1957 Travels to Washington for his first exhibition.
1958 At the age of 26 becomes Professor at the Bogotá Academy; seen increasingly as Colombia's foremost artist.
1960 Moves to New York.
1966 First European exhibition in Baden-Baden; exhibition at Milwaukee Art Center brings a break-through in the USA.
1970 Large touring exhibition in various German museums.
1971 Rents a house in Paris. Divides his time between Bogotá, New York and Paris.
1976–77 Devotes himself

exclusively to sculpture.
1983 Moves to Pietrasanta, a town in Tuscany famous for its foundries. Spends much of the year here working on his sculpture.
1986 Retrospective in Munich, Bremen, Frankfurt and Tokyo.

Francesco Clemente

1952 Born in Naples. He lives and works alternately in Rome, Madras (India) and, since *1982,* in New York.
1971 He had his first one-man show at the Galleria Valle Giulia in Rome, followed by numerous exhibitions at Gian Enzo Sperone, Rome/Turin; Lucio Amelio, Naples; Sperone Westwater Fischer, New York; Paul Maenz, Cologne; Bruno Bischofberger, Zurich.
1981 Takes part in the Western Art exhibition in Cologne.
1982 Takes part in Documenta 7 in Kassel; Zeitgeist exhibition in Berlin.

Le Corbusier

1887 Born Charles-Edouard Jeanneret in La-Chaux-de-Fonds, Switzerland.

1907–08 Studies with Josef Hoffmann in Vienna. Goes to Paris and earns his living with a part-time job with Auguste Perret.
1912 Appointed to teach "Decorative composition and its applications from architecture to the smallest objects" in La-Chaux-de-Fonds.
1917 Goes to live in Paris.
1918 Meets Amédée Ozenfant.

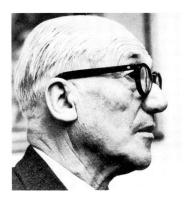

Begins to paint. The two artists publish jointly their manifesto "Après le cubisme" (After cubism).
1920–25 Founds and publishes jointly with Ozenfant and Paul Dermée the review "L'Esprit Nouveau". As an art critic Jeanneret works under the name "Vauvrecy".
1922 Architectural practice in partnership with his cousin Paul Jeanneret for all architectural and town-planning work up to 1940. Up to 1927 he draws and paints exclusively still-lifes typical of Purism.
1925 Pavillon de l'Esprit Nouveau.
1928 Jeanneret begins to sign his paintings and drawings "Le Corbusier".
1930 Becomes French citizen. Marries Yvonne Gallis.
1933 Honorary doctorate of Zurich University.
1943 Begins researching the "Modulor".
1945–50 Start of cooperation with André Wogenschky on all building and town-planning work.
1947–52 Unité d'Habitation, Marseille.
1950–56 Chandigarh.
1950–55 Chapel of Ronchamp.
1957 Flats in Hansa district of Berlin.
1965 Dies in Roquebrune, Cap Martin.

Eugène Delacroix

1798 Born in Charenton-Saint-Maurice near Paris.
1806 Family moves to Paris.
1815 Begins art studies at the Ecole des Beaux-Arts. Copies

many works in the Louvre, especially Rubens and Raphael whom he admires.
1817 Meets Théodore Géricault.
1822 Exhibits at the Salon. His "The Barque of Dante" causes a scandal. Delacroix begins his journal which, from *1847,* provides a true image of his life, his art and his thoughts.
1824 The "Massacre at Chios" shocks the art world. Gros describes it as a "massacre of painting".
1827 "The Death of Sardanapalus" causes the next scandal at the Salon.
1831 Awarded the Legion of Honour. Great success of "Liberty Leading the People" inspired by the July Revolution of 1830.
1832 Visits Morocco, a journey which is to influence his later work.
1839 Visits Netherlands. Deeply moved by Rubens.
1842 Onset of chronic laryngitis. First summer visit to Georges Sand.
1846 Paints the library of the Palais du Luxembourg.
1851 Ceiling paintings in the Apollo Gallery in the Louvre.
1854 Contacts with Courbet, François Millet, Théodore Rousseau.
1855 35 of his major works go on show at the Universal Exhibition in Paris. At the height of his fame. Manet comes to see him to ask permission to copy "The Barque of Dante".
1856 Has to break off work in the church of Saint-Sulpice due to illness.
1857 Moves to a studio at no. 6, Place de Fuerstenberg, now the Musée Delacroix.

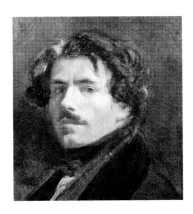

1860 16 works at the Matinet Gallery inspire the Impressionists, Monet and Renoir in particular.
1861 The Chapelle des Saints-Anges in Saint-Sulpice is completed. From here on influences the younger generation: Redon, Renoir, Pissarro, van Gogh, Cézanne, Signac.
1863 Dies in Paris on 13 August.

Jim Dine

1935 Born in Cincinnati, Ohio.
1957 Attends Ohio University.
1958 Moves to New York and in *1959* takes part in his first Happening "The Smiling Workman" at the Judson Gallery. From *1960* exhibits in various galleries and is soon known in Europe. The Seventies bring one-man shows in European museums.

1965 Visiting lecturer at Yale University.
1966 Moves to London where he lives until *1971*. On his return to the USA is visiting lecturer at a number of universities.
1978 Exhibition of prints at the Museum of Modern Art.
1980 Becomes member of the American Academy and Institute of Arts and Letters, New York.
1984 Start of a lengthy American tour of a large retrospective. Lives in New York but spends long periods in Europe.

Gilbert and George

Gilbert
1943 Born in Dolomites, Italy.
George
1942 Born in Devon, England.
Gilbert attends Wolkenstein School of Art, Hallein School of Art and Munich Academy.
George attends Dartington Adult Education Centre, Dartington Hall College of Art and Oxford School of Art.
1967 Both attend St. Martin's School of Art in London.
From *1969* Exhibitions of Gilbert and George as Living Sculpture on various themes and shows in European galleries and museums. They have had some 140 one-man shows and taken part in about 95 group exhibitions.

Vincent van Gogh

1853 Born in Zundert (Brabant). At first wants to be a pastor like his father.
1881 Begins to paint
1883–85 Paints peasant scenes in Brabant.

1885 Attends Academy in Antwerp.
1886 Joins his brother Théo in Paris. Paints 200 pictures in two years.
1888 Moves to Arles. Invites Gauguin to Arles. A quarrel between the two friends leads to the tragic incident on 24 December, in which van Gogh cuts off one ear. He is immediately interned.
1889 Enters the asylum at Saint-Rémy.
1890 Moves to Auvers-sur-Oise where he lives for a further two months. Shoots himself on 27 July and dies two days later. Buried in the cemetery at Auvers.

Paul Klee

1879 Born in Münchenbuchsee near Berne.
1898–1901 Studies art in Munich after wavering for a long time between art and music.

1900 Becomes pupil of Franz von Stuck.
1902–06 Lives in Berne.
1906 Marries Lily Stumpf and moves to Munich.
1911 Meets the artists of the "Blaue Reiter".
1912 Klee takes part in the second "Blaue Reiter" exhibition.
1914 Travels with Macke and Moilliet to Tunis and Kairouan.
1920 Appointed to the Bauhaus in Weimar.
1925 Moves with the Bauhaus to Dessau.
1929 Study tour to Egypt.
1931 Appointed to Düsseldorf Art Academy.

1933 Summarily dismissed by the Nazis; moves to Berne.
1934 Will Grohmann's work "Paul Klee's Drawings" is confiscated by the Nazis.
1937 Over a hundred of Klee's works are confiscated in Germany. Seventeen of his pictures are shown in the Munich "Degenerate Art" exhibition. Picasso, Braque and Kirchner visit Klee in Berne. Meets up with Kandinsky once more.
1940 Klee's later works are shown at the Zurich Art Museum. Klee dies on 29 June in Muralto-Locarno in Switzerland.

Sol Lewitt

1928 Born in Hartford, Conn.
1945–49 Syracuse University, Syracuse, New York.
1953 Moves to New York. Attends Cartoonists School (later known as The School of Visual Arts).
1960–65 Works on information desk and bookstall of Museum of Modern Art. Meets Lucy Lippard and artists Robert Mangold, Robert Ryman and Dan Flavin who are working as museum warders.
1963 First gallery exhibition.
1966–70 Takes part in important group shows.
1967, 1969 Two statements on Conceptual art, "Paragraphs on Conceptual Art" and "Sentences on Conceptual Art" (Artforum, June 1967, Art Language, May 1969).
1969–70 Takes part in exhibitions of Conceptual Art, eg "When Attitudes Become Form", Kunsthalle, Berne. Numerous exhibitions and publications follow.
1978 First large-scale one-man show at Museum of Modern Art.

Joan Miró

1893 Born in Barcelona. Begins drawing lessons at the age of 7.
1907 Enters art academy, but also trains as a shopkeeper.

1912 Joins Francisco Gali's art school.
1918 First one-man show at Dalman Gallery and meets Picabia.
1919 First trip to Paris, meets Picasso and from this point on spends his winters in Paris, returning to Spain each summer.
1924 Turns towards surrealism in his painting after meeting André Breton, Eluard and Aragon.
1929 Marries Pilar Juncosa.
1936 Leaves Barcelona at the outbreak of the Spanish civil war and lives in France until 1940.
1940 With the German occupation of Paris he goes to live in Palma de Mallorca.
1947 Works for a time in the United States. Commission for murals for the Plaza Hotel, Cincinnati.
1949 Retrospective at the Berne Kunsthalle.
1954 Wins the Graphics prize at the Venice Biennale.
1955–59 Devotes himself exclusively to ceramics.
1956 Moves to his studio near Palma, built by José Luis Sert.
1959 Retrospective at the Museum of Modern Art, New York, with further retrospectives in the following years in Zurich, London, Paris. Continues to live in Palma up to his death in *1983*.

Mimmo Paladino

1948 Born in Paduli in Benevento, Italy.
1964 At the age of 15 visits the Venice Biennale and is impressed by Claes Oldenburg and Jim Dine; begins a course at Benevento School of Art.

1968 Begins artistic activities.
1970–73 Only produces drawings.
1977 First one-man show put on by Lucio Amelio in Naples.
1978 Exhibits for the Franco Toselli Gallery in Milan. One of the works, a yellow canvas with a mask, becomes one of his masterpieces.
1980 Achille Benito writes "En de Re" for Paladino. Benito had earlier linked the young painter with other contemporaries in Italy and named them jointly "Transavanguardia". In the same year Paladino takes part in the Venice Biennale.
Since *1982* numerous one-man shows. Exhibited at the Sidney Biennale.
1985 Retrospective in the Lenbachhaus, Munich.

Oskar Schlemmer

1888 Born in Stuttgart.
1906–10 Attends Akademie der Bildenden Künste in Stuttgart. Meets Willi Baumeister and Otto Meyer-Amden.
1911 Visit to Berlin. Meets the artists around Herbert Walden and the "«Sturm»".

1912 Returns to Stuttgart. Pupil of Adolf Hölzel.
1914 Takes part in the Werkbund exhibition in Cologne.
1915 Wounded in the War.
1920 Works on "Triadic Ballet"; meets Paul Hindemith who is to write the music for the ballet. Exhibits with Baumeister and Walter Dexel at the "Sturm" gallery in Berlin and with Baumeister and Kurt Schwitters in Dresden. Marries Tut (Helena Tutein).
1921 Appointed to Bauhaus. Continues work on "Triadic Ballet" and designs the sets for Kokoschka's "Murderer, Hope of Women", music by Paul Hindemith.
1922 Premiere of "Triadic Ballet" in Stuttgart.
1923 Director of Bauhaus Theatre.
1929 "Metal Dance" is performed at the Bauhaus. Leaves the Bauhaus and goes to the Staatliche Akademie für Kunst und Kunstgewerbe in Breslau. Lectures on "Man and space".
1930 Stage designs for Arnold Schönberg's "Die glückliche Hand" (The Lucky Hand).
1933–34 His first major exhibition planned for Stuttgart is closed by the Nazis.
1937 A few of his pictures from German museum collections are included in the "Decadent Art" exhibition in Munich.
1938 Can no longer live as an artist but has to earn his living as a scenery painter.
1943 Dies after a heart attack while taking a cure in Baden-Baden.

Julian Schnabel

1951 Born in New York.
1965 Moves to Brownsville, Texas.
1969–73 Attends University of Houston.
1973–74 Whitney Museum Independent Study Program, New York.
1976 Works as a cook in Mickey Ruskin's Ocean Club Restaurant.
1978 First gallery show in Düsseldorf.
1979 First one-man show in Mary

Boone Gallery, New York.
1982 First big one-man show at Stedelijk Museum, Amsterdam.
1983 Begins producing sculpture as well. He has taken part in large group exhibitions, such as the 1980 Venice Biennale; A New Spirit in Painting, London 1981; Western Art, Cologne 1981; Venice Biennale, 1982; Nouvelle Biennale de Paris, 1985.

Cy Twombly

1927 Born in Lexington, Virginia, USA.
1948–51 Studies at the Washington and Lee University in Lexington, at the Museum School in Boston and at the Arts Student's League in New York.
1951–52 Black Mountain College where he meets Robert Motherwell and Franz Kline. Travels with Robert Rauschenberg through France, Spain, Morocco and Italy.
1957 Moves to Rome where he has lived ever since.
1951 Onwards, exhibitions in America and later in Europe.

Andy Warhol

1928 Born in Pittsburgh, Pennsylvania, as Andrew Warhola. His parents are immigrants from Czechoslovakia. He grows up in extreme poverty.
1945–49 Attends Carnegie Insti-

tute of Technology in Pittsburgh.
1949 Goes to New York and works as commercial artist. Designs shoes. His window displays are acclaimed.
1960 Produces his first paintings.
1962 Soup cans exhibited at Ferus Gallery, Los Angeles, and the same year at Sidney Janis and Stable Gallery, New York. He founds the Factory with a group of friends. Begins to work with silkscreen and can now "manufacture" his pictures. Produces between 100 and 1,000 pictures per year.

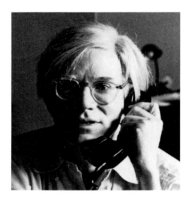

1963 Begins making films.
1964 Brillo Boxes exhibited at Stable Gallery.
1965 Flower pictures. Gives up painting and devotes himself to films.
1967 "Nude restaurant", "Lonesome Cowboys".
1968 Warhol is shot and seriously wounded by Valerie Solanas, a member of the Factory. The film "Flesh" is released. First issue of "Interview" published.
1970 Makes the film "Trash". First large retrospective in both the USA and Europe.
1972 Warhol begins to paint again.
1976 Hammer and Sickle pictures. Portrait of Sioux Indian, Russell Means.
1980 Autobiography "Popism. The Warhol 60's". Exhibition in Whitney Museum in New York, "Andy Warhol Portraits of the Seventies". Thereafter paints mainly high-society portraits.
1987 Dies on 22 February in New York after an operation for gallstones.

Exhibition guide

A selection of major exhibitions

AUSTRIA

SALZBURG

Kunstverein
Marga Persson. Tapestries and paintings

Museum Rupertinum
George Grosz
Spanish sculpture
Alfred Seiland. Colour photographs
Kurt Kocherscheidt
Carry Hauser
Gerhard Rühm
Friedensreich Hundertwasser

VIENNA

Graphische Sammlung Albertina
Albrecht Dürer. The green passion
Georges Rouault. Miserere

Künstlerhaus
Magic of Medusa

Museum des 20. Jahrhunderts
Kurt Kocherscheidt 1976–86
Since 1970 – Austrian art in the museum
Erika Giovanna Klien
25th anniversary of the Museum des 20. Jahrhunderts
Hans Holein

Museum für angewandte Kunst
Alphons Schilling.
Josef Hoffmann. Ornament between Hope and Crime
Sparta/Sybaris. Not a new building style but a new
lifestyle is needed

Palais Liechtenstein
Martin Disler. Sculptures

Sezession
Albert Paris Gütersloh
Malaktion Hermann Nitsch

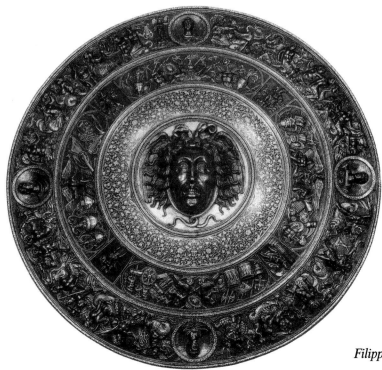

Filippo Negroli

FRANCE

BORDEAUX

Musée d'Art Contemporain
Art Minimal II. Carl André, Sol Lewitt,
Robert Mangold, Brice Marden, Robert Ryman
Wolfgang Laib. Sculptures
Robert Combas. Paintings from 1984 to 1986
Mario Merz. New works
Juan Munoz. Sculptures from 1987
José Maria Sicilia
Susana Solano
Christina Iglesias

CALAIS

Musée de Calais
Yayoi Kusama

MARSEILLE

Musée Cantini
Painting in the light of the Mediterranean

NICE

Musée des Beaux-Arts
Raoul Dufy

Villa Arson
Didier Vermeiren

Ishigaki Eitarò

PARIS

Centre Georges-Pompidou
The Japanese Avant-garde
Richard Baquie
The Graphic work of Oskar Kokoschka
History of the image
Hans Holein
The Centre Georges-Pompidou: architecture exposed
Totem for Saint-Etienne
Design for war
Mies van der Rohe and his followers
The Avantgarde at the end of the 20th century
Paul Outerbridge
Hugh Ferriss. Architectural drawings
Antonin Artaud. Drawings.
Liberties and limits: Porsche design
Avantgarde technology for everyday objects
Josef Sudek: Prague
The Le Corbusier adventure
Lucio Fontana
6 French artists

Grand Palais
Custom/Costume (Costume over 5 centuries)
An exhibition to mark the 50th anniversary of the
Musée National des arts et traditions populaires
Tabis. The Gold of the Pharaohs

Musée d'Art Moderne de la Ville de Paris
Hans Arp

Musée d'Orsay
Eight exhibitions on the theme "The artist's life"
Bohemians; Opera; Careers in architecture in the
19th century; Thonet-Industrie; Journalists in the
19th century; Divas and Stars. Until beginning
March 87
Architecture in Chicago 1872–1922

Musée du Luxembourg
Subleyras 1699/1749. Portraits and church paintings by
French and Italian masters

Musée Louvre
17th-century French drawings from Watteau to
Lemoyne
Regalia. Sacred objects of the Kings of France

Musée Picasso
Picasso as seen by Brassai

Musée Rodin
99 marbles by Rodin

Parc de la Villette
Les Allumés de la Télé. Hommage to the video
By Graphito, Kiki Picasso, Jeantet, Frères Ripoufin
and others

PONTOISE

Musée Pissarro
Georges Manzana-Pissarro (1871–1961)
Emile Gilioli (1911–77)

GERMANY

AACHEN

Neue Galerie Sammlung Ludwig
Recent acquisitions (1984–6) of the Walther Groz Foundation

BERLIN

Berlinische Galerie
Exhibition for the 750th anniversary celebrations of Berlin

Bauhaus-Archiv
The architect as teacher: Mies van der Rohe. Lessons in architecture 1930–58 at the Bauhaus and in Chicago.
The Hochschule für Gestaltung Ulm, 1953–68
50 years of the New Bauhaus, Chicago

Museum für Ostasiatische Kunst
Modern Japanese woodcuts

Nationalgalerie
Mies van der Rohe. A centenary exhibition
Jakob Mattner, sculptures and drawings
Alberto Giacometti

Staatliche Kunsthalle
Otto Dix/George Grosz, paintings, watercolours, drawings
Momentaufnahme (Snapshot) – Berlin art – Berlin Artists 1987

Staatliche Museen Preussischer Kulturbesitz
Archaeology and chemistry
Giacometti

BONN

Städtisches Kunstmuseum
Expressionist prints from the Dr. Kurt Hirche collection
August Macke. Centenary retrospective
Cy Twombly. Drawings
Bogomir Ecker

COLOGNE

Josef-Haubrich-Kunsthalle
Gold and power – Spain in the New World
Henri de Toulouse-Lautrec

Kölnischer Kunstverein
Arthur Segal. Retrospective

Museum Ludwig
Between dream and reality. 20th-century drawings
Per Kirkeby
Joan Miró the sculptor

Wallraf-Richartz-Museum
European historical paintings from Rubens to Manet

DRESDEN

Albertinum
Art treasures of the Medici

Henri de Toulouse-Lautrec

DORTMUND

Museum am Ostwall
Ernst Ludwig Kirchner. Pastels, watercolours, drawings

DUISBURG

Wilhelm-Lehmbruck-Museum
From Lehmbruck to Beuys
Claes Oldenburg
Chris Macdonald

DÜSSELDORF

Kunstmuseum
Swedish glass 1915–60
In the light of the north. Scandinavian painting at the turn of the century

Carl Larrsson

Kunstverein
Christian Boltanksi

Städtische Kunsthalle
Contemporary sculpture. Selected by Harald
Szeemann
Miró
Donald Judd
The axe has blossomed. Architecture and art in
international exhibitions during the 30s

ESSEN

Museum Folkwang
Robert Frank. New York to Nova Scotia
Folkwang 87. Sculptures for public places
American graphics of the 60s and 70s
Edvard Munch

FRANKFURT

Kunstverein
Students of the Hamburg Akademie
Oswald Oberhuber. Retrospective of works on paper
1947–87
Wolfgang Sprang—photography
Italian drawings 1945–87
Ilse Bing—photograpy
Art in Frankfurt 1987

Schirn-Kunsthalle
Bronzes from the Prince of Liechtenstein Collection
Jasper Johns. Prints
Fernando Botero. Paintings, drawings and sculpture

Städelsches Kunstinstitut
French paintings of the 17th and 18th centuries
French drawings 1550–1800
Adolf Wölfli. Drawings 1904–6
Walter Pichler—sculptures, drawings, models
Eugène Delacroix

HAMBURG

Kunsthalle
Rembrandt. Engravings
View of Florence

Kunstverein
Figural. Sculptures
Andy Warhol

HANNOVER

Kestner-Gesellschaft
Boyd Webb

Sprengel-Museum
Picasso. Paintings, drawings, prints
Wolfgang Mattheuer

KARLSRUHE

Badischer Kunstverein
Bruce Nauman. Drawings 1965–1986

MUNICH

Haus der Kunst
The graphic work of Toulouse-Lautrec

Kunsthalle
Fabergé. Court jeweller to the Czars
Niki de Saint-Phalle
Renato Guttuso
18th-century Venetian painting
René Magritte

Museum Villa Stuck
Oskar Kokoschka. Theatre illustrations (1907–67)
Edvard Munch – Paintings, watercolours, prints and
photographs from the Munch Museum in Oslo
From Marées to Picasso

Neue Pinakothek
Enrico della Torre

Staatsgalerie moderne Kunst
Marino Marini. Drawings
Sculpture from the DDR

Städtische Galerie im Lenbachhaus
Enzo Cucchi

MÜNSTER

Westfälisches Landesmuseum
August Macke. Retrospective
Sol Lewitt
Richard Serra. Drawings

Sol Lewitt

NUREMBERG

Kunsthalle
Paul Klee

STUTTGART

Galerie der Stadt Stuttgart
Robert Wilson

TÜBINGEN

Kunsthalle
Toulouse-Lautrec. Paintings and studies

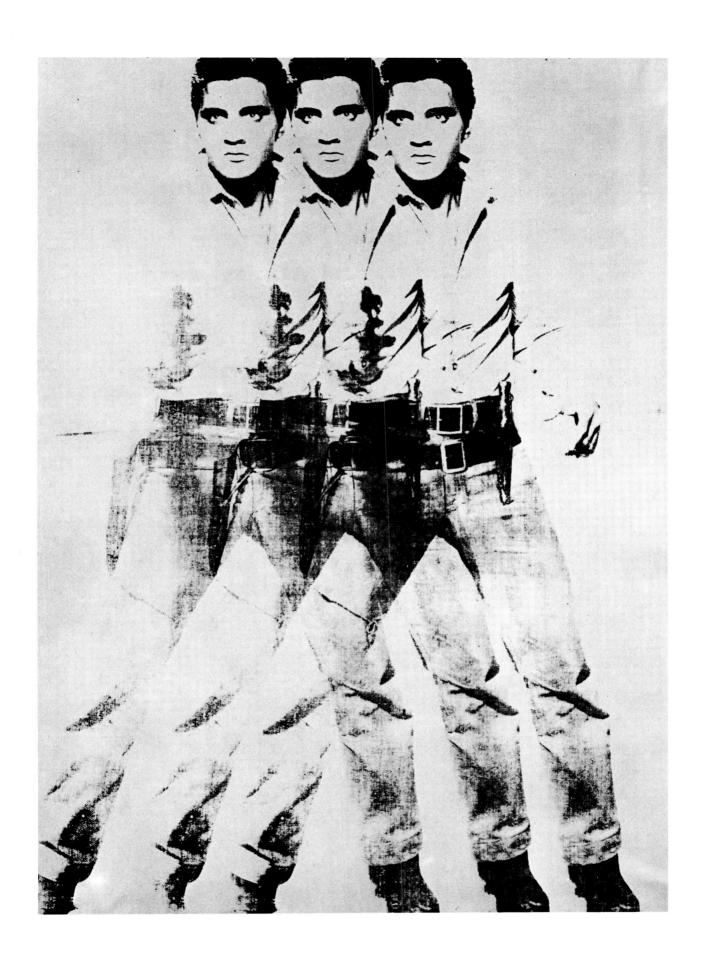

Andy Warhol

GREAT BRITAIN

EDINBURGH

Modern Art Gallery
New Scottish Art
French Master Drawings from Stockholm

National Gallery of Scotland
Robert Manteuil. Prints

LONDON

Barbican Art Gallery
Russian Court and Country Dress 1700–1920 from the Hermitage
Ansel Adams. Memorial Exhibition
The Image of London. Views by Travellers and Emigrés 1550–1920
A Celebration of Thailand

British Library
In Celebration of Pushkin
Rudyard Kipling (1865–1936)

British Museum
Archaeology in Britain since 1945
New Thracian Treasures from Bulgaria
Ceramic Art of the Italian Renaissance
300 years of bank note design
Glass of the Caesars

Hayward Gallery
Auguste Rodin. Sculptures and drawings
Le Corbusier Retrospective
Tony Cragg. Sculpture
Gilbert & George
André Masson. Drawings 1921–74
Diego Rivera

Institute of Contemporary Arts
State of the Arts. Survey of international contemporary art
Nancy Spero—Retrospective
Comic Iconoclasm—the comic strip and the fine arts

National Gallery
Body Lines. The Human Figure in art
G.L. Brockhurst 1890–1987. Portraits
The Artist's Eye: Lucien Freud

National Portrait Gallery
Queen Elizabeth II. Portraits of 60 years
Laurence Olivier. An 80th birthday tribute

Royal Academy
British Art in the 20th Century

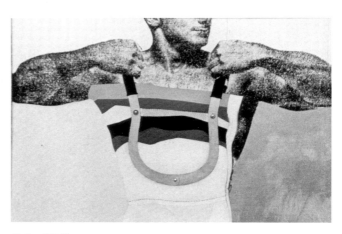

John Walker

219th Summer Exhibiton
Old Master Drawings from the Woodner Collection
The Age of Chivalry. Art in Plantagenet England.1200–1400

Tate Gallery
Naum Gabo. Retrospective
British and American Pop Art
Mark Rothko
Winifred Nicholson. Retrospective
Hogarth and British Painting 1700–60

Victoiria and Albert Museum
Irving Penn. Photographs
Alvar Aalto
Cecil Beaton

MANCHESTER

Whitworth Art Gallery
The Private Degas

OXFORD

Museum of Modern Art
Soviet Posters of the Silent Cinema

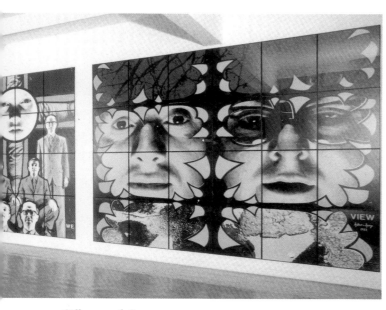

Gilbert and George

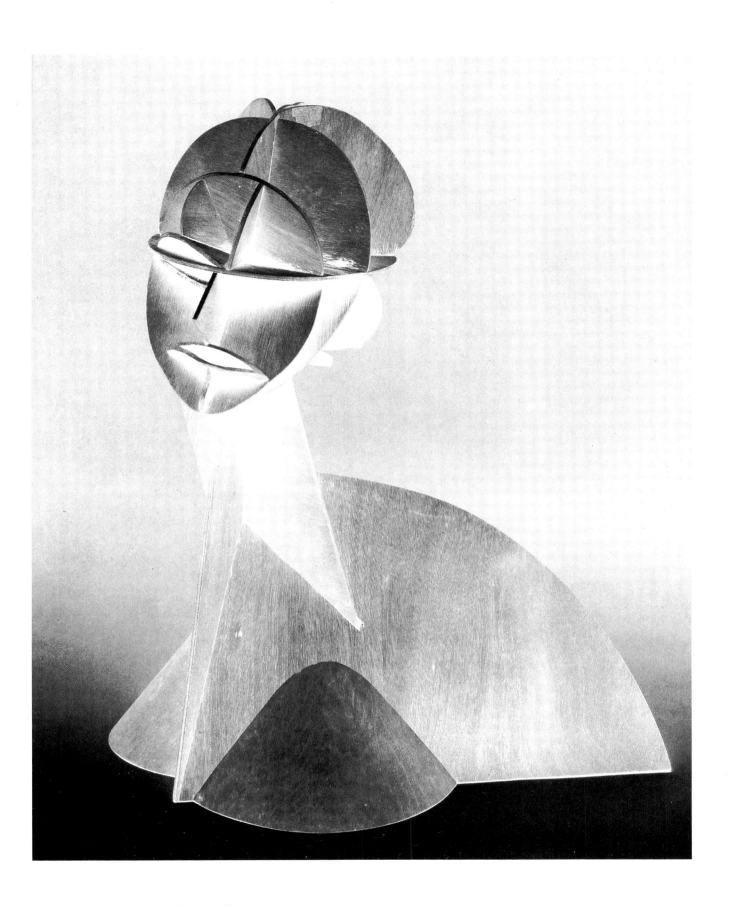

ITALY

FLORENCE

Palazzo Strozzi
16th-century Florence

Palazzo Vecchio
Capolavori e Restauri (Masterpieces and restorations)

SS. Annunziata
Church treasures

MILAN

Padiglione d'arte contemporanea
Il Cangiante
Contemporary Polish graphics

Palazzo Reale
Bruno Munari

ROME

Museo Capitolini
Giovanni Serodine

Palazzo Braschi
Louis Ducros

TURIN

Accademia Albertina
Mario Calandri

Castello
Markus Lüpertz and Giulio Paolini

Markus Lüpertz

Mole Antonelliana
Hundred years of the heart. Book and art

VENICE

Fondazione Guggenheim
Jean Dubuffet and Art brut

Galleria d'Arte Moderna
The London School

Museo Correr
Henri Matisse

Henri Matisse

Palazzo Ducale
Cina in Venice
The treasures of San Marco

Palazzo Fortuny
Dialectical landscapes. American
landscape photography

Palazzo Grassi
Effetto Arcimboldo

Palazzo Querini Stampalia
The Querini Stampalia

Giuseppe Arcimboldo

SWITZERLAND

BASLE

Kunstmuseum
Joseph Beuys. Watercolours, aquarelles and watercolour
drawings 1936–86
In the light of Holland

Museum für Gegenwartskunst
Contemporary Russian art
Francesco Clemente. Drawings, watercolours
Thomas Huber. The prehistory of painting

Francesco Clemente

BERNE

Historisches Museum
Krishna and Buddha. Religious art from India

Kunstmuseum
Der Blaue Reiter. Kandinsky, Franz Marc and the rise
of New Art in the 20th century
Meret Oppenheim. Legacy to the Kunstmuseum
Otto Tschumi. Retrospective
Paul Klee: Twitter-machine

GENEVA

Musèe de l'Athénée
Chagall. Japanese prints of the 18th and 19th centuries

Musé Rath
Minotaure: From Picasso to the Surrealists

LAUSANNE

Fondation de l'Hermitage
René Magritte. Retrospective

Musée cantonal des Beaux-Arts
Picasso. Engravings from the Gottfried Keller
Foundation

Musée de l'Elysée
Henri Cartier-Bresson

LA CHAUX-DE-FONDS

Musée des Beaux-Arts
Le Corbusier, painter before Purism

MARTIGNY

Fondation Pierre Gianadda
Henri de Toulouse-Lautrec

Henri de Toulouse-Lautrec

ZURICH

Kunstgewerbemuseum
L'esprit Nouveau. Le Corbusier and industry
Heart-blood. Forms of popular design

Kunsthaus
Joan Miró.
Works by female historical artists
Ivan Mestrovic. Sculptor
Eugène Delacroix
Viktor Hugo. French Photography 1840–71
Quiet afternoon. Aspects of young Swiss art
Brancusi. The sculptor as photographer
Edvard Munch.

Edvard Munch

USA and CANADA

BOSTON

Museum of Fine Arts
Gauguin and his Circle in Brittany

CLEVELAND

Museum of Art
Georgia O'Keeffe
Illuminations: The Art of Light

CHICAGO

Art Institute
Hodler and the Swiss Landscape
Gustave Le Gray

DALLAS

Museum of Art
102 Works by 54 Artists Representing Every Major
School of 20th Century Sculpture

DETROIT

Institute of Arts
W. Hawkins Ferry Collection
Ellsworth Kelly

HOUSTON

Contemporary Arts Museum
Beuys, Warhol, Polke

IOWA CITY

Des Moines Art Center
Pierre Alechinsky

LOS ANGELES

Country Museum of Art
Robert Frank
The Machine Age in America 1918–41
Jasper Johns

LOUISIANA

Museum of Modern Art
The Art of Mexico—before the Spaniards

MALIBU

J. Paul Getty Museum
Images that yet/Fresh images beget...
Photographs
Landscape Drawings

NEW YORK

American Craft Museum
Craft Today. Poetry of the Physical

Center for African Art
Masterpieces of African art from Völkerkundemuseum
Munich

Cooper-Hewitt Museum
Arches

International Center of Photography
David Seymour «Chim». The Early Years (1933–9)

Metropolitan Museum of Art
Van Gogh in Saint-Rémy and Auvers

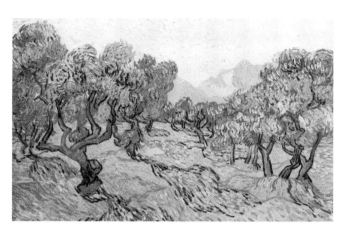

Van Gogh

Dance
Bamana. Sculpture from West Africa
Ancient Art in Miniature
Selections from the Ernest Erickson Collection of
Ancient Chinese Art
Edward Weston
Silver by Tiffany & Co.
Chinese Painting and Calligraphy
Hudson River School.

Museum of Modern Art
Mario Botta
Paul Klee

Paul Klee

Jacques Cartigne
Projects: Louise Lawler
Jan Groover

Gyula Gazdag
The Drawings of Roy Lichtenstein
Gauguin and his Circle in Brittany
Contemporary American Prints 1960–85
Cartier-Bresson. The Early Work
Berlinart 1961–87
Mario Bellini. Design
New Photography 3
Frank Stella
Surrealist Prints from the Museum
Bill Viola

Salomon R. Guggenheim Museum
Il Corso del Coltello (The stroke of the Knife)
Oskar Kokoschka (1886–1980)
Recent Gifts: Drawings Donated by Norman Dobrow
Peggy Guggenheim's other Legacy
Joan Miró. A Retrospective
Selections from the Exxon Series
Jan Dibbets
50 Years of Collecting

The Brooklyn Museum
The Machine Age in America 1918–41

The New Museum of Contemporary Art
Hans Haache. Retrospective
Bruce Nauman. Drawings 1965–86

The Studio Museum in Harlem
Art of Black America

Whitney Museum
John Storrs
Cindy Sherman
Charles Demuth
Julian Schnabel
Alexander Calder

PHILADELPHIA

Museum of Art
Joan Miró

SAN FRANCISCO

Museum of Modern Art
Nature and Architecture in the Work of Paul Klee

ST. MONICA

The J. Paul Getty Museum
16th-Century Drawings

TOLEDO

Museum of Art
Rembrandt's Holy Family from the Soviet Union

TORONTO

Art Gallery of Ontario
John Lyman. Retrospective
Surrealism and Its Influence
Roger und Myra Davidson Collection

Georges Rouault (1971–58)
Masterpiece Series: The Marchesa Casati

WASHINGTON

National Gallery of Art
Alexander Archipenko
The Age of Correggio and the Carracci
Emilian Paintings of the 16th and 17th centuries
Georgia O'Keeffe
Henri Matisse. The early years in Nizza (1916–30)
American Furniture from the Kaufmann Collection
The Age of Sultan Suleyman the Magnificent
Joseph Stella, Alfred Stieglitz
A Century of Modern Sculptures
Andrew Wyeth. American Drawings and Watercolors of
the 20th Century
Italian Master Drawings from the British Royal
Collection
Berthe Morisot (1841–95)
A Century of Modern Sculpture
Georgia O'Keeffe
William M. Chase

Joan Miró

Henri Matisse

Index of names

Picture credits